# photography

## OTHER BOOKS BY A. E. WOOLLEY

# photography

## a practical and creative introduction

### a. e. woolley

**McGraw-Hill Book Company**

New York
St. Louis
San Francisco
Düsseldorf
Johannesburg
Kuala Lumpur
London
Mexico
Montreal
New Delhi
Panama
Rio de Janeiro
Singapore
Sydney
Toronto

**photography:**  a practical and creative introduction

1234567890VHVH79876543

This book was set in Claro Light by University Graphics, Inc.
The editors were David Edwards, Robert Weber, and Susan Gamer;
the designer was J. Paul Kirouac;
and the production supervisor was Sally Ellyson.
The drawings were done by Eric G. Hieber Associates Inc.
The printer and binder was Von Hoffman Press, Inc.

**All photographs are by the author unless otherwise credited.**

Library of Congress Cataloging in Publication Data

Woolley, Al E
    Photography: a practical and creative introduction.

    1. Photography.  I. Title.
TR145.W78 1974     770'.28     73-7867
ISBN 0-07-071860-1

to ralph wickiser and ben karp

# contents

# preface

My professional career has been equally divided between teaching photography and practicing it. I have held teaching positions at the State University of New York and Louisiana State University and have conducted seminars at a score of schools and colleges. Photojournalism has taken me around the world to produce magazine stories and books. Both the teaching and the practice of photography are the foundations for this book—everything included has been tested by time and experience.

This book is oriented toward an introduction to black and white photography, though some chapters might be useful as well to a study of color photography. It is my conviction that anyone who follows this directed study through the various levels of photographic learning will have a firm working knowledge of the medium. At times I hope the reader will disagree with me and, in pursuit of another answer, discover a broader point of view. The chapter-ending lists of suggested readings have been included so that you will be able to find additional material to support an idea, or to intelligently debate a point with which you disagree. Discovery is a great traveling companion with creativity.

There are many people to whom I owe a special note of thanks and I would like to mention them: Pearl Oliwenstein, Joyce Rose, Roberta and George Riley, Bob Belenky, Lester Krauss, Javier Martinez, Les Kaplan, Howard Cohn, Joe Fletcher, Dave Sendler, John Durniak, Cheryl Messinger, Ed Pfizenmaier, Alfred Gescheidt, Cornell Capa, David Attie, and Andre de Dienes. My wife, Dorothy Ellen, deserves a medal for her patience.

Photography is enjoying a level of popularity which it has never before had. A camera over one's shoulder is as much a part of modern dress as a tie or jacket, jeans and sandals. Millions of rolls of film are exposed every day, often merely to record personal involvement with family and friends. But more and more these "family pictures" go beyond simple likenesses, and it is toward such improvement that this book is directed. For the person who has never taken pictures except as family records, this book offers improved ways of seeing and photographing; for the novice who has a slight working knowledge of photography, the contents explore techniques for improvement; and for the photographer who has made an attempt to delve into philosophies and techniques of photography, this book can serve as a road map.

**a. e. woolley**

photography

# part 1

## a frame of reference

# chapter 1
## the history of photography

The development of photography was a gradual process that involved the work and experiments of many people and took more than four centuries. However, the contemporary negative/positive concept of photography is only 140 years old. Photography may be defined in several ways, but basically it is the art of recording a moment of time by preserving it as a latent (invisible) image on light-sensitive film that is processed ("developed") to become a permanently fixed image. All these elements of the process were brought together through the efforts of experimenters using laborious and time-consuming procedures. One can appreciate the almost effortless methods available to photographers today when one learns how difficult it was to make a photograph in the early years.

**the early years**  Perhaps the single most important catalyst for the development of photography was the popularity of the *camera obscura* in the eighteenth century. The camera obscura ("dark room") was a dark chamber with a small opening or hole that allowed light to transmit an image from outside the room onto a flat white surface, opposite the hole. It was then possible to trace the outline of the image, and thus was used by many painters. The camera obscura was described by Leonardo da Vinci in his notebooks (c. 1490), and by Giovanni Battista della Porta in his book *Natural Magic,* first published in 1558. Daniele Barbaro added a lens to the design that enabled the user to control the size of a projected image. The principle of design for the cameras of today has therefore existed for about four hundred years.

To exercise optical control over the image another device was designed, the *camera lucida.* Invented in 1807 by an Englishman, William Hyde Wollastron, the camera lucida was placed on a flat surface, along with drawing paper. A glass prism was suspended at eye level over the paper. By looking through the prism, the artist saw both the drawing surface and the subject, and his charcoal or pen was guided by the image itself. The camera lucida was portable and became a favorite companion of traveling artists.

The camera obscura and camera lucida both enjoyed wide use and popularity in the seventeenth and eighteenth centuries, and many variations on their basic designs were devised. In the form of a darkened box, the portable camera obscura was a favorite of both artists and scientists.

The chronological development of any process does not necessarily run in parallel lines to its uses. In the early years of the eighteenth century Johann Heinrich Schulze discovered that light changes the nature of chemical substances. Schulze was experimenting with a mixture of chalk, silver, and nitric acid in a bottle and found that sunlight had changed the white precipitate to a deep purple. When he exposed the mixture to heat alone, nothing happened. He concluded that it was the light of the sun, not the heat, that altered the color. To demonstrate his theory he placed stencils of dark paper on the bottle containing the mixture. After exposure to light, the stencils were removed and their images could be seen clearly on the surface of the mixture. This discovery took place in 1727 and established, 100 years before the first successfully processed photograph, the process on which photography would be based.

Thomas Wedgwood, the son of the famous English potter, was one of the first to attempt stabilizing the camera obscura image. He made drawings on silver nitrate–coated glass which was exposed to light.

Where the glass was clear, light reached the silver and turned the plate dark; and where the glass was protected from light, there was no change. These "prints" were not permanent, for they darkened quickly when exposed to light, thus obscuring the image. They could be preserved only by storing them in a dark place and viewing them in a dim light.

Joseph Nicéphore Niépce of France was more successful in preserving the light-rendered image. In 1816 he properly described the negative image as it is known in contemporary photography, although he was unable to print one. Extensive experimentation led Niépce to discover the photoengraving technique which he named "heliography." The process involved a pewter plate coated with bitumen of Judea which dissolved in Dippel's oil. The engraving to be reproduced was placed on this plate and exposed to light. The image was "developed" in a solvent, washed, and dried. The plate was then etched in weak acid, and prints could be made from it. It resulted in a permanent image that was unaffected by light. This discovery stimulated his desire to fix the camera image, but he was not completely successful. In fact it was not until he joined in partnership with an artist named Louis J. M. Daguerre in 1829 that a permanently fixed camera image was obtained. Unfortunately, Niépce died in 1833 and did not see the results of their collaboration: In 1837 Daguerre made a bright, detailed photograph in his studio. Daguerre was successful using a modification of the heliograph process, which he changed sufficiently to warrant identifying the new process by his own name. The daguerreotype was born. In 1839 members of the French Academy of Science and the Academy of Fine Arts were given a demonstration of the process. In the same year Daguerre was awarded an annuity by the French Chambers of Deputies and Peers, and Isadore Niépce was also awarded an annuity for the contributions of his father.

The daguerreotype was a silver-covered copper plate made sensitive to light by the action of iodine. After exposure in the camera, the latent image was developed using vapor of mercury. It was fixed in hypo,[1] washed, and dried. The picture was a direct positive, since the areas struck by light became white, while the rest of the mirror-like surface was dark. It was not possible to make prints from the daguerreotype, and this was a major disadvantage.

[1]Hyposulfite of soda, or sodium thiosulfate, used as a fixing agent in photography.

The daguerreotype was an instantaneous success. Studios opened in almost every city and town. Daguerre published a 79-page booklet in a score of languages that was so complete in detail that anyone

following the instructions could expect successful images. When he died in 1851, he had lived long enough to see his contribution to creativity spread throughout Europe and North America.

No country, however, made the daguerreotype as much a part of its contemporary culture as did America. Improved designs made the cameras better. Double-element lenses, film plates with greater sensitivity, and a tougher, more lasting image contributed to the popularity of the process in America during the 1840s and 1850s. The privilege of having one's portrait painted had long been enjoyed by only the wealthy. Now, with the inexpensive daguerreotype, almost everyone could have a portrait made. Thus, the visual record of the nineteenth century includes not only the celebrated and well known but also the shopkeepers, farmers, soldiers, and ordinary workman.

The first photograph by Louis J. M. Daguerre. This is dated 1837 and is entitled "The Artist's Studio." **George Eastman House.**

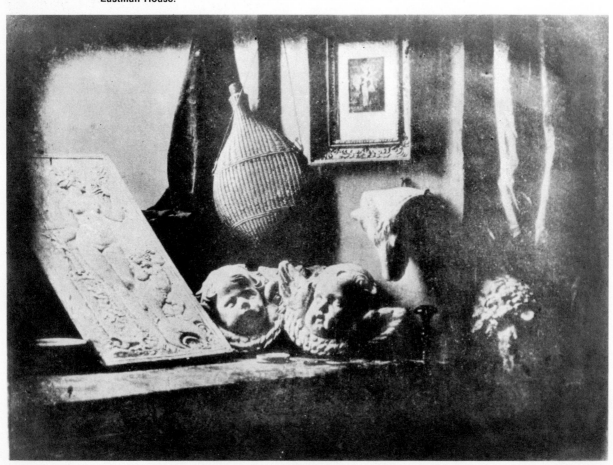

A calotype by Henry Fox Talbot. This process first used the negative-to-positive procedure which is employed in today's photography. The picture, "Open Door," was made in 1844. **George Eastman House.**

In England Henry Fox Talbot, who claimed to be unaware of the work of Daguerre in the early 1830s, was experimenting with permanent camera obscura images on paper. In 1835 he described one of his small pictures, which was actually a negative. Fearing that the efforts of Daguerre, whom he had learned about, might deprive him of recognition, Talbot presented samples of his work, which he called "photogenic drawing," to the Royal Institute in London in January 1839. Talbot was afraid that his process was the same as Daguerre, and he wanted to establish priority. He was unaware of the significant difference between the two techniques.

the talbotype, or calotype

Talbot had produced an image whose black and white tones were the opposite of the original subject (a *negative*) and then reversed the tones, creating a *positive* print; thus he had laid the foundation for the negative/positive photographic process.

In a letter to Talbot, Sir John Herschel, a British astronomer who experimented with the new process, suggested that the term "photographic" was more appropriate than "photogenic." The word "photograph" was derived from the Greek words *photo,* meaning "light," and *graphos,* meaning "to write." In addition, Herschel was the first to use the terms "negative" and "positive." Between Talbot and Herschel the new process was named and immediately included in every language of the Western world.

Talbot's process had a major advantage over Daguerre's method in that the original negative could be printed to a positive original as many times as wanted. But the quality of the positive was inferior in brilliance, sharpness, and clarity to the daguerreotype because of having to be printed through a paper negative. (It was not until glass was used as the negative base that these disadvantages were overcome.) Talbot improved his early methods, discovering the process of developing a latent image, shortening the time of exposure, and experimenting with different fixing agents. He called the perfected process the "calotype," later changing the name to "talbotype."

It was Talbot himself who kept the calotype, or talbotype, from enjoying the enormous popularity of the daguerreotype. Perhaps because he had received no more than token recognition—and no money—for his efforts, or for some other reason known only to him, Talbot chose to keep a tight hold on his process. It was not until August 1852 that Talbot relinquished his control on the invention, but even then he withheld its use for portraits for profits. This was an important limitation because at the time the major use of the photographic image was for portraits.

In 1854, a jury ruled that a portrait photographer using glass-based negatives was not guilty of infringing on the talbotype patent, but it did rule that Talbot was the true inventor of the negative-to-positive photographic process. In effect this decision placed the negative/positive method in the public domain. Talbot retained control on his process and continued trying to sell licenses for its use in portrait photography. The process was mildly successful in France but a total failure in the United States, where a mailing campaign offering licenses did not sell one license. Even though the talbotype failed to unseat the daguerreotype from its position as recorder of the American face, the process did achieve a level of acceptance with photographers of buildings, still lifes, and works of art. Cameras with large formats were designed for picturing these subjects. When the large paper negatives, some as big as 20 x 29 inches, were printed to positives of the same size, an image of high quality resulted.

The talbotype and daguerreotype both enjoyed success without major competition until 1851, when Frederick Scott Archer invented the wet collodion process, often called the "wet-plate" process.

Collodion is a sticky solution of guncotton and ether that, when spread on a smooth surface and dried, becomes a thin transparent membrane. In Archer's invention, collodion, in which potassium iodide was dissolved, was spread evenly on a glass plate. The coated plate was dipped in a silver nitrate solution and exposed while still wet. The exposed image was developed in pyrogallic acid. After development the negative image was stripped from the glass, rolled up with paper on a glass rod, and later fixed and washed. In this way the glass plate could be used repeatedly. Because of the high sensitivity of collodion, the exposure time was greatly decreased.

A modification of the collodion process became known as the "tintype" because of the thin metal plate on which the light-sensitive chemical was placed. A direct positive was produced. Tintype plates were manufactured in 1856 and were the toughest image surface then available to photographers.

**early photographers**

Among the outstanding practitioners of photography in the 1840s and 1850s were David Octavius Hill, a painter who used talbotypes to photograph 450 delegates attending a convention; Blanquart-Evrard, who reduced exposure time by using a modification of the talbotype; and André Adolphe Disdéri, who popularized the carte-de-visite photograph, the calling-card-size multiexposure wet-plate portrait which was shot in groups of eight to twelve pictures in one sitting, using one plate.

Other pioneers in photography in the nineteenth century were Gaspard-Félix Tournachon, a Frenchman known to the photographic world as Nadar; Oscar G. Rejlander, a Swede who won his fame by printing thirty separate negatives to create one final picture and is also believed to be the first to photograph nudes; Antoine Adam-Salomon, who first used high side lighting on his models; Juliea Margaret Cameron, who made impressionistic and sentimental portraits using optical diffusion and poor detail definition and was greatly admired by artists and critics of her time; and Roger Fenton, who photographed the Crimean War in 1855.

Daguerreotypes had been made of men and officers who served in the Mexican War, but Fenton took his camera and darkroom to the

A calotype portrait on waxed negative made by David Octavius Hill about 1845. Hill produced many outstanding portrait images using the calotype process. **Annan Gallery, Glasgow, Scotland.**

battlefield and introduced a new application of photography, the documentation of battle. When his negatives and prints were exhibited and published in England, Fenton became the first photojournalist—although the word was not coined until 100 years later.

Mathew B. Brady    The most famous nineteenth-century war photographer was Mathew Brady, an American portrait photographer who had enjoyed great success with the daguerreotype. When the wet-plate collodion process became available, he used this with equal success, especially

during the Civil War. He took his darkroom wagon into the battlefield not only to picture the men and the officers, but to record the war itself. Brady's wagon, carrying the needed materials and tools for coating the wet plates and developing them, appeared frequently on the battlefields, and the soldiers nicknamed it the "Whatsit Wagon."

But Brady did not take all the pictures he is credited with having made during the Civil War. He organized several teams of photographers, whom he paid to do the work. This undertaking cost him his fortune, which had been earned as a portraitist, and sent him into debt. He lost control of his negatives, some going for the payment of materials, others for storage charges. Fortunately, all these negatives are now preserved in the National Archives and the Library of Congress, Wash-

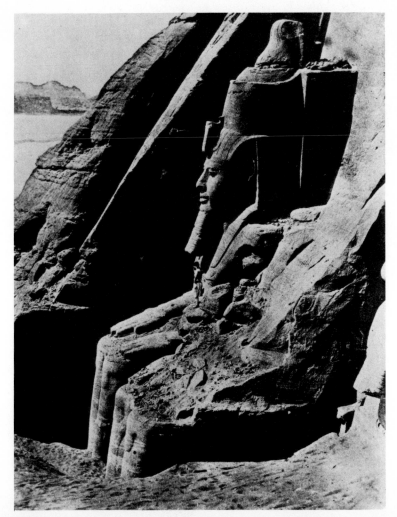

In 1850, Maxime Ducamp took his camera out of doors to photograph the giant Colossus of Abu Simbel in Egypt. **George Eastman House.**

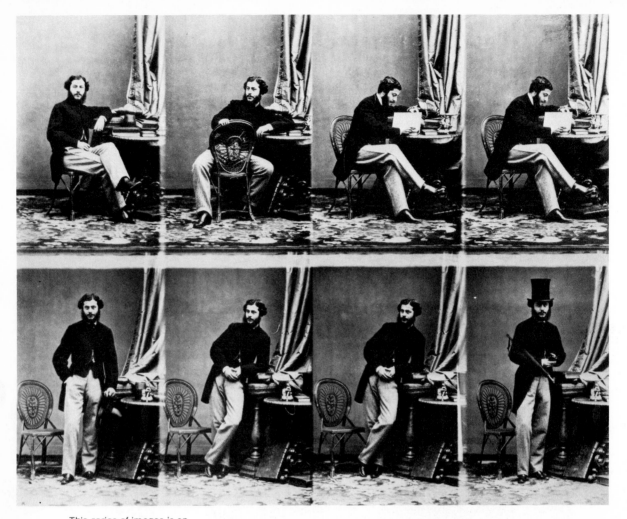

This series of images is an uncut print from a carte-de-visite negative taken about 1860 by Disdéri. The mass production of photographs as practiced by Disdéri proved to be a fatal blow to the daguerreotype for picturing the average citizen. **George Eastman House.**

ington, D.C. Brady's Civil War photographs were made on glass-based wet-plate negatives. Needless to say, some of these were damaged or broken, but most remain in good condition today.

Two men who worked for Brady in the Civil War venture left the project to make names for themselves: Alexander Gardner and Timothy H. O'Sullivan. Following their service in covering the Civil War, both men began to photograph the opening of the West. Gardner pictured the railroad as it pierced the western plains and mountains. O'Sullivan traveled with expeditions as they explored new regions. They did not have mobile equipment and the benefits of modern technology, but their photographs are outstanding, even when measured by today's photographic standards.

Experimentation continued to improve the processes. Talbot made an exposure using an electric flashlight; Gardner shot twin pictures to produce stereoscopic three-dimensional images; and Eadweard Muybridge photographed a horse in motion. For his work with photographic motion Muybridge used gelatin dry plates, which were newly developed. The demand for a more convenient film material stimulated continued experimentation, and in 1867 an English firm, Liverpool Dry Plate and Photographic Printing Company, marketed the first dry plates. These dry plates were slower than wet plates, but in 1879 Charles Bennet succeeded in making a dry plate which was sensitive enough to allow exposures of 1/25 second. Dry plates were much easier to use than wet plates, and their faster film speeds obviated the use of tripod-mounted cameras and made photography available to everyone.

**development of the process**

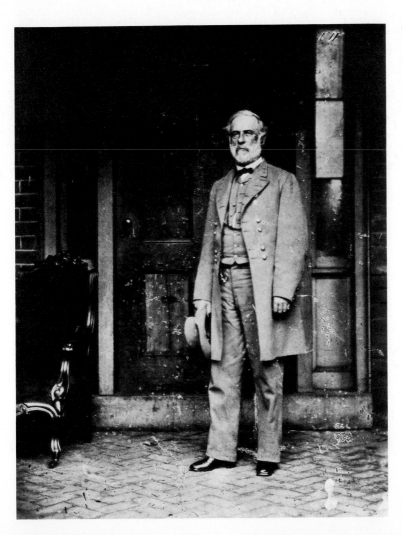

General Robert E. Lee from a daguerreotype by Mathew Brady. Brady was a famous portrait photographer before he invested all his time and money in documenting the Civil War. **Library of Congress.**

While Mathew Brady is most given credit for picturing the Civil War, other photographers did their part to record the conflict. Here is the wagon and camera of Samuel A. Cooley. **Library of Congress.**

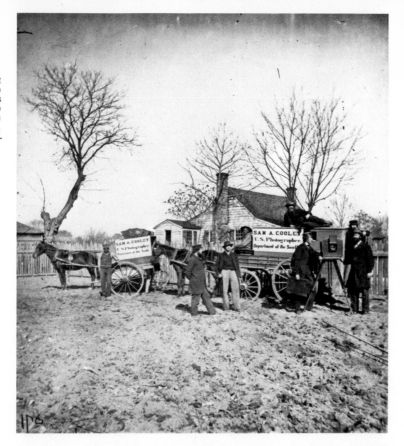

Handheld cameras became very popular in the 1880s. But it was the American inventor, George Eastman who made photography a household word. In 1888 he introduced the first roll-film camera, the Kodak, with a capacity of 100 photographs. The camera was bought with the film inside, and the exposed pictures were sent to the Kodak plant in Rochester, New York, for processing. The pictures were developed and returned along with the camera and a new roll of film for a charge of $10.00. The advertising slogan for the Kodak was "You push the button, we do the rest"—an apt description of the ease with which photography could then be accomplished.

**development of the art**

While Eastman made photography available to anyone with the price of the Kodak, creative men were making photographic images that challenged the art world for recognition of the process as an art. One of the early proponents of photographic art was Peter Henry Emerson,

an Englishman who expressed his views about the artistic merits of photography in 1886. But Alfred Stieglitz, an American, succeeded in having photography accepted as an art form. Stieglitz assembled photographic exhibitions that, as he said, showed photographs giving "distinct evidence of individual artistic feeling and execution."[2] He used his own camera creatively, and he encouraged the work of other young photographers such as Edward Steichen, Clarence H. White, Gertrude Käsebier, and Alvin Langdon Coburn.

[2]*America and Alfred Stieglitz,* Literary Guild, 1934.

In the beginning of the twentieth century Stieglitz opened a gallery, An American Place, in New York, which served not only to display the works of photographic artists, but also to introduce to the American audience European artists such as Matisse, Cézanne, Picasso, Rodin, and Brancusi.

Paul Strand, Edward Weston, Steichen, and Stieglitz produced photographs that proclaimed the artistic qualities of the medium. Through exhibitions and published works these men gained at least a small measure of recognition for the art of photography.

Another individual who helped to bring recognition to photographers and the art of photography was Berenice Abbott. She had her first

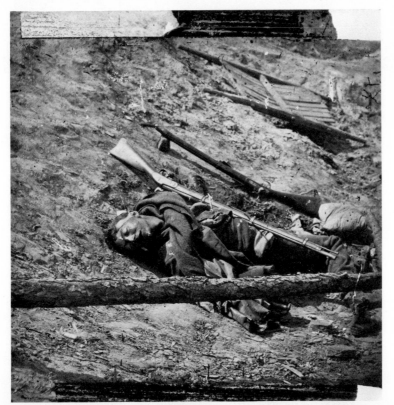

Several photographers working with Brady made outstanding pictures. This is one that might have been taken by either Alexander Gardner or Timothy H. O'Sullivan. These men took the camera out of doors and changed the role of photography. Photojournalism can be said to begin with the efforts of Civil War photographers. **Library of Congress.**

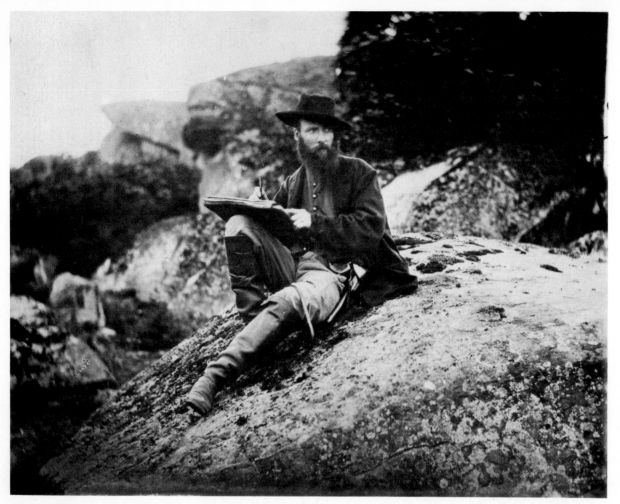

Timothy H. O'Sullivan made
this fine environmental portrait
of a battlefield artist at work.
The artist, Alfred R. Ward,
was photographed at
Gettysburg in July 1863.
**Library of Congress.**

"one-man show" in Paris in 1926; in 1929 she moved to New York, where she photographed and taught photography for the next thirty years. Berenice Abbott's photographs of famous people, buildings, and street scenes are sensitive and straightforward; her science photographs (done in the 1950s and 1960s) are beautiful and technically brilliant, conveying the force and power of physical phenomena.

One of Berenice Abbott's most significant achievements was collecting and publishing the photographs of Eugène Atget. She knew Atget in Paris, and after his death in 1927 she began a devoted effort to perpetuating his work.

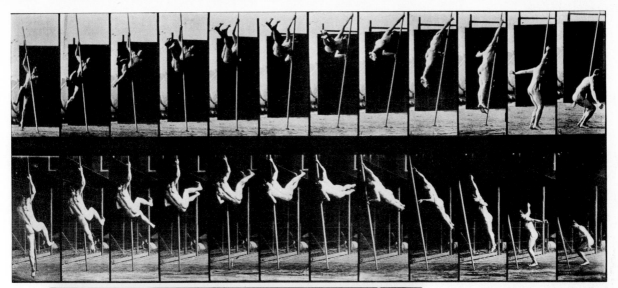

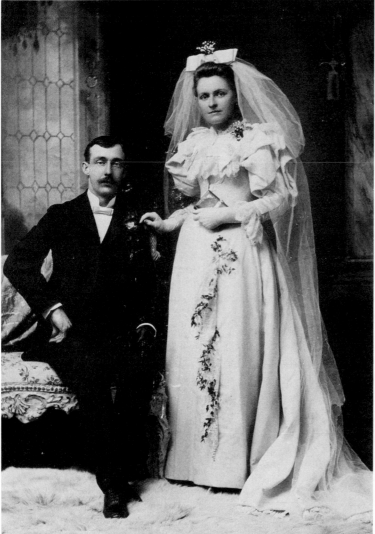

One of the early pioneers with motion in photography was Eadweard Muybridge. This series of images of a man pole-vaulting was made in 1887. **Library of Congress.**

A wedding portrait typical of the studio photographs popular about 1900. The slowness of film emulsions required long exposures and often the sitters had to have braces to hold their heads still. This resulted in very stiffly posed photographs. **A. V. Card, Kingston, New York.**

Edward Weston saw beauty and design in the shapes and objects of nature. He used an 8 x 10 view camera and composed the image exactly as he wanted it to appear in the finished photograph. His discipline and concern for the right components of composition frequently resulted in his not finding anything to photograph after a day-long outing with his view camera. **George Eastman House.**

Atget's photographs of Paris are the work of a great artist. Using a view camera on a tripod, he made lengthy exposures on 7 x 9 inch glass plates. The lens was stopped-down to a very small opening to ensure optimum sharpness and detail. His photographs were powerful and straightforward, and they became an inspiration for the young photographers who advocated straight photography.

Early in the years of struggle for acceptance of photography as an art, a European publication, *Studio One,* devoted an entire issue to the photograph. In 1905 the book presented tipped-in reproductions of photographs by Stieglitz, White, Steichen, Coburn, and many others. The publication of this volume—the special summer edition of 1905—devoted to photography was a landmark in the fight for recognition.

Many of the major contributors to photographic art were former painters or graphic artists. Steichen was a painter; Man Ray, who introduced the photogram, was an artist; Abbott was a sculptor; and Laszlo Moholy-Nagy was a teacher at the Bauhaus School of Design. Others, such as Ansel Adams, Imogen Cunningham, Willard Van Dyke, and Edward Weston, were either trained in art or had close personal relationships with artists.

While the artistic merits of the photograph were being extolled by Stieglitz and his followers, another application of photography was being made—social documentation. Louis Hine and Jacob Riis—both of whom worked in the first third of the twentieth century—showed how difficult life was for the poor and the working people of New York. Riis, himself an immigrant, pictured the deprivation of the newly

**photojournalism**

Robert Capa photographed war to his death. Beginning with the Spanish Civil War in 1936 with this dramatic picture of a soldier being shot through the head, Capa pictured the five major wars of the 1940s and 1950s.
**Magnum Photos, Inc.**

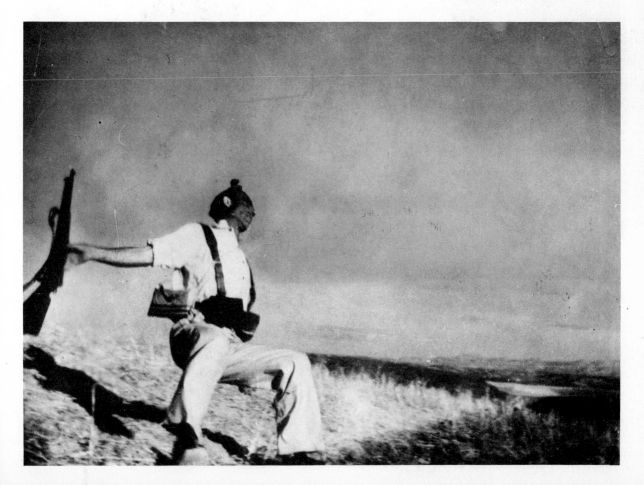

W. Eugene Smith's most famous picture the "Walk to Paradise Garden," is not only a great photograph, but an experience in a photographer's return from death. Smith made the picture after being almost fatally wounded in World War II. After two years without being able to practice photography, Smith managed to load his camera and make this remarkable picture of his children. **W. Eugene Smith.**

arrived citizens-to-be. His photographs helped to bring about improvements in the living conditions. Hine took his camera into the shops and factories where he photographed the working conditions and the children who operated some of the machinery. His photographs also helped to bring about reform. The work of Riis and Hine was the forerunner of *photojournalism.* In the early 1920s *Fortune*

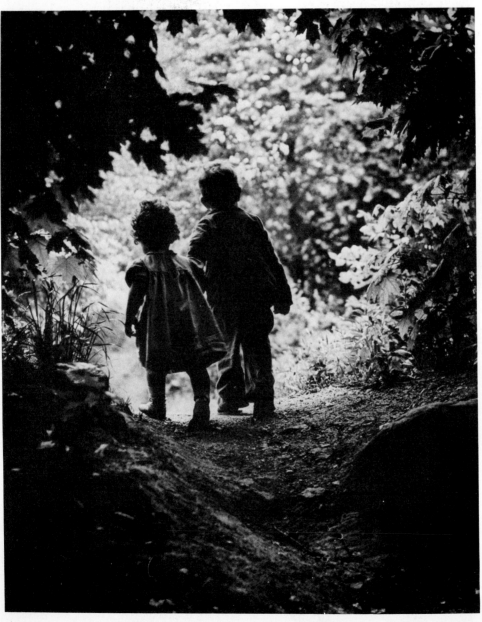

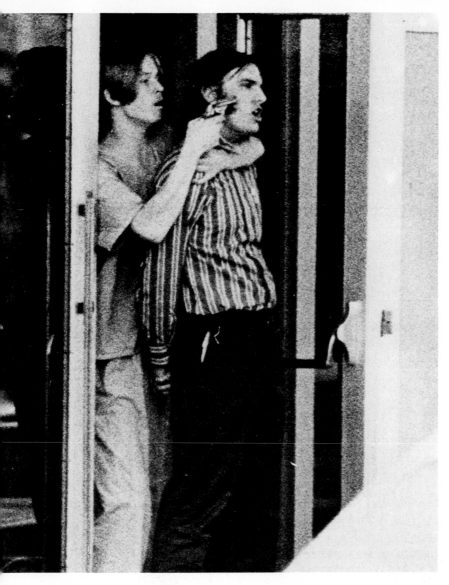

The monumental events of the twentieth century were circulated worldwide through the services of wirephoto, introduced in 1908. Pictures could almost instantly be telegraphed to newspapers and publications for immediate release. This service enabled photography to fulfill its role as eyewitness. **United Press International News.**

and *Time* magazines had published portfolios of photographs. But the full impact of visual communication was not felt until 1936.

Several technical advances occurred in the 1920s and 1930s; probably the most significant development was the invention of the Leica, the first 35-millimeter system of photography.

35-millimeter cameras

In 1924 Oskar Barnack of Germany presented his camera designed for using double-sprocketed motion picture film. The camera was

small, compact, and quickly operated; the film used in the Leica was approximately 35 millimeters in width.

Over a decade later a new breed of photographers launched picture journalism by utilizing the assets of the Leica camera: portability, compactness, more pictures per roll, faster lens, and faster films. Several of them established their fame by making pictures that would have been impossible with the larger cameras. Among the early pioneers of 35mm natural-light photography were Eric Salomon, Alfred Eisenstaedt, Thomas McAvoy, Margaret Bourke-White, Henri Cartier-Bresson, and Peter Stackpole. Stackpole, McAvoy, Eisenstaedt, and Bourke-White made up the original *Life* magazine photographic staff when it began publication on November 23, 1936. *Look* magazine appeared on the newsstand six weeks later. Regrettably, these magazines ceased publication within a year of each other (1971–1972). The influences these giants of visual communication exerted will be missed by both talented photographers and their audiences.

Another group who practiced the journalistic approach to photography was the Farm Security Administration Photographic Project under the direction of Roy Strycker. Members of this project became some of the most famous of all twentieth-century photographers. On the team were Arthur Rothstein, Walker Evans, Dorothea Lange, Russell Lee, Ben Shahn (a fine painter also), Carl Mydans (who joined *Life* a few weeks after the magazine began publication), John Collier, Jr., and Gordon Parks (the only black man in the group; he excelled in later years in music, writing, and film making).

Robert Capa

While these men and women were recording the impoverished years of the Depression and the migration to California in the 1930s, other photographers made contributions to photography in other parts of the world. Perhaps the most important of these was Robert Capa.

In 1936 Capa went to Spain to photograph the Spanish Civil War. He used the Rolleiflex (introduced in 1927), the Leica, and the Bell & Howell motion picture camera to record the action. His most memorable pictures were taken with the 35mm camera, such as his famous photograph of a Loyalist soldier having his head blown off. His book *Death in the Making* is filled with emotional images of the Spanish Civil War and is perhaps the first photographic book ever published that had a topical theme. This was the first of over half a dozen wars that Capa would photograph. In *Slightly Out of Focus,* Capa remarked that he would like to be known as an unemployed war photographer.[3] But such was not his fate, and in 1954 he was killed in the French Indochina war when he stepped on a land mine.

[3]Robert Capa, *Slightly Out of Focus,* Holt, 1947.

In the 1930s faster lenses, faster films, improved flash photography — including electronic flash — Eastman's Kodachrome color film, and infrared film were but a few of the technological developments. In the 1940s the technology revolution in camera designs, films, aerial photography, and color film materials continued. World War II no doubt hastened many of these photographic advances.

Numerous photographers are identified with the creative applications of photography in the years immediately following World War II. Prominent among these photographers are W. Eugene Smith, Henri Cartier-Bresson, Cornell Capa, Carl Mydans, William Mortensen, Ansel Adams, Edward Weston, Edward Steichen, Wayne Miller, Philippe Halsman, and Leonard McComb. Of these Smith and McComb deserve particular mention.

Smith, who had covered the Pacific battlefield in World War II, returned to his home in Croton-on-Hudson, New York, a crippled and dying man. He had received multiple wounds while photographing in Okinawa. Doctors had concluded that he could not live with the wounds he had. After two years without taking a picture, and in effect waiting to die, Smith agonizingly loaded his Rolleiflex and made one photograph. This picture, "A Walk to Paradise Garden," has become a classic. It was included in the exhibition "The Family of Man," and has been reproduced in practically every country in the world. With this new start, Smith became America's greatest camera essayist. His photographic essays for *Life* magazine in the 1950s on such subjects as "A Spanish Village," "Nurse Midwife," "Village Doctor," and "Albert Schweitzer" are classic examples of in-depth visual communication.

McComb became known for the informal natural qualities of his everyday subject matter. In the 1940s flash photography had been improved so much that everyone used a flash, even when it was not needed. McComb did not succumb to the temptation. When he signed with *Life* magazine, the contract stipulated that he would never use a flash for taking pictures.

The 1940s, in addition to being the war years, were the years of the large-format "press" camera, the 4 x 5 inch camera. Even some of the photographers who had made their reputations with the 2¼ x 2¼ square camera or the 35mm camera also used the big camera. Generally, it was thought that the picture was not of professional quality unless it was made with at least a 4 x 5 film. This concept was perpetuated by important photographers who excelled in the large-format camera and who called their Rolleiflex or Leica their "walking" camera.

**polaroid**  In 1947, a new concept in photography was introduced by Dr. Edwin Land: the Polaroid camera that developed the picture in a simple 1-minute operation. Because of the brown tint that characterized the early pictures, serious photographers scoffed at the Polaroid camera. Even the photographic giant Eastman Kodak did not consider the new picture-taking technique important, and they failed to investigate its potential (much to their regret). Polaroid cameras did indeed intrigue the general public, and in a decade Polaroid had a strong place in the photographic world. Polaroid black-and-white pictures are now developed in 10 seconds; color film, introduced in 1962, requires 60 seconds.

**Japanese cameras and lenses**  In 1950 the Korean War motivated combat photographers to return to the Orient, to Japan in particular. David Douglas Duncan, who had covered the Pacific campaigns as an official U.S. Marine Corps photographer, returned as a *Life* photographer. During his stay in Japan and Korea, Duncan discovered the camera products of the Nikon Camera Works. In *This Is War* (a book as sensitive in reporting men and battles as Capa's *Death in the Making*), Duncan praised the Nikon lenses, thus initiating an influx of Japanese cameras and lenses. As the German 35mm cameras and lenses had dominated the world scene before and immediately after World War II, the Japanese products now took over the world market. In the United States, the Nikon camera and lenses often replaced the long-established Leica as the 35mm camera for professionals.

While Nikon cameras and lenses were competing with Leica for top position, the Japanese industry also offered cameras of high quality at moderate or low prices. These inexpensive cameras flooded the market in the 1950s and forced all camera manufacturers to produce better and cheaper equipment.

**film speed**  The 1950s also brought other changes. Professional photographers delighted in the higher quality of lenses and cameras, faster lenses, and improved design for better operation. But the pros were not content with the restrictions imposed by the speeds of films. The fastest film speed, or light sensitivity, in black and white was about an ASA 100. (ASA refers to the system of measuring light sensitivity that is used by the American Standards Association.) The desire to increase, or "push," this film speed was shared by almost every working

photographer, and practically every photographer was experimenting with ways to overcome the limitation of the film speed. Photographers reported using hot developers, chemicals, mercury vapor, prolonged development, prefogged film, and altered formulas. Film manufacturing companies took note of the trend and produced faster and faster films. The speeds of over-the-counter films rose from ASA 100 to 1200 and sometimes higher.

The increase in film speed brought an expansion in photographic applications. Many of the heretofore impossible natural-light picture situations became commonplace. The late 1950s began a period when existing-light photography was practiced by almost everyone. The use of natural light was not a new concept (Salomon, Eisenstaedt, McAvoy, Bourke-White, and scores of others had employed this technique for twenty years or more), but it was now a technique that was available to all photographers because of fast lenses and films.

**the decisive moment**

Another important impact on photographic thinking, which coincided with the introduction of improved 35mm equipment and films, was a new attitude toward photographs. In 1952 Henri Cartier-Bresson published his book *The Decisive Moment*.[4] Cartier-Bresson's approach to photography was straight and simple. He used a Leica, usually with a 50mm lens, and captured on film the instant when his vision joined all elements together to create his photograph. The philosophy of the "decisive moment" swept the photographic world and influenced not only the images created by photographers but the museums and art galleries that showed photographs. Even the Louvre in France held an exhibit by Cartier-Bresson, the first photography ever shown in this renowned museum.

[4]Henri Cartier-Bresson, *The Decisive Moment*, Simon and Schuster, 1952.

**photography today**

In the twenty years following World War II, the number of people involved in photography either as a hobby or as a business skyrocketed into the millions. Camera clubs now are flourishing. International salons enjoy record entries. Attendances at trade shows, demonstrations, and exhibitions reach all-time highs. Not only have significant steps been taken in camera designs and material improvements, but the public's appreciation of photography as a creative visual art has risen to great heights.

Henri Cartier-Bresson contributed a new dimension to art and photography. His "decisive moment" approach to photography combined the discipline of Edward Weston and the significance of the event of Robert Capa. His use of the 35mm camera for quickness and ease of handling popularized the unencumbered approach to photography. **Magnum Photos, Inc.**

Space-age photography by astronauts who walked in zero gravity, and on the moon, added another historical chapter in visual communication. Cameras were especially designed for the jobs that had

The space program of the United States has required many special applications of photography. Its special needs have contributed to the development of better equipment and materials for the earth-bound photographers. **National Aeronautics and Space Agency.**

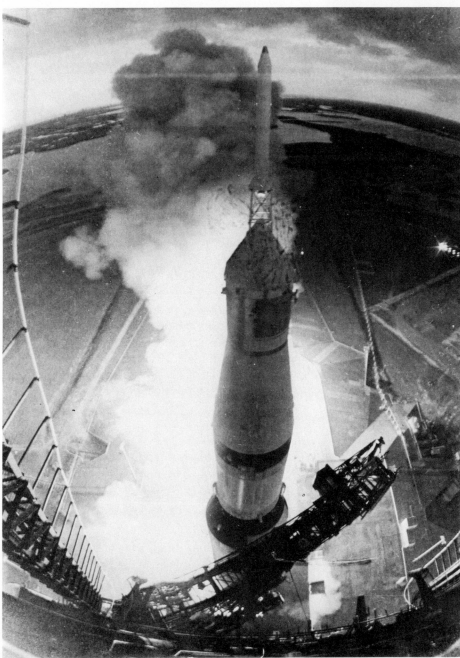

to be accomplished. Astronauts who used the equipment had to be instructed on getting the best photographs from the equipment. The product of the effort has been excellent photographic documentation of space exploration.

With the mass media serving as the gallery for outstanding photography, there was not as much need for a continuing campaign such as the one conducted by Alfred Stieglitz to have photography accepted as an art form. There was monthly, weekly, and even daily testimony to the esthetic value of photography as an art or communication form. Television, which had become nationwide in the United States in 1954, daily reminded everyone of the visual impact of news reporting. Museums and art galleries accepted, with little or no hesitation, the hanging of photographic exhibitions. Probably the single most important exhibition ever assembled for an art museum was "The Family of Man," created by Edward Steichen for the Museum of Modern Art in New York City. This show was opened to the public in 1955 and toured the world for many years. The popularity of the exhibition encouraged other shows and other photographic projects. Ivan Dmitri in association with the Metropolitan Museum, created the "Photography in the Fine Arts" exhibitions. While these shows were subjected to much criticism for the pictures selected, a major step forward was made by the fact that the Metropolitan allowed the hanging of a photographic exhibition as an art form.

An important barrier to photographic art was broken down in the 1950s when colleges and universities, and even high schools, placed photographic courses not in the science department or in the journalism department but in the fine arts department. Photography had reached acceptance as a valid subject for instruction on a level with painting, drawing, and sculpture.

**questions for review**

1    What is the camera obscura, and what is its importance?
2    Name the two men credited with making the first fixed photographic image.
3    What was Henry Fox Talbot's contribution to photography?
4    What is a daguerreotype?
5    What was Mathew Brady's major contribution to photography?
6    When was dry-plate film introduced and by whom?
7    Why is Alfred Stieglitz important to the development of photography as an art form?
8    Name and identify ten twentieth-century photographers.

**selected readings**

Abbott, Berenice: *Guide to Better Photography,* Crown Publishers, New York, 1941–1953.

*Art in Photography: A Special Summer Edition,* The Studio, London, 1905.

Bischof, Werner: *Werner Bischof,* Grossman, New York, 1972.

Braive, Michael F.: *The Photograph: A Social History,* McGraw-Hill, New York.

Capa, Robert: *Death in the Making,* Covici-Friede, New York, 1938.

——: *Slightly Out of Focus,* Holt, New York, 1947.

Cartier-Bresson, Henri: *The Decisive Moment,* Simon and Schuster, New York, 1952.

Deschin, Jacob: *Making Pictures with the Miniature Camera,* McGraw-Hill, New York, 1937.

Duncan, David Douglas: *This Is War,* Harper, New York, 1951.

Fraprie, Frank R.: *Americal Annuals of Photography,* American Photo, Boston, 1940–1950.

Gernsheim, H., and A. Gernsheim: *The History of Photography,* McGraw-Hill, New York, 1970.

Goldsmith, Arthur: *The Eye of Eisenstadt,* Viking Press, New York, 1969.

Hine, Lewis W.: *Lewis W. Hine,* Grossman, New York, 1972.

Mees, C. E. Kenneth: *From Dry Plates to Ektachrome,* Ziff-Davis, New York, 1961.

Milhollen, Hirst Dillon, and James Ralph Johnson: *Best Photographs of the Civil War,* Arco, New York, 1961.

Morgan, Willard: *Leica Manual,* Morgan and Morgan, New York, 1935–1970.

Newhall, Beaumont: *The History of Photography,* Museum of Modern Art, New York, 1949.

——: *Photography at Mid-Century,* George Eastman House, Rochester, 1959.

——: *Photography: Short Critical History,* Museum of Modern Art, New York, 1948.

Pollack, Peter: *Picture History of Photography,* Harry Abrams, New York, 1962.

Steichen, Edward: *Edward Steichen,* Museum of Modern Art, New York, 1961.

——: *Family of Man,* Maco Publisher, New York, 1956.

——: "My Life in Photography," *Saturday Review,* **3**(2):8, 1959.

Stieglitz, Alfred: *Alfred Stieglitz,* National Gallery of Art, Washington, D.C., 1958.

Szarkowski, John: *The Photographer's Eye,* Doubleday, New York, 1966.

Vanderbilt, Paul: *Special Collections of Prints and Photographs,* Library of Congress, Washington, D.C., 1955.

Webb, William, and Robert A. Weinstein: *Dwellers at the Source: South-western Indian Photographs of A. C. Uroma — 1895–1904,* Grossman, New York, 1973.

Weiner, Dan: *Dan Weiner,* Grossman, New York, 1972.

# chapter 2
## the basis of the image

All too often a photographer depends completely on the impact of an event to create a picture. The image is incidental to the emotion or shock value of the occasion. Such a picture is the photograph taken by Arnold Hardy in 1946 of a woman jumping out of a hotel during a fire. Hardy responded instinctively and succeeded in catching the woman as she fell to the concrete street and her death. Esthetically there is a minimum of value about the picture. Creatively the only thing that can be said is that Hardy's reflexes functioned at the right moment. (See page 44.)

**the place and time**

Compare Hardy's "luck of the moment" photograph with one by Henri Cartier-Bresson or W. Eugene Smith or Walker Evans. These men are totally aware of all they see. They perceive and select, mentally controlling everything in their sight. They are concerned with the subject and its environment, and they choose whether or not to include the elements that make up their pictures. Their creative discretion involves taking chances, but they control as many elements as it is possible to do. The more one learns photographic skills and develops awareness of techniques, the more one is able to combine all the elements at one time and record the image conceived in one's mind.

Visual communication in photographic form is quick and detailed. Unfortunately, many equate quickness with lack of quality. A photographer can shoot many pictures quickly and they may all attain an acceptable level of quality. But the ultimate goal is to have one of the pictures contain *all* the factors the photographer has perceived and

Real images become abstract designs when the eye of the beholder isolates and arranges those shapes and forms to his own taste. In this picture a view camera was used to select the exact elements to form the composition.
**Burney Myrick.**

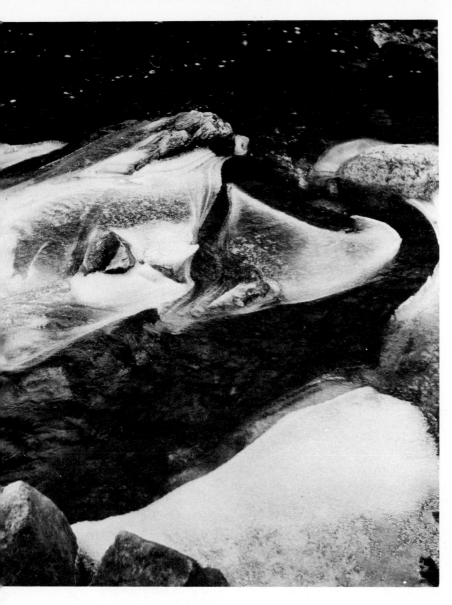

A twin-lens-reflex camera was used to picture an ice formation on a stream. Use of lighting and shapes combined to create an abstract motif of a very real image. **Sandra Short.**

conceived. Other pictures might be considered "good" by most standards of measurement, but they do not express all that the photographer wants to communicate.

What is a good photograph? The expression "good" is used and misused by everyone. Is a photograph good only because it is properly

**photographic "values"**

exposed? Can a good photograph be poor in technical quality? Is a photograph unsuccessful because it lacks technical qualities?

Let us define as best as possible what the term "good photograph" means.

A photograph is not necessarily good or meaningful because it has been properly exposed. The mechanical skills required to operate an exposure meter, set the camera, and release the shutter can be learned by anyone who can read. Automated cameras further reduce the margin of error. But if a photograph is improperly exposed, the content or ideas are often strong enough to make it valuable. Technical minimums are, with few exceptions, present in any photograph that can be processed to a finished print.

Similarly, a bad photograph may be technically of high quality. But if it does not communicate anything, if the content is poor, it will be an unsuccessful photograph. Thus, a successful photograph is not dependent on technical values; but a superior photograph is produced when the photographer unites all his creative abilities with optimal mechanical controls.

The portrait of the man is visual interest because of the projected pattern. A very real image is given a touch of the abstract by the combination of images.

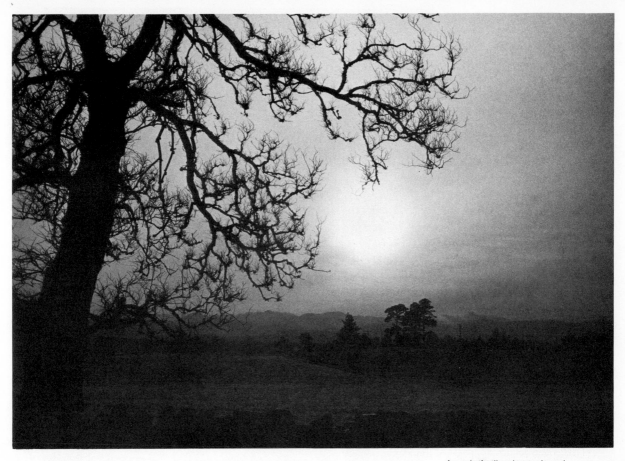

An erie feeling is produced by a foggy evening and a cloud-filtered sun. The scene is real but has a quality of fantasy. The unreal and the real were successfully combined to create a picture of mood and intrigue. **Richard S. Mrstik.**

Sometimes technical imperfections will enhance a photograph. Forgetting to change the exposure, failure to focus sharply, faulty processing, and other errors in judgment have resulted in outstanding photographs. Taking advantage of errors and recognizing the effect they produce are part of the creative act. When an element is included which the creative artist did not plan, the recognition of whatever value it contains is an important aspect of the creative process. And an inferior photograph can become the basis of a superior one if the photographer recognizes the contributing factors and employs them creatively.

Family albums are filled with pictures of birthdays, anniversaries, graduations, and weddings. These pictures are intended to be viewed only for the event itself. The value of the image was not the primary concern of the photographer, yet the composition and content in many of these pictures may be good. The person who made the pic-

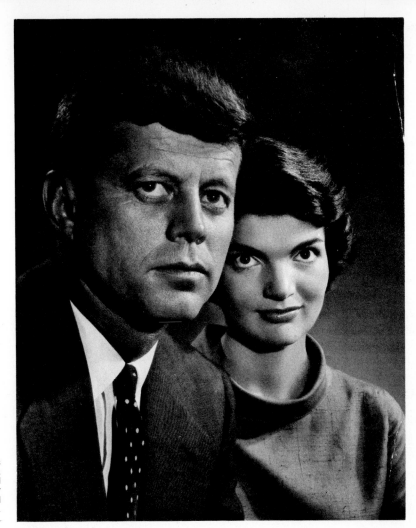

The young John F. Kennedys
are approached with a
straightforward, highly detailed
technique. The photographer
had full control over all
elements of the photograph.
**Y. Karsh.**

ture may be unaware of these values or of the fact that he or she has
the ability to capture such images. But the photographer who seri-
ously approaches all events and scenes with the desire to create
images of significance is not satisfied with a picture that "comes out";
he tries to place on film all the emotion, action, and people participat-
ing at that moment in time.

**what the eye sees;
what the camera
records**

From their earliest days cameras have served artists (see Chapter 1).
The camera has functioned as a sketch pad for painters, and it has
also served as the writer's notebook. For the photographer, the cam-

era is both sketch pad and notebook, recording the essence of the photographer's eye and all that he or she sees. In a fraction of a second the camera, serving as the single-frame projection of the photographer's mind, claims a moment in time and space that is isolated for study and contemplation. What does the eye see? And how much does the camera record?

There are many basic differences between the way the eye sees and the camera records. For example, the human eye is stereoscopic and

Gathering in all he saw in the one instant he called the "decisive moment," Henri Cartier-Bresson used a 35mm camera to record his spontaneous responses to people in their natural environs. With this approach the photographer controls only his own emotional reflexes. **Henri Cartier-Bresson.**

Objects often suggest other shapes or subjects. This lettuce leaf appealed to the photographer as a flowing head of hair. Using a 35mm camera, the maximum texture was achieved by a small lens opening and a tripod.

thus can determine the depth of objects, whereas the camera has only a single "eye," and the image it records is flat and two-dimensional. The eye functions subjectively, sometimes not noticing things, and sometimes seeing them differently from the way they are. But the camera records whatever it sees—objectively and indiscriminately. The eye has vision ranging from about 160 degrees right to left and 120 degrees top to bottom, and it sees sharply from inches to infinity. The camera does not have such latitude of vision. But the angle and focus on a camera can be altered; the eye has a fixed angle of vision and a single focus. The eye automatically adjusts to changes in illumination; the camera must be mechanically adjusted to light changes.

In an experiment designed to answer some of the questions above, a model was photographed rapidly as she went through a series of poses. The poses changed so quickly that she was almost seen in constant motion. Then, the same rapid series of poses was repeated, and the photographer drew them with pen and ink. When the photographs were compared with the drawings, it was found that both

emphasized the same lines of the model. Even though the drawings were made quickly and were not detailed, they did contain the linear strength that was seen in the photographs.

Some say the drawback of photographic vision is the ease with which images are made. But is it not equally true that the ultimate value of

A high-rise building with many windows has an interesting design quality. The lights and darks of the windows combine to form a study in contrast.

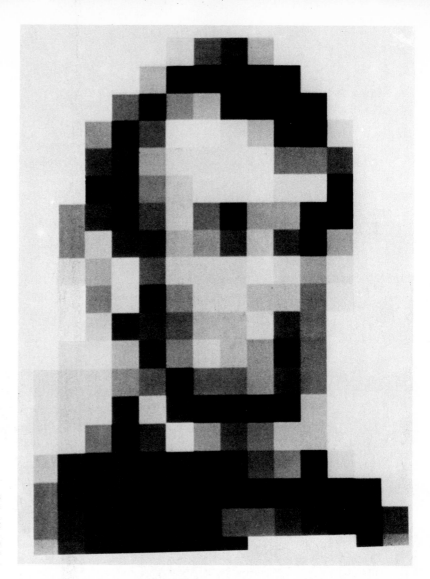

A study in lights and darks that was produced not by a camera but by a computer. The shapes form an abstract image of Abraham Lincoln. Compare this with the windows of the building in the previous photograph.

photography lies in this ease and quickness? If fault is found in ease of camera operation, it must be identified with the photographer, not with the medium. Today the camera's mechanical capacity to hold more film, record sharper lines, show greater detail, and operate faster than ever before mean absolutely nothing unless the photographer is ready to take the responsibility for the creative judgments necessary to communicate. The fact that a camera can now hold thirty-six or more latent images does not in itself establish it as a creative instrument. Rather, photography has flourished because it

is an excellent means for recording instantaneously detail and emotion. In a fraction of a second an expression, gesture, or movement is frozen in space and time. And this will continue to be of particular value to successful photographic imagery.

The camera has been described as unable to lie, but this is not true. The camera can and does lie. In the hands of a person who wants to distort or fabricate, the camera can perform the functions. Such distortion may be a creative device, or it might even constitute libelous assault. Abstraction is one form of distortion, which is usually employed creatively. But it is important to remember that the camera is only a tool and that the person operating the camera controls the image.

**controlling the image**

A moving figure has the interesting qualities of both an abstract design and a real image. Frequently the most exciting images are those which combine techniques. A real image is not always the most detailed and sharp photograph. **Edward Pfizenmaier.**

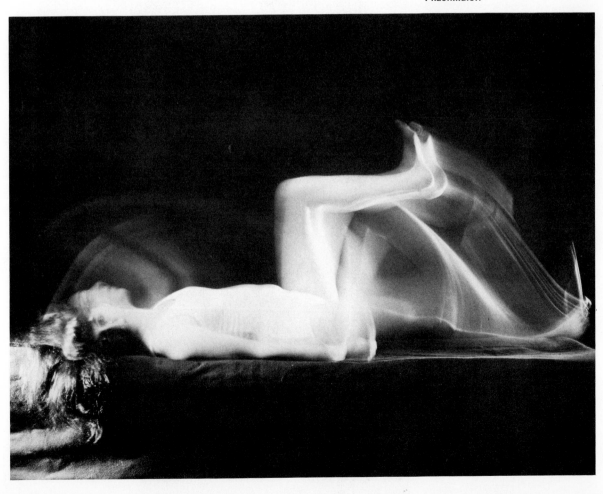

Exploring the town dump for abstract images revealed this drink-carton mask on an oil drum. Sharply detailed and defined, this composition takes on unreal qualities because of the isolation of the elements.

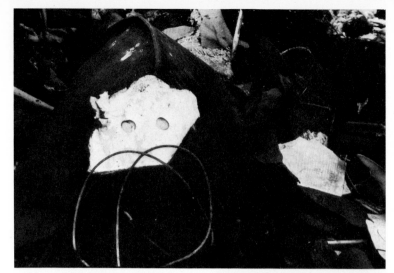

A real-pattern design is achieved in this view-camera composition by employing shapes and shadows, lights and darks. **John Steele.**

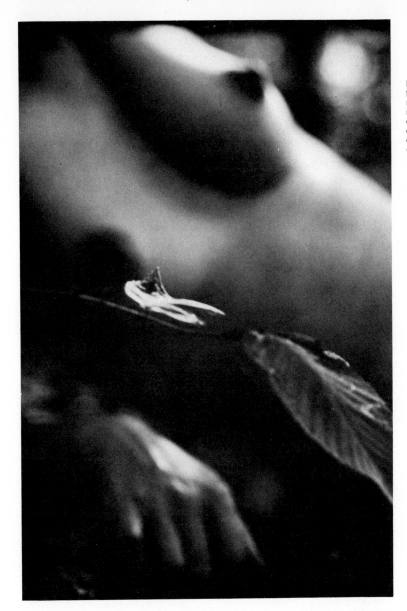

By focusing on the leaf in the foreground, the shape of the nude figure achieves a more mystical feeling. Photography can accomplish both sharply detailed images and soft, diffused shapes through optical techniques.

Even the most real photographic image, finely detailed and sharply rendered, is an abstraction of the original subject. Whenever anything is altered in shape, size, or content, it has been abstracted. Through influences of the photographer, controls of the camera, and chemical/optical alterations, nature is isolated to become a photograph. These processes, combined to record a real event or subject, actually create an abstraction of that event or subject.

The only value this picture has is the action it has caught— a very real image of a woman falling to her death. The photographer happened to be in the right place at the right time. Compare this kind of picture with those by Henri Cartier-Bresson or W. Eugene Smith. **Arnold Hardy.**

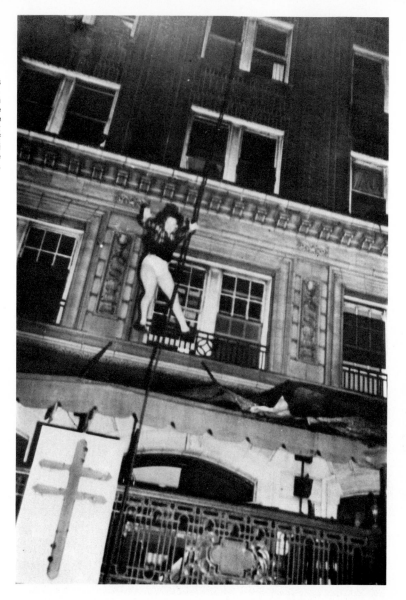

Although all photographs are abstractions, some represent as nearly as possible the original subject and are considered "life-like" pictures. Conversely, a photograph that deviates greatly from the original subject is considered an abstraction. Such a definition is unwarranted if the image is strengthened by the lighting, strong tonal contrasts, selective sharpness, or focusing. Designs may be created through the use of such devices, which in fact truly represent the original subject, yet at the same time are so unreal in visual terms that the image be-

comes an abstract one. It is possible to form an abstract image while retaining a real representation, as with a pattern or repetitive design.

All black and white photographs are abstractions because of the elimination of color and the creation of a monochromatic two-dimen-

Sharp, beautifully composed, and full of emotion are but a few of the descriptions that apply to this excellent picture by W. Eugene Smith. Unlike the chance happening that placed Hardy at the scene for his picture of the falling woman, Smith has carefully planned and selected his ingredients, arrangements, and moment of exposure. **W. Eugene Smith.**

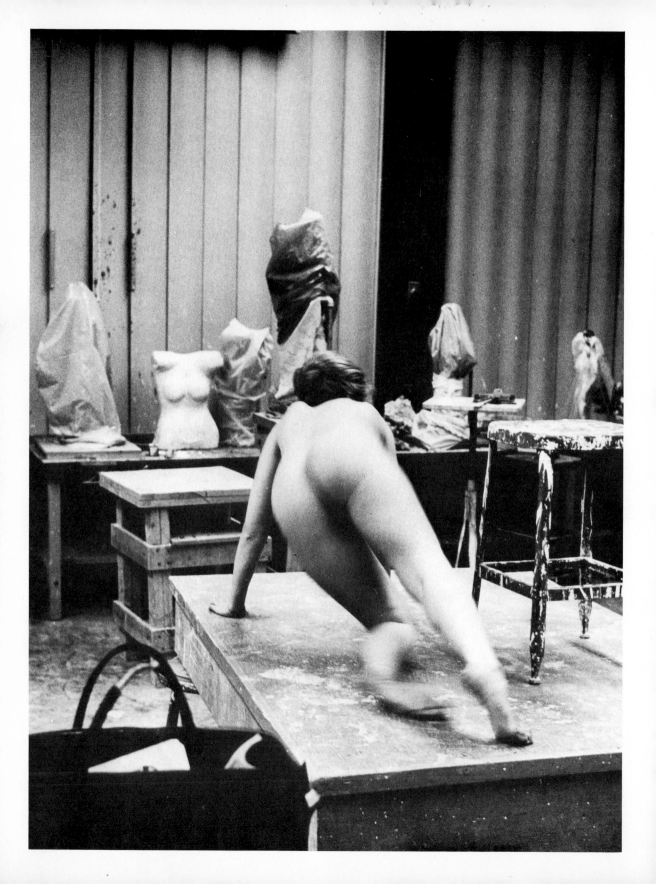

The eye of the artist and the eye of the photographer select, isolate, and record. In this pair of pictures, one a 30-second sketch and the other a photograph, the model was pictured first in a series of poses with a camera. She went through the same poses again while the photographer made 30-second drawings. When the two images were compared it was easy to see that the essence of the eye had seen the important shape and movement in both.

sional design. But this is not to say that color photographs cannot be abstractions. The varying shades of color, the influences of reflected light, and the limitations of man-made films contribute to the degree of abstraction in color photographs.

**real images**

"Real images" are those photographic impressions that most closely represent the original scene, event, or subject. Such images are sharply rendered and well lighted, contain fine detail, and evoke an emotion of the viewer's being present at the moment the picture was made. The photographer who takes a real-image photograph wants his picture to be as much like the thing he is photographing as is mechanically and optically possible.

In making real-image photographs the photographer must be fully aware of the technical capabilities of his equipment. The combination of proper exposure, sharp focusing, sharp lenses, and quality film is of primary concern. It is possible to make real-image pictures without all these characteristics but most of them will be present. A landscape that is a successful real image has sharpness and detail and has been properly exposed. Perhaps it should be pointed out that a proper exposure is one that is appropriate for the content or theme of the picture as well as for the lighting. It is conceivable that a real-image picture could be underexposed or overexposed. If the moody quality of a foggy morning on the waterfront where boats are moored is to be realistically portrayed, the picture may have to be a little overexposed. By making the negative denser than normal, one can increase the gray scale and the grain pattern, which will enhance the feeling of fogginess.

Likewise, underexposure deepens gray tones toward black and frequently a scene is more real looking when the dark gray tones are richer.

Real-image photographs contain motifs of composition, content, plus design, and the quality of any photograph depends on good design. Whether the design is the product of predetermined structure or the impulse of the moment does not alter the need to consciously use space. The photographer who is seeking to record a scene realistically uses his creative skills and mechanical controls to recreate the selected segment of that scene in the best possible manner. Failure to organize the scene leads to an uninteresting picture or an unreal image or both.

**abstract images**

The abstract photographer uses nature as a means to his own end and has (1) greater freedom from rendering images that are identifiable in themselves and (2) the opportunity to portray and present images which exist solely because of optical or mechanical controls.

For the creation of abstract images the photographer must be concerned with the *form* of the setting, subject, or object rather than with what it is. A bridge is not seen as a bridge but as a linear structure that cuts the space around it into shapes and tones that form patterns. Rocks become faces, faces become silhouetted skylines, figures become mountains, and so on.

Successful photographs that are abstractions of the real subject are not as easily accomplished as one might think. Because the concern is to create another image out of an existing image, one must control

the lines, proportions, contrast, space, and exposure more than is usually necessary when producing real images. The formation of rocks remains rocks unless the photographer exercises creative control over the optical, design, or mechanical tools at his command to convert the rocks to an image existing in his mind. Peeling paint or eroding earth only become patterns or designs when selected and isolated by the photographer. A nude human figure is a naked body until the abstract photograph selects, isolates, and records the lines and masses that become the design and content of the picture.

The most real image that one might photograph of a scene could very well be an abstraction of that scene. By converting the real image into an abstract image, a photographer makes a truer statement with stronger impact. The photographer has the prerogative about how he will approach a picture's content each time he opens the camera shutter.

**questions for review**

1    Define the term "real photography."
2    What is "abstract photography"?
3    What is meant by "luck of the moment" photography?
4    Compare Henri Cartier-Bresson's "decisive moment" with Arnold Hardy's "luck of the moment."
5    What is a "good" photograph?
6    What is a "bad" photograph?
7    How would you differentiate between what the eye sees and what the camera records?

**selected readings**

Bourke-White, Margaret: *Portrait of Myself,* Simon and Schuster, New York, 1963.

Feininger, Andreas: *Creative Photographer,* Prentice-Hall, Englewood Cliffs, N.J., 1955.

Kepes, Gyorge: *Language of Vision,* Theobald, New York, 1945.

Lowenfeld, Viktor: *Creative and Mental Growth,* MacMillian, New York, 1949.

Mydans, Carl: *More Than Meets the Eye,* Harper, New York, 1963.

Rothstein, Arthur: *Photojournalism,* Amphoto, New York, 1956.

Szarkowski, John: *The Photographer's Eye,* Doubleday, New York, 1966.

Wickiser, Ralph: *Introduction to Art Education,* World Book, New York, 1957.

Woolley, A. E.: *Camera Journalism,* A. S. Barnes-Amphoto, New York, 1966.

———: *Creative 35mm Techniques,* A. S. Barnes-Amphoto, New York, 1963, 1970.

# chapter 3
## the image and its design

Some photographers who write from experience and are well regarded as authorities in the field strongly advocate discarding rules or theories of compositional structure. One very talented photographer who probably can serve as spokesman for the dissenter is Andreas Feininger. He writes, "As a matter of fact, such rules exist and can be found in many books and articles on pictorial photography. Unfortunately, what they automatically lead to are the stereotyped photograph and the photographic cliché."[1]

There is a measure of fact in Feininger's broad assumption that all rules lead to clichés. But it is also true that many roads would lead to frustration and confusion unless some road signs have been posted to inform the photographer of the paths others have taken. If one is

[1]Andreas Feininger, *The Creative Photographer,* Prentice-Hall, Englewood Cliffs, N.J., 1955, p. 289.

not cognizant of established photographic principles, how is one to know whether or not he is making a good photograph?

It seems far more logical that the photographer who understands what is happening to the space with which he is working will achieve a better use of that space. Whether he follows rules or breaks them to suit his feelings is for the photographer to determine. But he must understand what he is altering before he can creatively alter.

In the early years of photographic history (see Chapter 1), the painter exercised enormous influence not only on the chemical and mechanical aspects of his art but also on the creative concepts. As we noted, Daguerre, a painter, is given credit for the discovery of photography. And many other artists made significant contributions to its development.

While no one artist is honored with defining photographic composition, painting certainly deserves credit for being the foundation on which camera compositions are based. The influences of Rembrandt, Van Gogh, Rubens, DaVinci, Michelangelo, Goya, and many others are certainly noticeable in the work of pictorial photographers of the late nineteenth century and the first two decades of the twentieth century. The photographs of Steichen, Stieglitz, White, Fraprie, Hammond, and Jordan contain the strength of formal organization which characterizes the compositional approaches of painters. There are identifiable designs that these photographers used effectively. Later we will define these compositional concepts, and we shall also concern ourselves with how to break these "rules" and yet enjoy successful designs.

**rules**  A rule is an idea that has been conceived and practiced by another person. For him, the act of carrying out the concept transforms the idea into a guideline for future use and development. When this idea is imposed on someone else—as a teacher might direct the use of the concept he uses personally—the concept becomes a directive.

If a person, such as a student following his teacher's instruction, accepts the directive and proceeds to apply the concept himself, he is forming a rule for himself. But when the directive is applied to the *creative practices of one's own thinking* it becomes a tool: a means of measuring both the present work and all future efforts.

W. Eugene Smith stated in a lecture to a workshop class at the New School for Social Research his view about rules of compositional

Photography is the art of subtraction. The photographer must isolate compositional components from the whole which combine to express his visual thoughts. Photography and sculpture share a kinship because both are arrived at by subtracting from the whole.

design: "Rules are made for other people to follow. I cannot be restricted by the decisions of others."

Photographic composition is an attempt to create order and structure from the multitudes of elements which can be included within the range of normal vision. As noted in Chapter 2, the eye's vision ranges from about 160 degrees right to left and 120 degrees top to bottom, and it sees sharply from inches to infinity. But the camera does not have such a broad range. The photographer must learn to conceive the important elements of his subject and translate them into two-dimensional lines which recreate on film the essence of the scene.

**the discipline of isolation**

Photography is the art of subtraction. In composing a photograph the photographer must isolate the components which combine to create the image on film which has been conceived in his or her mind. By taking away unwanted or undesirable elements the photographer expresses his thoughts in the elements that remain. Just as a sculptor chisels the marble or wood he is working to create the figure in his mind, so the photographer must cut and crop noncontributing characteristics to produce his image. This is a major difference between the creative process of painting and that of photography. Painting is the art of addition: Painters begin with a blank piece of canvas or paper and add lines, figures, colors, and structures to create the images that exist in their minds. On the other hand, photographers begin with a real image and by isolating the lines, figures, and structures, they assemble from the existing images a simplified arrangement of elements that communicate their thoughts. Such discipline of isolation is the single most important training a photographer can undertake and master.

**the viewing square**

One device that may be used initially to develop an awareness of the difficulties of isolating or selecting from the whole of one's vision those segments that will make a communicative composition is the viewing square. This device may be made by cutting two L-shaped right angles from medium-weight cardboard. By placing the two shapes together with the right angles opposite each other, a frame is formed. The frame may be enlarged or reduced and turned vertically or horizontally; both squares and rectangles may thus be formed.

The frame enables the photographer to study a scene without his

camera. Of course, the same thing happens when viewing a scene through the camera's viewfinder or ground glass. The difference when using the L-frame is the flexibility one has. The frame may be changed to many four-sided shapes and sizes as one studies the compositional possibilities of the scene. There is no demand to find a composition that seems suitable and record it on film. The demand, if there is one, is to determine as many compositions as possible. The first shape and size tried could be that of camera format the photographer uses, or a proportional shape which is larger. For example, a 35mm-camera user might want to use a frame that is in proportion to the 1 x 1½ inch format of the camera. Someone who uses a 4 x 5 camera might make an 8 x 10 viewing frame. To study the scene, hold the frame at about half arm's length and look through it with one eye to isolate the elements of the scene. Move the frame about to alter the position of the skyline, the position of figures, the boundaries of trees or buildings. Be concerned not only with the space used but with the space not used. Care must be taken that one is not distracted by the contrast or color of the scene.

There are a few basic theories that define the use of space. Photographers should know these rules even if they choose not to practice them.

"In the picture-making medium of photography, visual grammar and syntax are as much needed as grammar and syntax are needed in verbal language. Arrangement or organization of lines and areas of light and shade is necessary if the picture is fully to express its meaning. Composition is a method of creating meaning." Thus wrote Berenice Abbott in her book *New Guide to Better Photography.*[2]

[2]Berenice Abbott, *New Guide to Better Photography,* Crown Publishers, New York, 1941, 1953, p. 111.

My personal grammar of visual language includes five basic forms of composition: They are the grids through which I see the world. Understanding the techniques of space division and relations will assist the photographer in the construction of visual statements. Knowledge of these rules is the foundation from which the photographer builds his own style.

**five compositional forms**

The five arrangements of compositional structure that are used most are (1) the *L shape,* which consists of a strong vertical line and a horizontal base that does not extend to both sides of the vertical; (2) the *T shape,* which has a strong vertical and a strong horizontal line (both the L and the T shapes may be inverted); (3) the *diagonal,* and crossed diagonals, whose lines form shapes dividing the space and

Composition is both a structured assemblage of shapes and forms and an emotional experience. When one has mastered the basic designs of space division, he will seldom make a photograph that does not contain these influences.

All elements of a composition contribute to the message or statement intended by the photographer. The star-effect of the light from the sun becomes not only the source of illumination but also the major force in the compositional design.

Divide the photographic format into equal parts both vertically and horizontally. This division will help you to understand placement of action within the total compositional area. A figure or action is stronger when placed close to one of the vertical or horizontal lines.

suggesting motion; (4) the curved *S shape,* which is the most graceful linear form (shorter curves may form a *C shape*); (5) the circle, or *O shape,* which is sometimes called the "target device."

One of these five devices of compositional structure usually serves to isolate the scene to be photographed. Possibly a combination of these designs may form an arrangement suited to the subject being pictured. It is not uncommon for the L shape to be combined with the curved line or for the T to be matched with the circle shape.

Another technique for dividing space in order to emphasize an aspect of the picture and achieve a pleasing or interesting composition is the *theory of thirds.* In this theory the picture space is divided vertically and horizontally into three equal areas. If the vertical and horizontal lines are drawn, there are four points where the lines intersect. Thus, by dividing the format into thirds, four areas of design strength are established. Placement of the major elements of the composition at, or near, one of these four intersecting points will give added strength and importance.

The four areas have different degrees of strength themselves. The lower left intersection is the weakest because the occidental eye travels from left to right. If a major element of design is placed here, the eye passes over it en route to viewing the rest of the composition. The lower right is next weakest but has a little more strength than the lower left. The eye travels into and over the bottom part of the picture as it views the total composition. The second strongest area for subject placement is the upper left. Here, a subject has more viewing interest because the eye travels into and upward within the composition before continuing on to the remainder of the picture. The strongest point in which to place the major ingredient of the photograph is the upper right. To reach this point in the composition,

**the theory of thirds**

Divide the photographic format into equal parts both vertically and horizontally. This division will help you to understand placement of action within the total compositional area. A figure or action is stronger when placed close to one of the vertical or horizontal lines.

the eye travels from the left to the right encompassing the fullness of the structure of elements. Because this area of space commands maximum attention, it has come to be called the "dominant third."

The combination of the types of composition (that is, the L, T, circle, diagonal, or curved line) with the areas of strength as determined by the division into thirds forms the foundation for almost all photographic compositions.

Even when one is breaking these rules, the rules are at work because they are the basis from which departures are made. Creative applications are as unlimited as the photographer's imagination.

**creative characteristics of composition**

Other characteristics which affect the composition are *mood, motion, repetition, contrast, framing, motif, space, impact, tonal values, third-ground rules, selective focus,* and *light.*

Because photography is the art of the instant the photographer must develop an intuitive feeling about how he will isolate the contents of the picture—he has only that instant when the shutter opens to transmit light to the film. There is no time to squiggle a line or two as in a

For a more important analysis of a compositional area, the format is divided into nine equal parts by drawing both horizontal and vertical lines. The breaking of a photographic format in this manner is called "division of thirds."

When the picture area is divided into nine equal parts there are four intersections where placement of the center of interest will command the most attention or impact. In this picture of actress Elizabeth Ashley, the subject is visible in three of the four points where the dividing lines cross.

drawing and then alter those lines if second-guessing occurs. The photographer must see, recognize, and record in a fraction of a second. Slow reflexes and hesitation are the enemies of creativity with the camera, and because of them uncounted moments have been allowed to pass unrecorded. The more disciplined a photographer is toward developing compositional controls, the sharper will be the honing of his intuition and reaction.

Combining compositional designs with characteristics of content and individualized reflexes are mandatory to successful photographic image making. The content characteristics mentioned earlier may compose the theme of the picture, its design, or the composition itself. Let us define these:

*Mood* The emotional level in the event itself or the emotional feelings created by the photographer through the use of lighting, angle, or structure.

*Motion* The feeling of action whether suspended, frozen, or fluid which is created by the photographer with mechanical means or by use of linear design.

The head-to-body-to-hands design of this wedding portrait gets its compositional strength from the L style of composition.

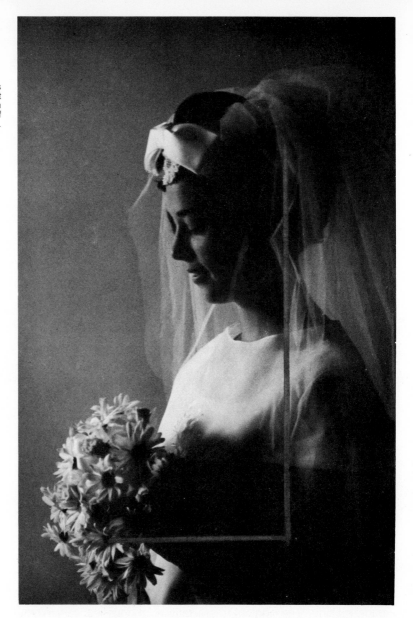

*Repetition*  A rhythm or pattern formed through the use of linear design from event or created mechanically.

*Contrast*  The variation between the compositional elements which are caused by difference in color or hue.

*Framing*  Using an element of composition to focus attention on the major theme or subject of the picture. A foreground frame would occupy areas in the immediate fore region of the design. A background frame would be in that area behind the subject.

*Motif*  A composition that depends entirely on pattern (though not necessarily repetition of the same pattern) to form the design.

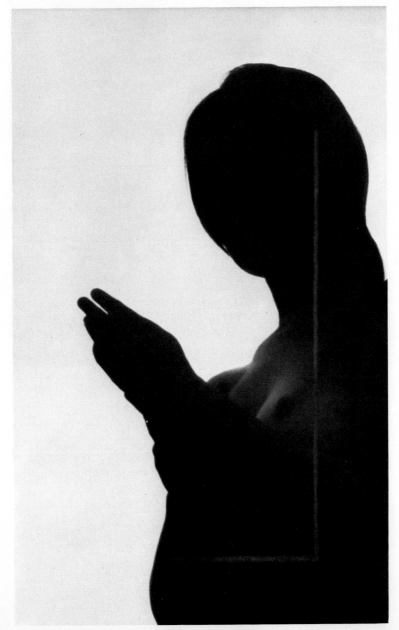

Two L-shaped compositions that are alike in design. The emotional response in each is different because of the model.

Two L-shaped compositions that are alike in design. The emotional response in each is different because of the model.

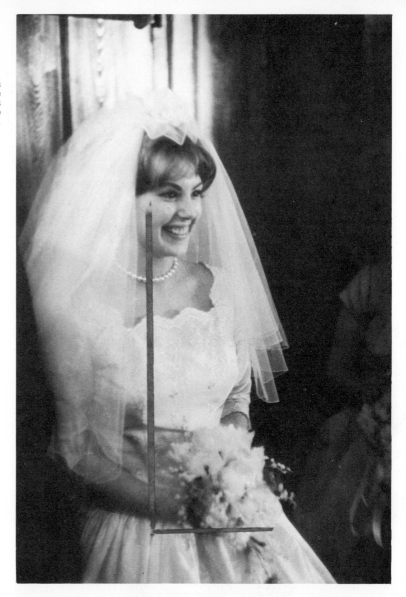

*Space*  The division of the picture format and how it is used or not used to emphasize the contents of the design.

*Impact*  Introduction of shock value or emphasis to make the picture emotionally stronger.

*Tonal values*  The use of gradation in monochromatic or polychromatic shades to form a compositional design (this could be used in association with contrast).

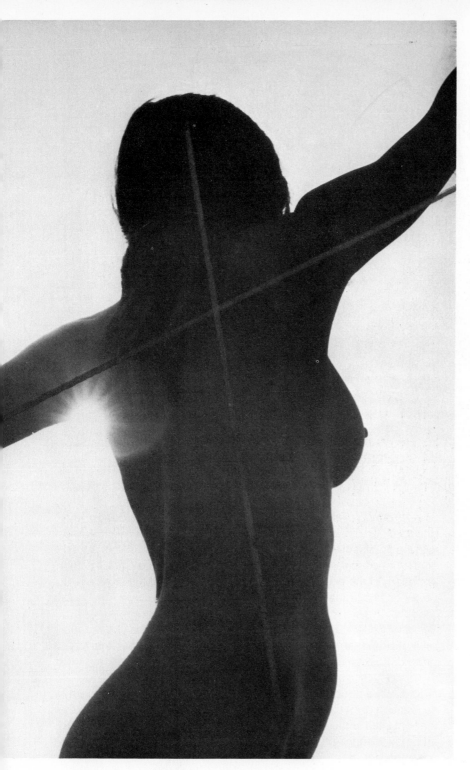

Strong diagonal lines of the nude form complement the silhouetted shape of the model and produce a dramatic compositional structure.

The graceful curves of the
walkway form a pleasing S,
or circle, style of composition.

*Third-ground rules* Division of the horizontal area of design into
one-third versus two-thirds for design purposes (not to be confused
with the dominant third). The skyline or major horizontal line is placed
so that it occupies a position one-third of the distance from the top
or bottom of the picture. The remaining two-thirds of the picture falls
below or above the main line.

*Selective focus* Emphasizing the subject or theme of the photograph
by focusing sharply on the subject and permitting either the fore-
ground, background, or both to be less sharp.

*Light* All compositions depend on light, and lighting may be any
source and of any intensity. Full emotional ranges may be created by
the light used in the photograph. Light values range from high to low
and may form the character of a composition by casting shadow or
accentuating an object.

How a photographer employs content characteristics, space divisions, and linear design depends not so much on the subject as it does on the effectiveness of the ingredients as he perceives them. Composition is actually an application of sensations which is based on orientation and training.

The ways to apply compositional theory to the act of making a photograph vary as widely as the camera designs used to record them. Actually, a photographer using an 8 x 10 ground-glass-view tripod-mounted camera would meet the situation much as if he were using a 35mm handheld camera. The greatest teacher of compositional structure is experience, and the greatest approach to learning composition is by starting with an 8 x 10 view camera and its restrictions

**format and size**

The S, or circle, style of composition is the major point of this photograph's design, but the addition of the baby gives the eye a definite point on which to focus. **Lester Krauss.**

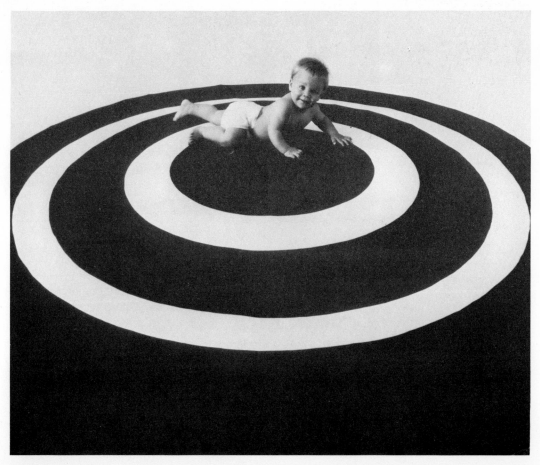

More than one compositional structure is employed in this photograph. The L and T shapes combine with the diagonal between the two children to form a conflict which supports the mood of the picture.

of mobility. Learning to fill the entire picture area demands that the photographer "think out" the picture fully before inserting the film plate.

When this format is mastered, the size and shape can be reduced to either 5 x 7 or 4 x 5 inches. The care and concern established with the tripod-bound 8 x 10 will extend into the smaller formats. This will

reduce the tendency to think that further cropping can be accomplished in the enlargement. The 8 x 10 view is printed in contact and is only rarely enlarged. The smaller the film size the more probability that the film will be enlarged.

From the 4 x 5 or 5 x 7 image size the next reduction is to the 2¼ square or 2¼ x 3¼. These sizes will be enlarged as a matter of standard practice because the film size is not large enough to present the photograph for viewing in contact size. Therefore, from the begin-

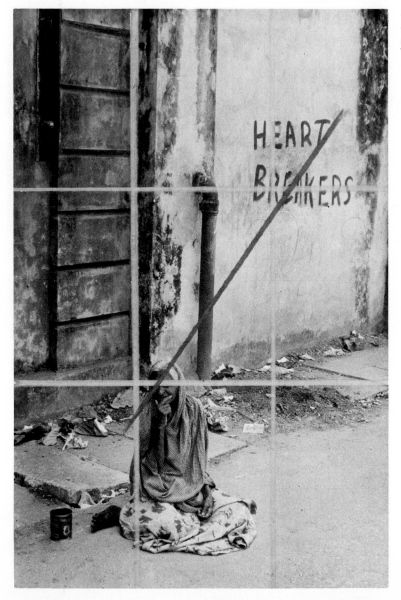

A woman begger on a Rangoon street combines the T shape with the diagonal play between the sign on the wall and the woman sitting.

There are both diagonal
forces and circular forces of
composition at work in this
picture of a prison inmate.
The lines and shapes
compliment and contrast each
other for a solid space
division.

ning, the photographer knows he is going to subtract the contents which form his picture. It will be reduced to a small format. Later the image will be enlarged to a size which is still only a fraction of the size of the original object. This elasticity of image means the small negative composition should be stronger and tighter than a big negative, which remains the same size when it is printed. If the discipline of the early use with the large-format cameras has been learned well there will be fewer problems of compositional structure in the smaller image size.

From the 2¼ x 2¼ format the next step is to the 35mm, 35mm half frame, or the subminiature film size. Because the 35mm format is the most versatile and useful, our main concern will be for that size.

The problems of reducing the actual scene to a small film format and then enlarging that frame to a fraction of the original image which exist in the 2¼ format are even more obvious when using the 35mm camera. The 1 x 1½ inch film size is hardly bigger than a postage stamp. Viewing the images on the 35mm film is almost impossible unless one uses a magnifier. Usually 35mm pictures are studied under a viewing glass which enlarges the image to about 3 inches. Black and white pictures are contact printed for easier study. Color transparencies are most often projected. With all these film sizes and shapes, one prints the composition just as it was exposed. In the 8 x 10 format, the

Selective focus is an excellent means of bringing the viewer's eye to the important part of the picture. By shooting through snow, the Jefferson Memorial building is seen more quickly and with more impact.

Sometimes breaking the rule
will create a far better
photograph. This priest
jumping a puddle is strong
because the man appears to
be jumping out of the picture.
After the basic rules of space
division are understood, they
can be broken with purpose
and innovation.

Contrast is another method of strengthening a compositional design. In addition to the strong lines of the church and cross, the added feature of tonal contrast increases the emotion of this photograph.

The theory of the dominant third is illustrated in this picture of three camels on the horizon. The placement of the animals was done intentionally to emphasis their size against the large expanse of land.

film is contact printed in a 1 to 1 ratio to produce the finished photograph. Smaller film sizes are usually enlarged, unless the photographer wants to have a small photograph. Often the act of enlarging weakens the design of the original exposure. If the practice of alteration during enlarging becomes a habit, it can result in a sloppy attitude in composing the picture during camera exposure. It is not uncommon for a photographer who uses a 4 x 5 inch film size to form haphazard shooting habits, as he knows he will enlarge a small part of the film when he prints. For this photographer, cropping in printing becomes part of the compositional act. This is not to say that cropping or compositional alteration during printing is never to be done. What it does suggest is that the disciplined photographer will not plan to crop or trim his original composition. He prefers to make the most of his film size at the time of exposure and use the cropping option only when circumstances prevent composing the picture fully at the time of shooting.

The geometric pattern of the Iranian mosque is given an extra touch of compositional interest by the placement of the figure in the doorway. This kind of added quality requires patience and awareness of what is needed to enhance an already effective design.

The contrast of the newly washed sneakers against the darker tonal values of the sampan area of the Hong Kong waterfront helps to make a statement about the need for cleanliness. When the structural design can contain emotional ingredients the picture will have a stronger appeal.

The instantaneousness of photographic composition demands maximum awareness of linear design, content, and light. The ease with which photographs can be recorded must not become the measurement of accomplishment. The fact that a dozen or more pictures may be exposed in a minute or two does not mean they are successful pictures. If these pictures have been taken with variations of angle, distance, design, and dimension, there will probably be one that prints

The small boy in a South African tribal village is highlighted by the use of backlighting and contrast. Backlighting casts a shadow which links with the real figure. Both are outlined sharply against the lightness of the ground surface. Contrast is a powerful asset in composition. Always be aware of its contributions.

The stark white of the Washington Monument is created by bright spotlights with the blackness of night as a background. The photographer used the combination to dramatic advantage. **John Sanford.**

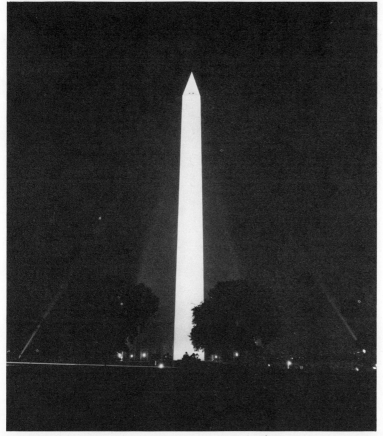

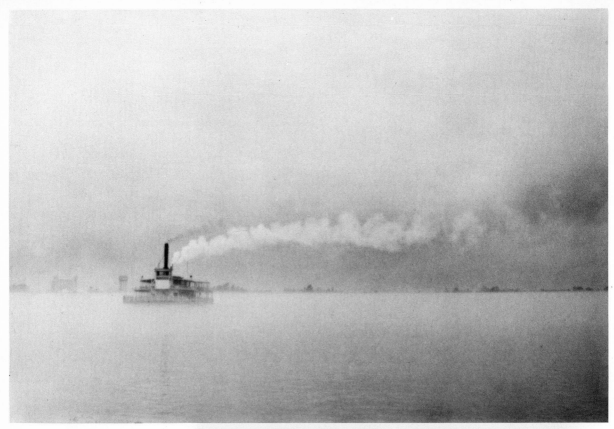

A strong feeling of size can frequently be achieved by placing a small image in a vast setting. This picture of an old steamboat has additional effectiveness because it is surrounded by the bigness of the sky and water.

There are times when it is impossible to get the image as big as one would want it. The photographer should take advantage of the surroundings and let them help to place the theme of the picture in the right proportions. The two basketball players are less overwhelming in their size when contrasted to the gym in which they play.

well. It is the photographer with sensitivity to content changes who realizes the fullest of accomplishment in his compositions. Just as Claude Monet painted one haystack several times (working on each canvas under the same conditions at the same time), so a photographer should be aware of the ingredients with which he is working and react to any alterations in them.

Focus on the blossoms with the remainder of the composition going out of sharp focus creates a charming motif. This technique has limited use, but when the right situation exists, the results can be outstanding.

The foreground was allowed to remain soft while the hand holding the cigarette was sharply focused. There is no mistake about what the photographer wanted the viewer to see.

**questions for review**

1. What is meant by the "art of subtraction"?
2. What are the five basic compositional forms?
3. Identify the theory of thirds.
4. What role does the dominant third play in image management?
5. Identify the order of dominance when intersecting lines divide a space into equal thirds.
6. What twelve characteristics influence compositional design?
7. What is meant by the statement, "photography is the art of the instant"?
8. How do film size and format affect composition?
9. Of what concern is cropping when exposing the film?

The rhythm of the curving lines of the waterway lock created a natural curved composition. Spilling water gives the eye a point on which to focus. The photographer must master all the basic designs and variations of compositional structures to be prepared to recognize new picture possibilities where they exist.

Abbott, Berenice: *New Guide to Better Photography,* Crown, New York, 1941, 1953.

Adleman, Robert: *Down Home,* McGraw-Hill, New York, 1973.

Armitage, Merle: *Brett Weston,* E. Weyhe, New York, 1959.

Cartier-Bresson, Henri: *The Decisive Moment,* Simon and Schuster, New York, 1952.

Feininger, Andreas: *Creative Photographer,* Prentice-Hall, Englewood Cliffs N.J., 1955.

Glyck, Zvonka: *Photographic Vision,* Amphoto, New York, 1965.

Hammond, Arthur: *Pictorial Composition in Photography,* American Photographic, Boston, 1946.

Jonas, Paul: *Guide to Photographic Composition,* Universal-Amphoto, New York, 1961.

**selected readings**

Repeating compositional designs form patterns that are stronger than a single design. The circular shape of the bowl is repeated in the clinched fist. Both emotion and design motif are combined.

Mortensen, William: *The Model,* Camercraft, San Francisco, 1956.

Newhall, Beaumont: *The History of Photography,* Museum of Modern Art, New York, 1949.

Newhall, Nancy: *Edward Weston,* Grossman Publishers, New York, 1971.

Sherman, Paul: *Harry Callahan,* Museum of Modern Art, New York, 1967.

Woolley, A. E.: *Outdoor Four Seasons Photography,* Amphoto, New York, 1962.

# chapter 4

## the uses of photographic images

Photography now enjoys a popularity that it has never before known. Even when the excitement of the new invention from France had great impact on nineteenth-century America and the Western world, interest did not equal today's. Millions of people throughout the world pursue photography for professional or personal reasons, with practically no age limitation or economic restrictions.

**photography as art**

Debate about photography's role as art has existed from the beginning and will no doubt continue for many years. But today most artists and sculptors agree that photography is a creative medium, and many museums have hung major exhibitions. Collectors have moved into the field with enthusiasm, and galleries offer photographic prints for exhibition and sale.

The Museum of Modern Art has maintained a schedule of major photographic exhibitions for over three decades. "The Family of

The contrast of the nude model against the darker tones of the woodland gives both drama and design to the composition. Applications of composition, structure, tonality, and subjects are learned best in dialog with other photographers. More and more photography programs are being offered in classrooms from junior high school through college.

Photography is more popular than it has ever been. Whether the product is for commercial use, as this illustration is, or for personal creative achievement, there is an ever-increasing involvement in the medium. **Lester Krauss.**

Man'' exhibition in 1955 under the direction of Edward Steichen, with assistance from Wayne Miller, remains a hallmark accomplishment of photography as art. And though the ''Photography in Fine Arts'' exhibitions which Ivan Dmitri directed for the Metropolitan Museum of Art in New York City provoked controversy about the quality of photographic art, it nevertheless initiated major annual exhibitions in the august halls of the museum. Probably one of the most significant breakthroughs took place in Paris, where photography was originally

A dramatic photograph of a group of people worshiping material goods. There is as much innovation in producing illustrations for publication as there is in selecting compositions from the beauty of nature. Photography is an art, and the artist accepts many challenges in producing dramatic photographs. **Carroll Seghers II.**

introduced. The world famous Louvre Museum presented a one-man exhibition of the work of Henri Cartier-Bresson; it was the only one-man show ever hung in the great museum.

Throughout the world photography has been displayed as art. Exhibitions such as "The Family of Man" have toured scores of countries; world fairs and expositions have established photographic exhibitions as essential parts of visual presentations. Perhaps because photography is so fully accepted as art it today enjoys unprecedented popularity and interest.

**the camera in the classroom**

Today, schools from the elementary grades through college that do not offer an introductory course in photography are not presenting a full program of the visual arts. And journalism schools that fail to offer a minimum of three courses in camera journalism can hardly be said to instruct students in the most significant communication medium of the present and future.

Many elementary and secondary schools introduced photography as part of their program because a dedicated teacher was interested in the subject. An outstanding teacher/photographer made this photograph. **Betty White.**

Museums have hung many major photography exhibits The debate about photography being a fine art has continued since its beginning. But with the exhibition activities of the Museum of Modern Art, The Concerned Photographer, and the Louvre, arguments are fewer and less violent. This picture is one of two the author has in the permanent collection of the Museum of Modern Art.

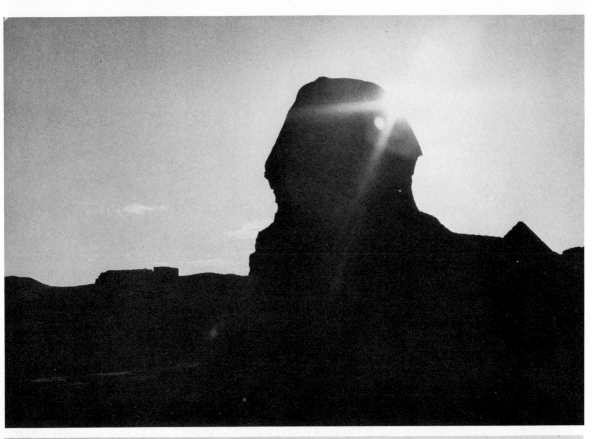

Whether or not photography courses are included in the art program depends on a school's administration. For many years architects have recognized the need for teaching photography, and contemporary school buildings usually include at least one darkroom in the floor plans. Photography is most often introduced in elementary, junior high, or high schools by individual teachers who volunteer to supervise a camera club, usually after school hours. If the volunteer teacher is effective, he might persuade the administration to include photography in the regular curriculum. If not, the medium can still serve in noncredit, extracurricular activities.

Fortunately for many children today, some college faculty members and administrators of earlier decades did lay plans to include photography as one of the visual arts. Especially important were schools of art education. Colleges and universities that offered photography as required course work in art education set the stage for expanded teaching of the medium. Art education programs which included photography courses served to prepare teachers who would go into

*Photos on opposite page:*
A famous landmark might be used as a camera composition in itself as illustrated by the sunburst over the great Sphinx. Or it can serve as a stage to present another element of importance as demonstrated by using the man in the foreground of the pyramids.

Reporting with a camera is as creative as using it in careful studies of nature. This photographer had to get up early to take this picture of a father and son strolling along the lakeshore at sunrise. The esthetic qualities are as powerful as the communicative objective. **Tom Bergman.**

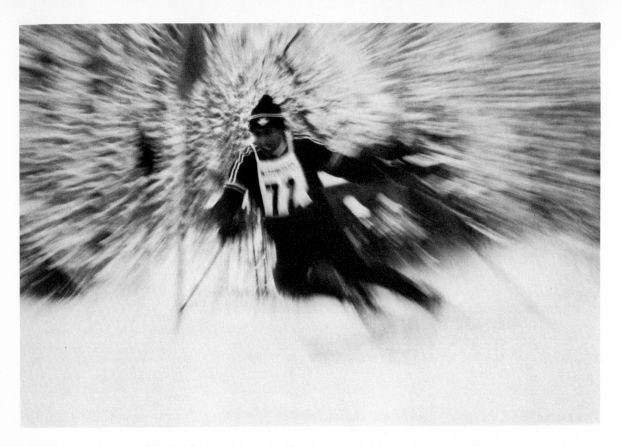

The many techniques of photography permit liberties of image management which show not only the action but the beauty of the action.

elementary, junior high, and high schools to begin photography projects. These art education teachers carried a working knowledge of photography with them, and if their personal interest was high enough to integrate photography into regular art studies, the medium claimed immediate status on a par with painting, drawing, and sculpture. The 1950s and 1960s produced thousands of art education teachers with excellent knowledge of photography and a personal interest in it. And thus many unused broom closets were reclaimed by art teachers who wanted a darkroom for photography.

**the camera
and communication**

Like all the arts, photography communicates, and no other recent art has had so great an impact on so many people. The photographic image of an event is the next best thing to experiencing it personally, and television has made Marshal McLuhan's "global village" a reality. In the years since *Life* and *Look* introduced picture journalism, we have become accustomed to seeing the world's news first hand. The horrors of war, the destruction of hurricanes and tidal waves, the

assassination of presidents, the meetings of national leaders, the weddings of notables, and the coronation of royalty have all been recorded by photography. Camera images present events for contemporary man to see, and they preserve the event for historians to study. Camera journalism has provided a vital link between man and his world.

Reporting with a camera can be as creative as art photography, and many talented photographers in the 1940s and 1950s directed their

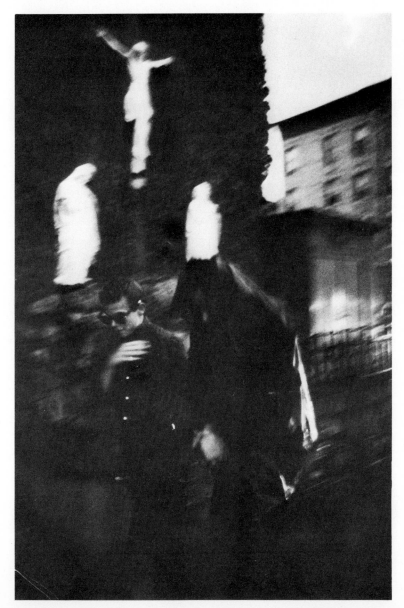

Camera journalism is the link between man and his world. The photographer allowed a slight blurring in this picture of a New York gang as one boy crossed himself when passing a church. **Bruce Davidson.**

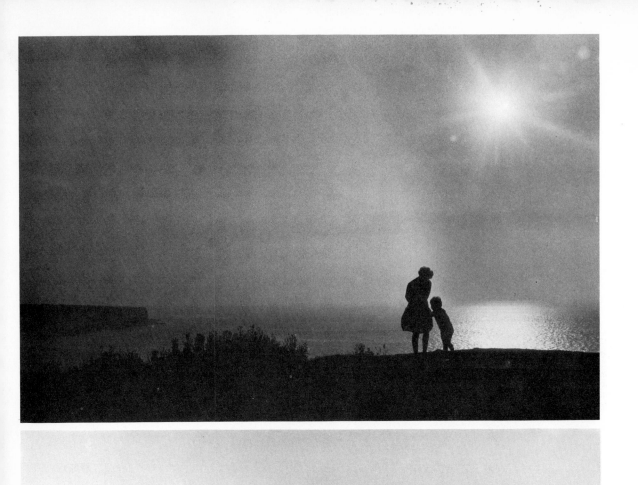

efforts toward photojournalism. The pages of magazines offered a greater audience for their photography than was believed possible, with subscribers numbering in the millions. Photographers whose work might have been seen by only a few thousand people visiting galleries became familiar names throughout the world. But camera journalism not only presented historical events, it also produced portfolios of photographs that rival any artistic medium for creative content.

Presentations of photographs in magazines influenced young talents, and photojournalism became their chief outlet. With photographs by such outstanding photographers as W. Eugene Smith, Ansel Adams, Henri Cartier-Bresson, Eliot Elisofon, Alfred Eisenstaedt, Arthur Rothstein, Dorothea Lange, Gordon Parks, Milton Greene, John Dominis, Ernst Hass, Cornel Capa, Robert Capa, Leonard McComb, and many, many others as their inspiration, young photographers directed their talents to producing photographs for magazines. They, too, wanted their work exposed to the mass gallery of magazine readerships. Photojournalism had become the patron of photographic art and artists. Just as the church and other organizations had sponsored artists of previous centuries, magazines sponsored the twentieth-century camera artists. Unfortunately, the two magazine giants, *Look* and *Life,* ceased publication in 1971–1972. The impact of their departure on camera art will not be known for many years, but one can safely assume that many talented photographers will never enjoy the benefit of the mass audience these two publications offered photographers for three and a half decades.

*Photo on opposite page, top:* Historical events can also be pictured with an eye for the dramatic. This World War II picture of Normandy, France, contains the beauty of composition and the statement of an event.

*Photo on opposite page, bottom:* Mass magazines have become galleries for creative photographers. Picture books have contributed to presenting photographs in exhibition form. This Iranian landscape is from a book the author produced about Persia.

**group photography**

Camera clubs provide many worthwhile objectives for photographers. Through activities of a camera club, a photographer can continue his education, enter into competition with his peers, and evaluate his abilities. Programs for education and information are part of the basic function of such clubs. Most clubs are conducted by the more experienced and talented members. These leaders are always ready and willing to offer their knowledge and abilities to a new member, or to less informed members.

For example, I joined a camera club at the age of thirteen and benefited greatly from the knowledge of older members. For several months I was invited to participate in all activities, including working with individual photographers in their darkrooms. I have never forgotten the assistance I received from camera club members, and even today I am never too busy to discuss another person's photography.

Presentations, such as photographic essays and picture stories, in magazines influenced young photographers, and in the two decades after World War II, magazines became the patrons of photographic art and creative photographers.

Good dialog is both a teaching and learning experience, and camera clubs are vehicles of creative exchange. Members of a club do not hesitate to exchange ideas, and the comradeship among club members stimulates dialog.

**photography as a teaching aid** Photography can be a marvelous teaching aid to supplement other courses; it can be integrated into every course offered. Photographic

Camera clubs play an important part in the development of photographers. The exchange of ideas and dialog benefit both the novice and the experienced member.

images are a valid means to comment on a political situation, for instance. A political science report is not only more interesting when photography is part of the unit, but it is also more impressive. There are many areas of study which are heightened by collaboration with photography. Not only will reports be better, but students will be more strongly motivated.

As a case in point, the Green Chimney School of Brewster, New York, under the direction of Samuel B. Ross, Jr., succeeded in getting difficult students to use a camera to express themselves. Children who refused to read or write about the usual academic subjects enthusiastically wrote movie scripts or talked about how or why they made a particular photograph. Aggressions were relieved through discussion and commentary about the students' pictures. Thus photography played a major role in the education of these special young people.

**questions for review**

1  Name two men who fostered photography as art through major exhibitions, and name the exhibitions. Why were they important?

2  What role does photography play in academic services?

3  Why is camera communication a "universal language"?

4  Identify five photographers who are considered both artists and journalists.

5  What are some advantages of a camera club?

6  In what ways can photography serve as a teaching aid?

The author won his first prize at the age of thirteen in a camera club with this picture. Group activity in camera clubs enables a teaching/learning relationship that is worthwhile to both parties.

A five-year-old made this picture with an Instamatic camera during a special workshop in photography. She was one of twelve students whose ages ranged from five to seventeen. The older children helped the younger, and the situation stimulated cooperation. **Jennifer Kennedy.**

Photographic education is
related to every experience
one can have. A teenage girl
photographed her brother
in this fine composition.
Sensitivity to everything
around you will lead to
discovery of exciting pictures
using familiar subjects.
**Wendy Woolley.**

7   How can you combine photography with another area of study to give it greater impact? What subjects can profit especially by the use of photographic images?

8   With your teacher's permission, prepare a report that employs your own — or others' — photographic images.

**selected readings**   Allen, Mary: *Photography as a Teaching Tool,* Hastings House, New York, 1971.

Bourke-White, Margaret: *The Photographs of Margaret Bourke-White,* New York Graphic Society, New York, 1973.

———: *Portrait of Myself,* Simon and Schuster, New York, 1963.

Capa, Cornell: *Let Us Begin,* Simon and Schuster, New York, 1960.

Capa, Robert: *Images of War,* Paragraphics-Grossman, New York, 1964.

Cartier-Bresson, Henri: *The Decisive Moment,* Simon and Schuster, New York, 1952.

———: *The Europeans,* Simon and Schuster, New York, 1955.

———: *From One China to Another,* Simon and Schuster, New York, 1954.

Feininger, Andreas: *Successful Photography,* Prentice-Hall, Englewood Cliffs, N.J., 1954.

Gardner, Helen: *Art through the Ages,* Yale University Press, New Haven.

Hamilton, Edward A.: *School Photojournalism,* National School Public Relations, Washington, D.C., 1958.

Hicks, Wilson: *Words and Pictures,* Harper, New York, 1952.

McLuhan, Marshall: *The Medium Is the Message,* Bantam, New York, 1967.

———: *Understanding Media,* Signet–McGraw-Hill, New York, 1968.

———: *War and Peace in the Global Village,* Bantam, New York, 1968.

Reed, Carl: *Early Adolescent Art Education,* Charles A. Bennett, Peoria, Ill., 1957.

Rothstein, Arthur: *Photojournalism,* Amphoto, New York, 1956.

Schuneman, R. Smith: *Photographic Communication,* Hastings House, New York, 1971.

Smith, W. Eugene: *W. Eugene Smith, Photographer,* Aperture, Boston, 1971.

Spencer, Otha C.: *Art and Techniques of Journalistic Photography,* Henington, Wolfe City, 1966.

Steichen, Edward: *Family of Man,* Maco, New York, 1956.

Wickiser, Ralph: *Introduction to Art Education,* World Book, New York, 1957.

Woolley, A. E.: *Camera Journalism,* A. S. Barnes-Amphoto, New York, 1966.

———: *Creative 35mm Techniques,* A. S. Barnes-Amphoto, New York, 1963, 1970.

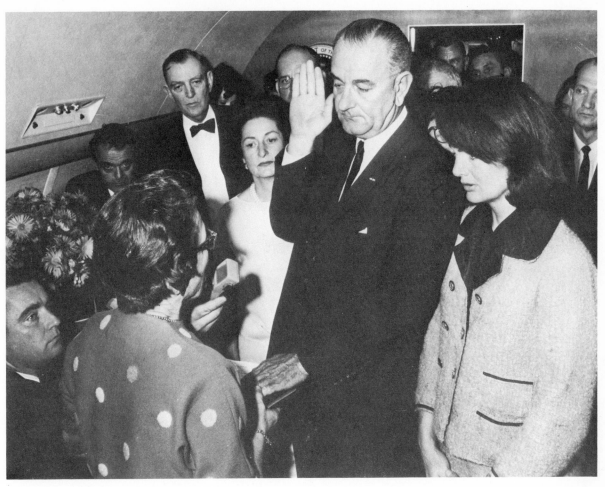

Not all photographs are innovative examples of image or design. Pictures such as this one of Lyndon B. Johnson being sworn in as President depends primarily on emotion for effective communication. **United Press International.**

# part 2

## photographic equipment

# chapter 5

## the camera and its accessories

As we noted in Chapter 2, the camera can falsify the images it records. But fidelity of image has long been the concern of serious, dedicated photographers, and so mastery over the camera is prerequisite to mastery over the image, or the message.

The word "camera" is of Greek origin: *kamara,* which means anything with an arched cover. In practice it signifies something that is light-tight. The light-tight box comes in many shapes and sizes. But the

basic design of the camera remains as it was when Daguerre or Talbot first exposed light-sensitive film plates. The camera obscura evolved into the light-tight box used in the 1830s.

Essentially the camera is a box with a hole in one end. In addition to the box itself, it has three important parts: *lens, shutter,* and *focusing apparatus.* A glass lens is placed in the hole to achieve control over the image and light transmission. Further control is added when light is governed by the opening and closing of a shutter. With the advent of faster films and instantaneous exposures—even in studio light—the shutter became an essential part of the camera's operation.

**camera nomenclature**  *Body*  The box that holds the light-sensitive film material is the unit around which all of the parts of a camera revolve. All functioning parts of the camera are attached to, or are dependent on, the body.

The camera body can be almost any shape. But only extreme experimental designs make the body anything other than a rectangle or a square. Some camera bodies are constructed with solid materials such as wood or metal. Others are basically wood or metal with cloth used in bellows as part of the total construction. Each body is designed to accommodate an established film size. Because the film size is directly related to the shape of the body, which in turn is related to the kind of lens that is used on it, there is an interrelationship that must be considered when designing a camera.

*Lens*  Light is controlled in the camera by two components of camera design: the lens and the shutter. Each camera body has a particular lens that is best suited to that body. To determine what that lens will be the diagonal of the film format is measured. The length of that diagonal is the "normal length" or "focal length," of the lens for that body. To define it further, if a film format is 4 x 5 inches, the normal length of lens for that film size would be 5¼ to 5½ inches. That length of lens would enable the outside edges of the lens to transmit light to the outer edges of the film without cutting off any of the image.

With the length of the lens established, the next determinant is the transmitting power of the lens. The ability of the lens to project light to the film is called the "speed" of the lens. The more the lens is able to transmit light to the film, the faster is the lens *Lens speed* is calculated by dividing the diameter of the lens into the distance from the center of the lens to the film plane. To define it in numerical terms: The normal-length lens of the 4 x 5 inch film size is 5¼ inches. The outside

edges of the lens to be fitted to this body measure a diameter of 2 inches. If the 2 inches is divided into the 5.25 inches we will have a quotient of 2.67. This would mean that the maximum speed of the lens we are fitting to this body will be f:2.67 (or focal stop: 2.67) when the lens is at its biggest or fullest diameter. If the lens is reduced in diameter through the use of a control (called "f:stops," "diaphragm," "aperature") the speed of the lens is reduced. In numerical terms: When the same 5.25 inch focal-length lens is given a smaller diameter —say, 1 inch—it is no longer an f:2.67 lens; it is now an f:5.25 lens, because we divide the 1 inch diameter into the 5.25 inch focal length to decrease the effective light transmission of the lens. It is easy to see that we have reduced the lens diameter, or opening, by half, and in doing so we have reduced the speed of the lens by half. The lens can no longer transmit as much light because it is 50 percent smaller in diameter. All other calibrations on the lens are determined in this manner.

In addition to the normal-focal-length lens that fits a camera body or format, there are lenses that either increase or widen the image sizes. These are called "wide-angle" or "telephoto" lenses. The speeds of these lenses are determined by dividing lens diameter into the distance from the center of the lens to the film plane. A 100mm diameter lens which is fitted to a camera body with the film plane 8 inches from the front center of the lens will thus have a maximum light transmission speed of f:2.

In addition to transmitting light to the film the lens serves to render the image in sharp detail and definition. The light travels through the lens in sharp lines and is recorded on the film. When the lens is set for the normal focal length, the image on the film will be sharp at "infinity" (the most distant point visible). If the object to be photographed is closer to the camera, the lens must be focused to make the image sharp. Every contemporary camera has some kind of device for focusing the lens. For some cameras the focusing is done with the lens itself, while the image is inverted on ground glass at the film plane. Other cameras have range finders which are coupled with a lever, or rotating barrel, on the lens mount. Still others are focused by rotating the lens to a calibrated footage on the camera front. Camera designs have many forms of lens focus, but all are intended to accomplish the same function: to render the image clear and detailed on the film.

*Shutter* The shutter also controls transmission of light through the lens, and it stops the action of the scene by doing so. All shutters are

calibrated in fractions of a second. A typical shutter range of a camera will run from 1/500 second to 1 full second. Even the most inexpensive cameras manufactured today have shutter "speeds," or settings, of 1/25 second, 1/50 second, and 1/100 second. These settings are combined with the lens settings (f:stops) to control the amount of light that travels to the film in making pictures. This control is called "exposure."

**the pinhole camera**   The simplest camera one can use is the pinhole camera. The design for this camera is a rectangular box (a shoe box is excellent) with a hole punched in one end. The use of a pin to punch the hole (aperture) in the box gives the camera its name. A film plane is positioned inside the box at a point where the image will cover the shape of the light-sensitive paper used for taking the picture. This can be determined by pointing the pinhole at a scene and moving a sheet of white paper, placed upright inside the box, until the image covers the format of the paper. Make the film plane stationary. It is on this film plane that a sheet of photographic paper is attached. The top of the box is secured, and a piece of black masking tape is used to cover the pinhole. The placement of the light-sensitive photographic paper in the box is done in the safety of a darkroom.

To expose the paper, point the camera in the direction you desire to photograph. Be certain the box is secure. Gently lift the black masking tape from the pinhole. Expose the scene for several seconds and replace the tape on the hole.

This experiment with the simplest of camera designs will help you to understand some of the problems which the pioneers of photography experienced. It will also reduce the gadgetry of photography to zero. Contemporary cameras are slick, neat, functional packages of technology. And because of the high quality of design, photographers tend to excuse their need for discipline because the camera can, in their own minds, make up for their haphazardness. But after trying this experiment, it should be easy to appreciate how the basic parts of a camera function.

**the camera body and lens**   The camera body may be as compact as the subminiature 14mm or as big and heavy as the 8 x 10 view camera, and some are even designed to be smaller or larger than these. But for most photographic applications the camera body size ranges from 35mm to the 8 x 10.

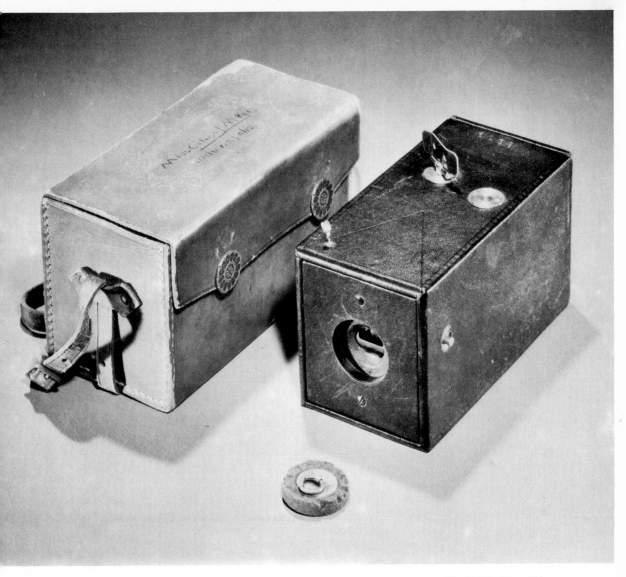

The first flexible-roll-film camera was marketed by the Eastman Kodak Company. The camera had a capacity of 100 pictures, which were exposed and returned to the company for processing. This camera made photography available to the mass population. It was promoted with the slogan, "You push the button, we do the rest."

The lens is designed to fit the particular camera on which it will be used. As mentioned earlier, the focal length of the normal lens is determined by the diameter of the lens and the distance from the center of the front element to the film plane. In addition to the standard, or normal-length, lens the camera body may be designed to use lenses such as wide-angle and telephoto. These lenses alter the visual distance from the camera to the subject by reduction or magnification—there is no physical change of distance involved.

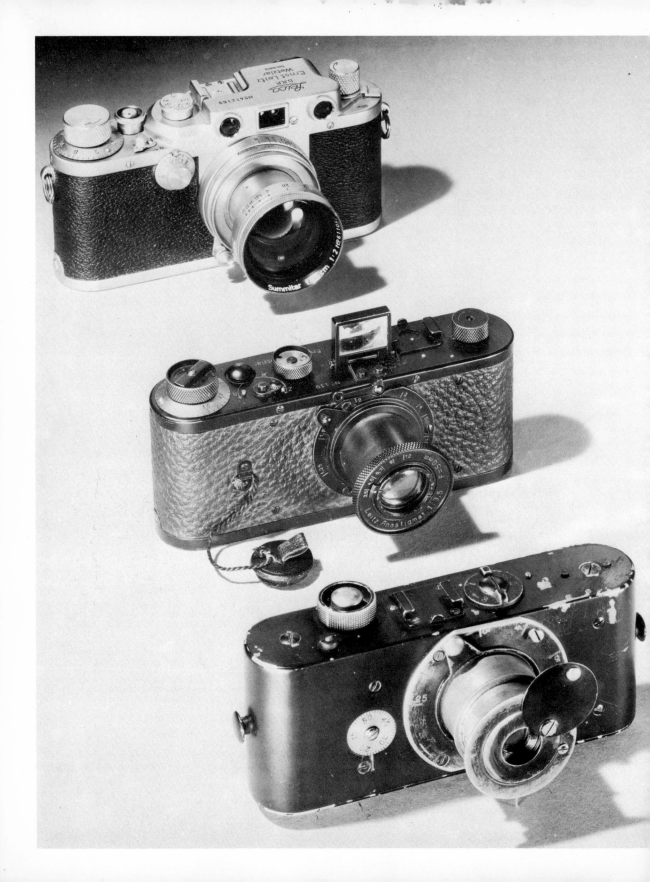

*Photo on opposite page:*
Miniature-camera photography
began with the introduction
of the first Leica in 1924.
This picture shows the first
model in the foreground, an
early production model, and
the Leica IIIC.

The newest Leica and its
working parts: 1. 50mm lens;
2. range finder–focusing
window; 3. shutter-speed dial;
4. shutter release; 5. focusing
knob; 6. rewind lever; 7.
depth-of-field scale.

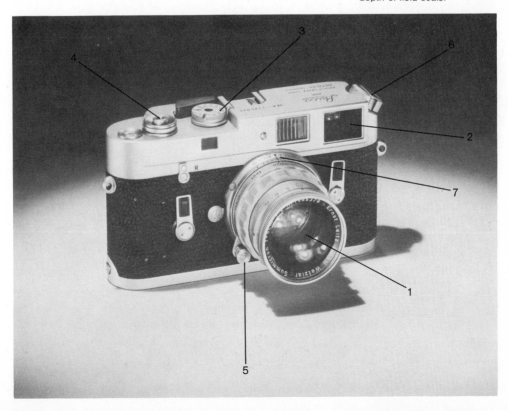

The world-famous Rolleiflex also brought a new dimension to photography. The 2¼ x 2¼ negative was an acceptable compromise for photographers who preferred large film: 1. twin lens for viewing (top) and taking (bottom); 2. shutter release; 3. focusing knob; 4. film-advance lever; 5. viewing hood; 6. shutter-speed dial; 7. lens-setting dial.

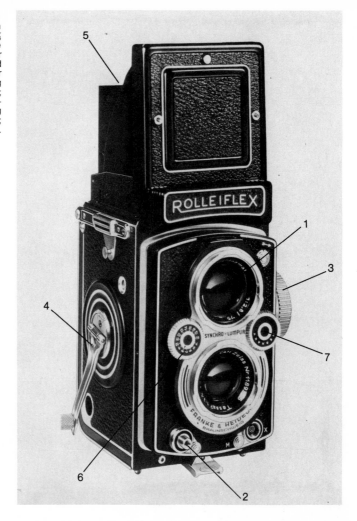

Focusing sharp images is achieved in one of several ways, depending on the lens design. Some lenses are focused by rotating the barrel mount in which the glass optics are housed. Other lenses are focused by turning the lens mount, which is coordinated with a metal arm connected to the range finder. Other lenses are focused by a bellows that traverses on a track. Single-lens-reflex cameras focus through the same lens that takes the picture. Cameras with twin-lens-reflex design are focused by moving the entire front of the camera.

Light is controlled by both the lens opening (also known as dia-phragm, f:stop, aperture, and lens stop) and the shutter. Each lens has a maximum opening and a minimum opening. The smaller the num-ber, the larger will be the opening which permits light to reach the film. The larger the f:stop (f:16, 22, 32, 64), the less light transmitted, and the slower the exposure. By closing or opening the lens, light is controlled. As a rule of thumb, one can assume that each lens stop changes the opening by 50 percent, reducing as the lens is made smaller and increasing when the lens is larger. When the lens is turned from f:11 to f:16, it can be assumed that the light reaching the film

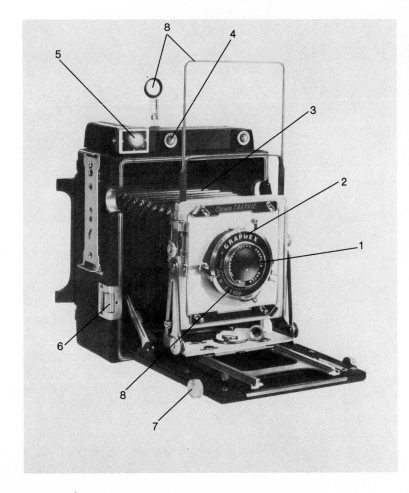

Once the trademark of the professional photographer, the Speed or Crown Graphic is still a highly versatile camera. It uses sheet or cut film, but can use roll film with a special adapter. 1. 127mm lens; 2. shutter speeds; 3. bellows for focusing and extending for longer lens lengths; 4. range finder; 5. view finder; 6. shutter release; 7. focusing knob; 8. lens settings.

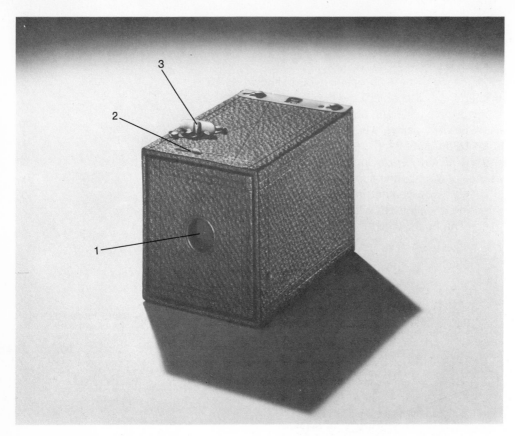

A box camera, designed after the pinhole camera. The simple camera has: 1. a lens; 2. a shutter release; and 3. a film advance.

at f:16 is about half the intensity of f:11. Conversly, when the lens is "opened up" by going from f:16 to f:11 the light has doubled.

Exposure meters are designed to take the guesswork out of determining correct exposures. Some cameras have exposure meters built into the camera body; these are synchronized with the shutter release, automatically allowing the proper amount of light to reach the film. Exposure meters will be discussed and defined later in the chapter.

Each lens has a range of sharpness that increases or decreases as the f:stops are made smaller or larger. This area of sharpness is called "depth of field." Contemporary camera and lens design has the depth of field indicated on the lens mount where it is easily seen and used. The depth of field (sharpness) in front of and behind the critical point of focus is greater when the lens opening is small and more shallow when the lens opening is bigger. At any given f:stop there will be a range of sharpness of one-third in front of the subject and two-thirds

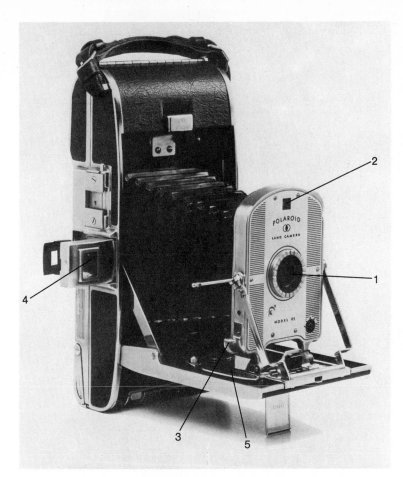

The Polaroid camera has the same essentials as other cameras: 1. lens; 2. shutter; 3. shutter release; 4. view finder; 5. focus. But the film plane is designed to accommodate the special twin rolls of paper and chemical necessary to make the Polaroid picture.

The single-lens-reflex, 2¼-square film size of the Hasselblad camera is a system of photography used by many professionals. There are lenses and accessories that will adapt the camera to every possible picture situation. This camera was selected for the trips to the moon. 1. telephoto lens; 2. normal lens; 3. viewing housing; 4. prism viewing housing; 5. film advance; 6. film magazine; 7. film wind; 8. shutter release.

Cameras are produced in an infinite variety. This selection spans over seventy years in design and production.

No. 4 Folding Kodak Camera
1890

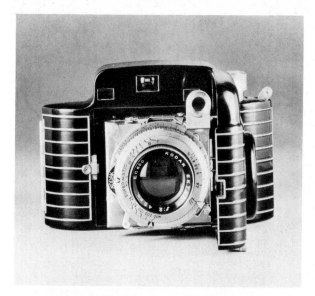

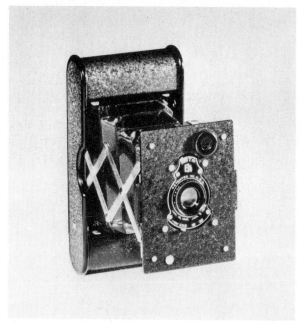

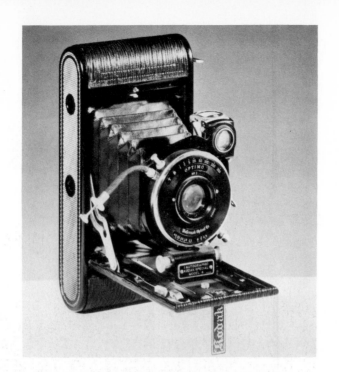

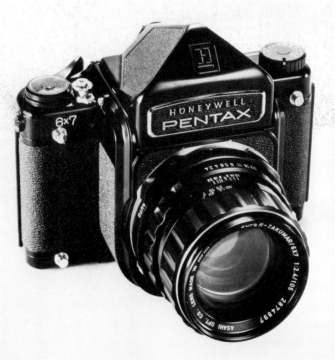

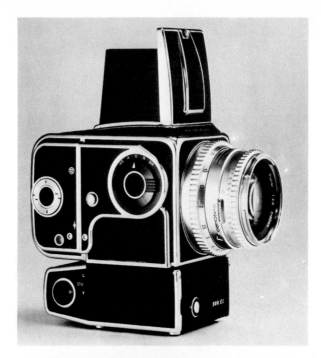

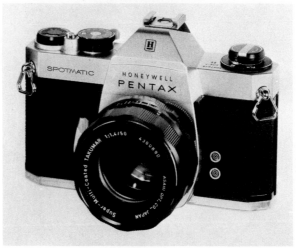

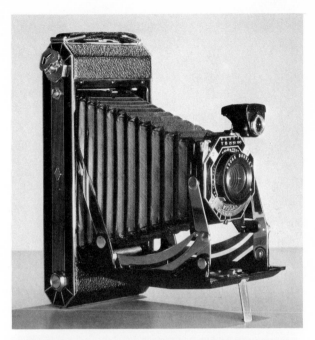

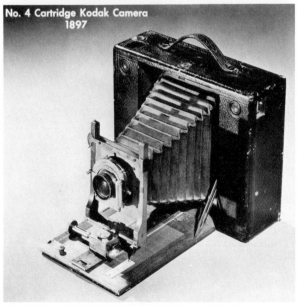

No. 4 Cartridge Kodak Camera
1897

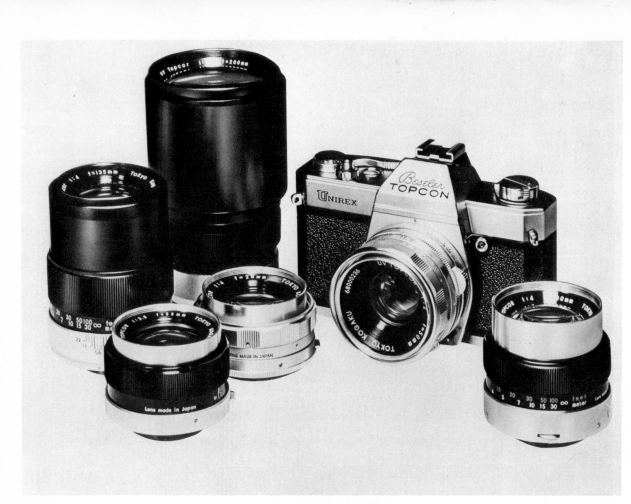

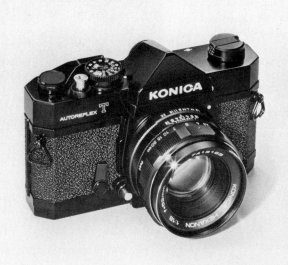

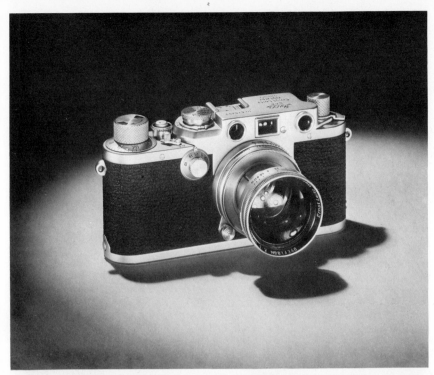

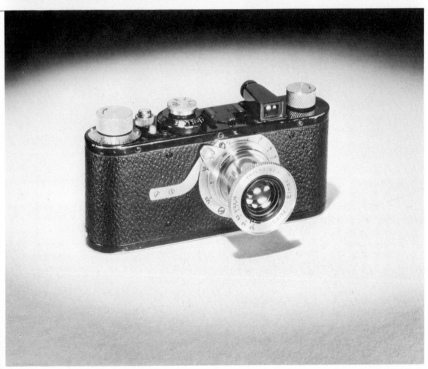

beyond the subject measuring from the camera. To put it in figures, if the f:stop is f:16 and the distance to the subject is 10 feet, the depth of field would be from 7 feet to 16 feet, with the critical point of focus at 10 feet. This will vary with each f:stop and with each focal point of the lens. But the principle will be the same. There is no need to

remember the depth-of-field figures, as each lens has the scale on the lens mount. Understanding and using the depth of field are of prime importance for creative applications of the optical characteristics of all lenses.

The camera and lens are tools which the photographer must master. Understanding the parts of the camera is important only as an orientation to the instrument and how it can serve the creative process. Far too many photographers become so intrigued with the mechanics of the camera that they fail to use the instrument to their creative advantages. The bright chrome finish often hypnotizes the owner into admiration for the instrument itself, and the creative beauty of the camera emerges only when the fascination for the design has worn off and photographs are filmed.

**camera accessories**

The camera is all that is needed for the mechanical performance of photography. The basic design of a camera requires that it have a light-tight box, a method of controlling light, and a place for film.

The 2½-square format is ideal for illustration because it allows space to add the story title and some text on the cover or layout. **Richard Kehrwald.**

The 35mm format is fine when picturing children. The quickness of operation and longer film roll enables taking pictures faster and in greater numbers.

A family outing lends itself to coverage with a Polaroid. The pictures can be seen immediately, and extra prints are made by copying the best shot. Additionally, enlargements can be made from the copy negative. Polaroid provides all these services.

Man in space has been documented fully with still photography. A special Hasselblad was used to picture the first American walking in space. **National Aeronautics and Space Administration.**

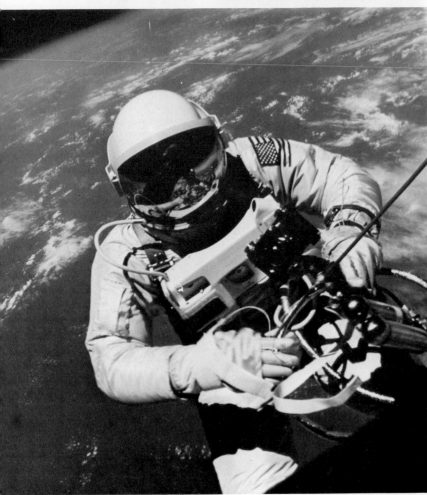

Natural daylight and a 35mm camera were used to picture this young boy taking his Saturday bath. Photojournalists use small handheld cameras for almost all their photography. **Robert Simmons.**

View cameras with large film sizes are the usual choice of photographers who picture sharp, detailed compositions.

Special cameras with special lenses are used to achieve striking or unusual effects. A wide-angle lens was used to achieve this panorama image of Hubert Humphrey. **Dennis Brack.**

The simplest camera can produce outstanding results if the photographer has the vision to find the compositions. This photograph and the pictures of winter shown on the opposite page and on page 130 were taken with a Baby Brownie and 127 roll film. The camera was a simple box camera with nothing added (it is shown on page 122, bottom illustration).

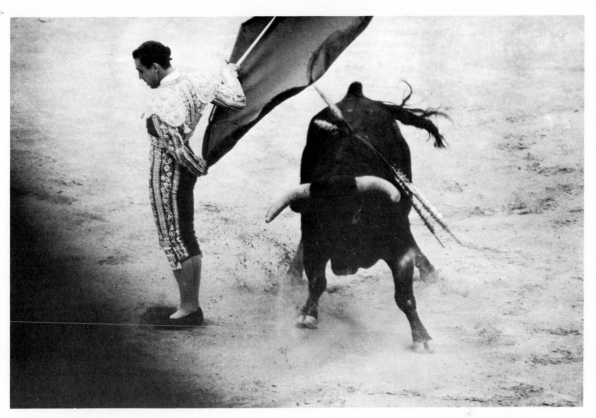

The normal lens is not always the right choice for the situation or the effect wanted. Cameras that allow interchangable lenses will permit alteration of visual distance. This picture of a Spanish bullfighter was taken with a 400mm lens on a 35mm camera, which increased the image size eight times.

While there are hundreds of variations on how these three essentials are coordinated in the instrument, they are necessary. For most photography these basic components are enough. But there are variations and controls over these basic elements, and these addition-al contributions or controllers are categorized as accessories. Using such devices as exposure meters, tripods, wide-angle or telephoto lenses, close-up lenses, and filters enables the photographer to extend

Pictures in studio settings can
be made with almost any
camera. Professionals prefer
the large-format view cameras.
This portrait was taken with
a 5 x 7 inch film size.

A handheld camera is often referred to as a "walking camera" because of its mobility and ease of handling. This scene of a boy and his top was quickly recorded with a 2¼ x 2¼ camera.

Fast lenses and fast films available for 35mm cameras enable photographers to make pictures in many difficult circumstances. This picture in a mental institution was taken with only the light that was present. The speed of the films and fast lens make it possible to get a good quality picture that retains the feeling of the scene.

Almost all cameras are adaptable to using close-up attachments. With a supplementary lens the photographer can move in for fine detail of important activities.

A full range of lens and
shutter speeds offers the
photographer the choices
necessary for recording
difficult situations. The indoor/
outdoor problem of lighting
in this scene in India
required the author to
"bracket" his exposures
(making exposures over the
normal exposure-meter
reading and under the normal
reading).

TILTED

Correct exposure is the
secret to quality photographs.
The more complicated the
lighting conditions, the more
important will be accuracy of
exposure.

The exposure meter: 1. ASA, or film speed setting; 2. shutter settings; 3. lens settings; 4. needle indicator of light intensity; 5. index for corrolating light-level needle and lens-shutter settings; 6. light-sensitive cell with gate closed for bright-sun readings; 7. gate may be opened for low-light reading or covered with attachment for incident-light reading.

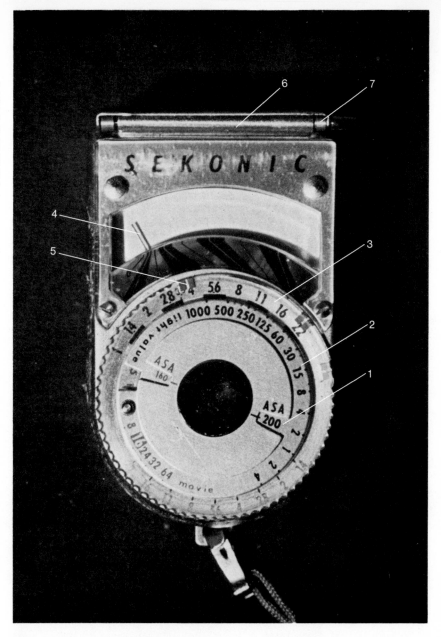

the limitations of his basic camera design. The tools are more supplementary to production than accessory to the basic unit. Greater control of the broader range of photographic situations may be accomplished through use of all other tools available.

The lens and shutter mechanism are the camera controls for transmission of light to the film. Proper setting of lens and shutter must be made to correspond with the speed of the film. The ASA speed of the film is essential to the exposure equation (ASA/light=lens/shutter). To arrive at the lens and shutter settings one either guesses the light level or uses an exposure meter to measure it.

**the exposure equation**

Data sheets are packaged with every roll or box of film. Included in the information on these sheets is an exposure chart which calculates the performance for the film under four lighting conditions: bright sun, shaded sun, dull sun, overcast. By following the lens and shutter settings indicated for different lightings, one will achieve an acceptable exposure range for that film. The resulting negatives will be average both in quality and in printability. If the photographer uses the same film for an extended time, he will acquire a working knowledge about its performance under various lighting conditions.

In 1932, the Weston Electrical Instrument Company invented the photoelectric exposure meter. However, professional photographers felt that knowledge of a film's characteristics was the minimum requisite for working professionals, and they held it inexcusable for one not to know how to set the lens and shutter without an exposure meter. But before exposure meters were invented, most film was developed by inspection, and any exposure faults could be corrected by darkroom manipulation. With the introduction of panchromatic films, this practice of "inspection developing" was replaced by time and temperature development. With this, the need for correctly exposed film became apparent, and the Weston exposure meter came into widespread use. Not until the Norwood Director meter was introduced in the 1940s was the supremacy of the Weston challenged.

**exposure meters**

In 1962 cadmium-cell exposure meters were introduced, and other alterations such as spot-metering (zeroing-in on one area of the composition), continued to improve the design. The most important innovation since 1965 is the built-in, automatic meter. Automatic meters set the lens opening to match the shutter speed, and the guesswork has been eliminated from this aspect of photography.

The early exposure meter was the basis for contemporary ones: Intensity of light (footcandles) is measured by a light-sensitive cell, and this reading is recorded; then the index for the light level is matched with the film speed. Several combinations of f:stops will align with the

shutter speeds, and any of these may be set on the camera. Step by step, the procedure goes as follows:

1    Set the ASA or film speed on the meter.
2    Point the meter in the direction of the subject.
3    The footcandle, or light level, will register.
4    Turn the index to match the light level.
5    Rotating the index dial also rotates the lens-setting dial and lines up shutter speeds according to the light present.
6    Read the lens and shutter settings. Any that match may be used, depending on effect desired.

using the exposure meter

All exposure meters are designed for three kinds of light: bright, low, and incident. For bright and low readings, light intensity is measured by *reflected light*. The meter is pointed in the direction of the subject, and light falling on that setting is reflected toward the meter. The indexes for these two reflected light readings are usually marked by different colors that correspond with those on the meter. When a bright-light index is set opposite the bright-light scale, the readings will be correct for that light. The same is true when using the low-light indexes.

For *incident light* readings, the procedure is somewhat different. Incident light is the light falling on the scene. To measure this kind of light, the photographer must get as close as possible to the scene and hold the meter in the direction of the light. If the sun is the light source, the meter must be held close to the center of the area being pictured and pointed at the sun. An opaque attachment for the meter is used to measure incident light. Failure to use the opaque shield will cause the indicator to go completely off the scale. The Norwood meter was designed especially for incident-light reading. It is still the best meter for this kind of light.

After the light level has been measured for incident readings, the meter is handled the same as with reflected readings. Of course, the settings of indexes are those specifically for incident light. Using these correct indexes will line up the proper lens and shutter settings for the light present.

After the correct light levels have been determined and indexes are matched, the photographer selects the lens and shutter combination he wants. It must be pointed out that all matching combinations will produce a correctly exposed film. The lens and shutter dials show

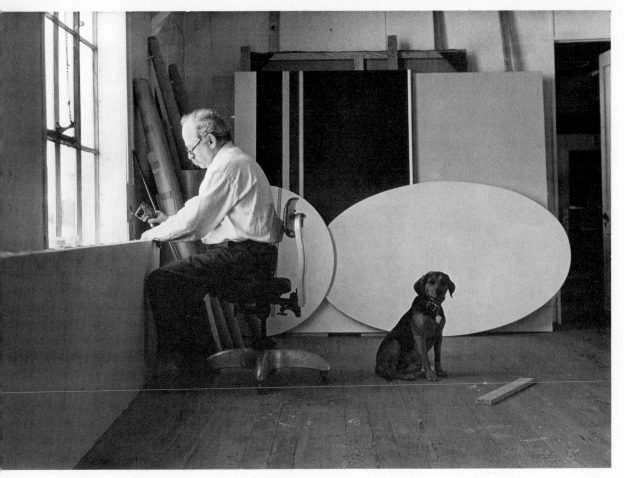

combinations from the widest opening to the smallest. Lens stops from f:1.5 to f:32 will have corresponding shutter speeds, and all settings will control the light reaching the film and thus the accuracy of the exposure. The photographer may choose any of these settings, depending on his circumstances and intent.

When the light is evaluated and indexes are set, the lens and shutter dials might line up like this:

| f: stops: | 1.5 | 2 | 4 | 5.6 | 8 | 11 | 16 | 22 | 32 |
|-----------|-----|---|---|-----|---|----|----|----|----|
| seconds: | 1/500 | 1/250 | 1/60 | 1/30 | 1/25 | 1/8 | 1/4 | 1/2 | 1 |

Following are some examples of how to apply the various lens/shutter combinations for different effects.

*Selective focus* "Selective focus" is the intention to accentuate sharply one important area and allow everything else to be less sharp.

For picture situations which combine strong outdoor light with soft indoor light, a reading should be made of the light from the strong source and also from the softer source. A compromise lens/shutter setting on the camera combined with the latitude of the film will produce a negative with good tonal qualities.

Short-length lenses are best to use when both near and far objects are to be in focus. The shorter lenses have greater depth of field. When the lens opening is stopped down to a small aperture, maximum sharpness results.

When control of sharpness is wanted, as in this selective-focus picture of a cocktail glass at a party, a long or medium-long lens will restrict the depth of field even when the lens opening or f:stop is small.

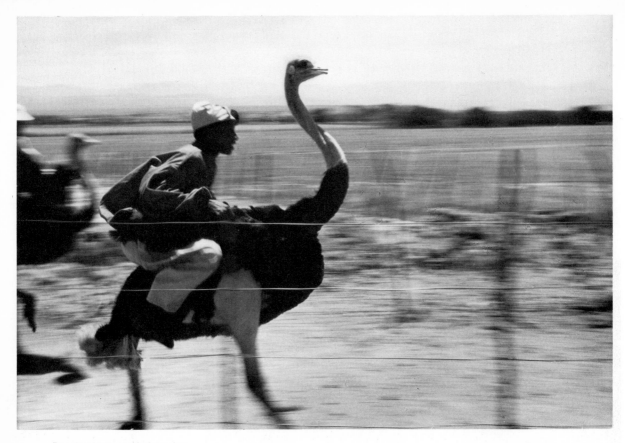

Panning is one technique that allows concentration on the main interest of the picture when other devices such as lens length or depth of field are not workable. The photograph above and the photographs on pp. 145 and 146 illustrate the variety of effects obtainable using this technique. The racing ostrich was running at high speed, while the wagon in Ireland (photo on p. 145) was moving rather slowly. The zebra in South Africa (p. 146) was shot from a moving truck, which caused blurring in all the picture as well as in the motion of the animal.

The lens selection would *not* be one that permits maximum depth of field. Rather, a large lens opening would be used to assure a shallow depth. Conversely, if selective-focus composition is designed with all areas sharp, the smallest lens opening would be used to gain the greatest depth of field.

*Panning*   To show motion without freezing it, the photographer follows the action as it approaches him. As it passes him, the photographer swings, or "pans," his camera with the action, at the same pace or speed. The shutter is pressed when the action is directly in front of the camera. The panning is continued, following the action as a follow-through. A slow shutter causes the action to be partially stopped when the shutter is pressed. The background and foreground are unsharp and slightly stretched by the movement of the camera plus the follow-through.

Selection of a shutter speed for this kind of photograph is determined by the speed of the action itself. If the subject is slow-moving, the

shutter selection would be slow also, perhaps even as slow as 1/10 second, or even 1/2 second. But if the action is fast, the shutter speed would be perhaps 1/100 second.

*Critical focus* Another consideration for lens and shutter selection would be a composition where some of the design is sharply focused and the remainder is in motion. Take a composition where an object (a bird perhaps) is on a fence in the foreground, and an airplane is taking off in the background. The idea is to show the bird sharp and the plane in motion. Critical focus would be on the bird. A lens opening would be selected that would retain the critical focus yet give a degree of depth. The shutter speed would need to be slow enough to permit action of the plane to blurr.

*Automatic meters* Lens and shutter combinations should be viewed as part of the creative process. Correctly exposing film is no longer considered the hallmark of an accomplished photographer as it was

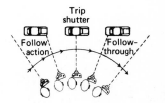

This diagram shows the technique of panning: as the action approaches, sight it in the viewfinder; when the action is directly in front of the camera (90 degrees), release the shutter; continue to follow the action as it passes.

before exposure meters. Today everyone can take acceptably exposed negatives. It is selection of the combinations that determines the clarity of the contents.

Early in the 1960s cameras were designed with built-in exposure meters. Before that, attempts had been made to hook the exposure meter to the camera but not to synchronize the two. The new idea of synchronizing the camera to the meter reduces the photographer's involvement in determining correct exposures. The meter is coupled to the lens, and the desired shutter speed is set; the film speed is preset. As the picture is taken, the camera is pointed in the direction of the scene. The meter automatically registers the light level (footcandles) which matches the shutter speed. As the shutter is released, the lens opening is automatically selected. The photographer does not touch the lens setting. With semiautomatic meters, the lens setting is indicated in the meter housing. The photographer manually sets the indicated f:stop immediately prior to exposure.

Most cameras are designed either with fully automatic meters or with semiautomatic ones. Some lenses for automatically controlled meters

are semiautomatic because of the long focal length of the lens, which makes coupling nearly impossible.

Automatic exposure meters also have a switch for converting to a manual operation. Sometimes special circumstances require that the lens be so controlled. The photographer should check the operator's guide furnished with the camera to see if the camera has such a control.

Exposure is one major key to quality black and white prints. Negatives that are too dense or too thin will never print with the tonality or beauty that a properly exposed negative will have. Care at the time of exposure will save fruitless hours of labor in the darkroom trying to salvage an interesting composition.

**tripods and camera supports**

One of the most useful supplementary tools for a photographer is the tripod. As the name implies, this is a three-legged support. The three legs are topped with a small platform, or "panhead," on which the camera is mounted. The camera is attached firmly to the support base by a screw with a tightening lock. If the panhead is more elaborate, one can turn and tilt the camera. A single arm usually projects from the panhead for the photographer to hold. The arm locks and unlocks by a slight twist. When unlocked the panhead will rotate or tilt as desired. When locked, the camera remains stationary.

The three tripod legs are — with few exceptions — designed to telescope for ease of carrying. Each extension will open to increase the height of the legs as much as three times the length of one section. Some supports, called "elevator tripods," have a center post that will crank up to 18 inches or more.

The uses for a tripod are many. Primarily, it makes the camera as steady as possible. When long exposures are to be taken, the tripod supports the camera. Night photographs generally require a very steady camera. Maximum sharpness when using a slow shutter and small f:stop also demands the use of a tripod. Large-format cameras such as the 5 x 7 or 8 x 10 require a tripod because of their weight. Small-format cameras are lighter and more portable, which reduces the need for a tripod.

In addition to the tripod, other devices are used for supporting cameras. Some have clamps with spring-gripping jaws that will hold onto fence posts, tree limbs, table edges, etc. This type of support is small and compact and seldom has a panhead, using only a screw to attach

Camera supports are available in many forms. The tripod is perhaps the most used. But unipods, chestpods, and alligator clamps are also useful at times. The close-up of a water drop on a child's swing on the opposite page (p. 149) required a tripod.

the camera. The tilt or rotation of the camera is restricted to a single position, though degrees of angle may be altered by moving the clamp.

Another popular camera support is the "gunstock." This is constructed of wood and resembles the butt of a shotgun for easy holding. The camera is mounted with a locknut screw on top of the gunstock, where the range finder sight would be located on a gun. Some gunstocks have special cable releases which attach to the shutter re-

lease, and taking a picture is much like firing a gun. The gunstock is a very helpful accessory when using long telephoto lenses on 35mm or 2¼ x 2¼ cameras.

A "chestpod" is another camera support that has special use. It is designed to fit over one's shoulders with the platform resting at chest level. The camera is attached by a lockscrew. Some chestpods have panheads and even elevator center posts for maximum control of the camera tilt, rotation, and angle. Chestpods are very useful in crowded conditions or when the action is fast-moving. Big and small cameras are used on chestpods.

"Unipods" are also used to hold the camera steady. The unipod is a one-legged tripod. It might have a panhead, but usually does not. The camera is screwed onto the top, and the leg is extended to the height most comfortable for the photographer. In use, the unipod is no more difficult to handle than a walking cane. Photographers who use small

Another form of camera support which is very useful when working with heavy cameras, or cameras with long telephoto lenses, is the gunstock. The camera is mounted in the position where the target sight is located on a rifle.

cameras find the unipod highly desirable for added support when using telephoto lenses in crowds and for fast-paced action.

Photographs will always be sharper when camera supports are used. With the camera firmly supported by a tripod, clamp, or unipod, there is less camera motion at the time of opening the shutter. No matter how careful the photographer is, he cannot hold the camera as firmly as a support can. When time and circumstances allow, a camera support should be used.

Our technique that assists the photographer in holding his camera steady without a support is similar to the approach of a rifleman. The scene is sighted and composed; all slack in the shutter release is taken up by pressing it to the point just before activating the shutter. Holding the release in this firm position, the photographer takes a deep breath

and exhales about half of it. With elbows pressed firmly against his ribs, the photographer's body becomes the camera support. As the instant of exposure is reached, the shutter is pressed firmly and smoothly. Though this technique for firm support of handheld cameras requires practice, it is well worth learning.

There are different philosophies about using or not using camera supports. No one argues that sharper pictures will be made when a tripod or similar aid is used. But the photographer must weigh the added time and problems that using a camera support require against the kind of pictures he wants to make. For one who photographs only landscapes or still subjects, the tripod is a necessity to achieve optimal sharpness. Yet, if he is careful, the photographer who uses a 35mm or other small-format camera can realize highly sharp images without a tripod.

Filters are the most often used camera accessary. A filter was used to strengthen clouds in this picture. Filters can also reduce contrast, alter film speed, and bring out detail.

**filters**   Filters are used in black and white photography to control both the amount of light and the color of light that reaches the film. Even though film material is monochromatic, filters of different colors are used to achieve these two controls.

Five colors, in various degrees, are used to filter light in black and white photography: yellow, orange, red, blue, and green. Panchromatic films in wide use today are sensitive to all these filter colors.

filter identification   Filters are colored glass or plastic units which fit over the lens of the camera. The color of the filter is the color of the light spectrum that is being controlled. The complement of that color is the color that is given increased sensitivity. For example, if a yellow filter is used, the yellow color of the spectrum is transmitted and lightened by the filter as it goes through the lens to the film. At the same time both the blue and red light rays are darkened. Therefore, if the picture is a sky with billowing clouds, the yellow light rays are reduced in value, and the red and blue rays are increased, making the clouds more visible because

Dramatic effects are possible with filters. A deep-red filter made this picture of a nude against the sun a study in silhouette. The filter eliminated all detail but dramatized the shapes and sunlight.

the sky is darkened. The deeper the shade of yellow, the darker will be the sky, and the brighter will be the clouds.

To use another example, if an orange filter is used when taking a picture of a girl in orange clothes, the filter will reduce the orange light value and make the dress lighter. Using a green filter when photographing a wooded or foliage-filled landscape would reduce the contrast between the foliage and the sky. The green filter would lighten the green values and cause the film to record more detail in the foliage. The sky would also be affected, because the yellow light rays would be altered.

As a rule of thumb regarding the use of filters in black and white photography, it could be stated that one would use the same color filter as the light value or color he wants to control. Improving clouds is the first use that photographers make of filters. By using a medium-yellow filter, clouds are made whiter because the blue sky is darkened. The filter lightens yellow light and deepens blue light, causing an adjustment in relative tonal values. The clouds appear whiter because the sky is darker. But photographers also use filters to alter contrast, to reduce ASA rating for exposure control, and to achieve special effects.

Filters are most often used to control contrast. A subject or scene may be more exciting, interesting, and dramatic with an alteration in contrast. To achieve the alteration one must remember that a filter transmits and lightens colors which are the same as the filter. It also absorbs and darkens colors which are opposite or complementary to the color of the filter. Here are examples:

Yellow filter lightens red and yellow; darkens blue and green
Green filter lightens green; darkens red and blue
Orange filter lightens red, yellow, and orange; darkens blue
Blue filter lightens blue; darkens red and yellow
Red filter lightens red, yellow, orange; darkens blue and green

Filters come in different hues, and the deeper the hue, the more effective or dramatic it will be: The deeper the yellow of the filter, the more yellow will be lightened, with a proportionate increase in the darker tones of blue and green. Applying this idea to the situation of a cloud-filled sky, the deep-yellow filter lightens the clouds more and darkens the sky more, giving a sharper contrast between the two.

When using filters there is a change in exposure. The filter reduces the amount of light that reaches the film. To compensate for this change

filter factors

a reduction in film speed is necessary. The percentage of change necessary for the various filters to work is called a "filter factor." The filter factor is the amount of correction necessary to allow the proper amount of light to reach the film. Table 5-1 lists the color of the filter and the compensation necessary to ensure correct exposures.

In practice the filter factor changes the film speed by reducing its light sensitivity. To correct the film speed, the filter factor is used to reevaluate the ASA. If the film is Plus X with a normal ASA to arrive at a new ASA for the filter in use: ASA 160; the filter is orange (G) with a factor of 3; dividing 3 into 160 we arrive at a new ASA of 53 or, rounding it off, 50. The new ASA 50 is now used on the exposure meter. All exposures through the orange filter will be based on the film speed of ASA 50: no filter/ASA 160 =G/ASA 50.

Another method of using the filter factor is to equate the factor with one-half the number of f:stops. This is not a critical-exposure method but useful within the latitude of the film. If the factor is 3, that would be the same as 1½ f:stops. Again using an ASA 160, with no change in the exposure-meter ASA setting, the light is read. The exposure is determined to be 1/250 at f:16. The filter is added, and the factor 3 is now important. One and one-half f:stops or shutter settings or combinations setting could be 1/250 at f:8; or another one could be 1/125 at f:11; another one could be 1/60 at f:16. In each of the examples, the factor of 3 has been used to reduce the lens f:stop or the shutter speed by 1.5 or 2 from the nonfilter ASA reading, or exposure of 1/250 at f:16, to compensate for the reduced light intensity and to have a correct exposure.

Correct exposure when using filters is very important. If the exposure is incorrect, the filter used will be ineffective. Underexposure is the most common error when using filters because of the filter factor. The faults of underexposure—such as lack of detail, reduced contrast, and weak highlights—are to be anticipated when an uncorrected ASA or exposure setting has been used with a filter.

There are times when a filter can be used to adjust the ASA or exposure. For instance, a beach scene, where the light is very bright, is such a setting. The film in the camera is Tri-X with an ASA 400. Your camera has a shutter speed of 1/500 second as its fastest and an f:stop of 16 as its smallest. The exposure meter reads an exposure of 1/500 at f:32, or 1/1000 at f:22. You have neither on your camera. By using a filter with a factor of 3, you would be able to reduce the Tri-X film ASA to 125 (round numbers) which would allow exposures at 1/500 at f:11 or 1/250 at f:16. The filter has been used to control not the color or light value, but the volume of light.

| Filter Color | Identification | Factor |
|---|---|---|
| Light yellow | K-1 | 1 |
| Yellow | K-2 | 2 |
| Deep yellow | K-3 | 3 |
| Orange | G | 3 |
| Light green | X-1 | 4 |
| Medium green | X-2 | 5 |
| Deep green | B-2 | 8 |
| Light red | A-23 | 6 |
| Medium red | A-25 | 8 |
| Deep red | F-29 | 16 |
| Blue | C-5 | 3 |

TABLE 5-1
FILTER COLORS
AND EXPOSURE FACTORS

Filters may also be used to produce dramatic effects. The most frequently used effect is to make bright sunlight appear as a moon-lighted scene. Motion picture cinematographers use this technique to effect night scenes. This dramatic effect is done by using a deep-red filter. Midmorning or midafternoon are the two best times to attempt this type of picture. The filter factor will alter the exposure. The shooting angle will be into the sun. The exposure will be for the brightness of the sun. Because of the brightness, there will be a silhouette of all objects between the camera and the sun. The composition will appear to be a nighttime scene with all foreground shapes dark and the "moon" (sun) full and bright.

Filters do not correct the errors of photographers. If they are not used correctly, and with concern for the effects that are possible, filters can contribute errors and problems. Filters have specific purposes and should be used with those purposes well understood. They are not the solution to every problem, but they can be the right prescription for many pictures suffering from poor contrast and tonal relationships. Filters are but one ingredient in the making of a good photograph.

**lenses and their use**

The professional photographer will not find more serviceable camera accessories than a variety of lenses. Through lenses of various lengths the photographer is able to control visual distance, perspective, distortion, compression of distances, juxtapositioning of either related or unrelated subjects, and depth of sharpness. These visual controls are combined with compositional structures to form motifs and designs. Lenses of different focal length and speeds are an optical keyboard upon which the photographer plays a visual melody. Our concern here will be to identify the various lenses and to define how they serve the photographer.

Extra lenses enable the photographer to have complete control of the image size of this picture. These four pictures indicate the image management possible with 35mm, 50mm, 135mm, and 200mm lenses on a 35mm camera. The photographer did not move. Image magnification was produced optically.

normal-length lenses

There is an appropriate lens length for every camera which will give sufficient coverage and angle of vision. This lens is the "normal focal length" for that camera design. A normal-length lens has a focal length equal to the diagonal of the film format. For example, if a film format is 4 x 5 inches, the normal-lens focal length would be 5¼ or 5½ inches. If the film format is 2¼ x 2¼, the normal focal length would be 2¾ to 3 inches. The normal-length lens for 35mm is from 45 to 55mm in length, with 50mm (2 inches) being most used.

Lens settings or f:stops for the normal-length lens are calibrated with the diameter of the lens and the distance from the center of the lens to the film plane. For example, if a 1 inch lens is fitted on a 35mm camera which has a 2 inch distance from the center of the lens to the film plane, the optimal lens opening or f:stop would be f:2 (1"D/2"FL =f:2).

From that optimal f:stop the smaller f:stops are also calibrated. As the lens is "stopped down," or made smaller, the diameter of the lens changes. The smaller opening is divided into the constant distance from lens to film. Each of these quotients establishes an f:stop.

The determination of f:stops is the same no matter what the focal length of the lens. Whether normal, wide-angle, or telephoto, the lens settings are determined by the same process.

depth of field

The normal-length lens allows a good angle of vision and an acceptable depth of sharpness when the lens is set at its largest opening. The f:stop which is used for the particular situation will influence the depth

Another use of long-length lenses is the compression of distance. Here, the photographer used a 200mm lens to "squeeze" the seats of the stadium into the illusion of one plane. **Dick Sroda.**

Wide-angle lenses allow a broader view with maximum sharpness. The wheel of the buggy is as sharp as the horse and rider are.

of sharpness but will not change the angle of view. The smaller the f:stop opening, the greater will be the depth of sharpness. Tables 5-2 through 5-4 show the different lengths, f:stops, and depth of field for identifiable distances. While these tables will be of use if they are available when you need them, the best place to find the depth-of-field range for the lens you are using is right on the lens barrel itself.

TABLE 5-2
DEPTH OF FIELD
FOR 152MM, f:4.5, 4 x 5 CAMERA

| Focus in Feet | Lens Setting | | | | | |
|---|---|---|---|---|---|---|
| | f:4.5 | f:8 | f:11 | f:16 | f:22 | f:32 |
| Infinity | 190–Inf | 107–Inf | 78–Inf | 54–Inf | 27–Inf | 19–Inf |
| 100 | 66–209 | 52–Inf | 44–Inf | 35–Inf | 21–Inf | 16–Inf |
| 50 | 40–67 | 34–95 | 30–137 | 26–Inf | 18–Inf | 13–Inf |
| 25 | 22–29 | 20–33 | 19–37 | 17–47 | 13–Inf | 10⅝–Inf |
| 15 | 14–16 | 13–17 | 12–18½ | 11–21 | 9–33 | .9–69 |
| 10 | 9½–10 | 9¼–11 | 8–11½ | 8½–12½ | 7¼–15½ | 6½–21 |
| 6 | 5¾–6¼ | 5¾–6¼ | 5–6½ | 5⅔–7½ | 4⅝–7¾ | 4½–8¾ |
| 3.5 | 3½–3½ | 3½–3½ | 3⅓–3⅓ | 3⅓–3⅔ | 3–4⅕ | 3–4½ |

TABLE 5-3
DEPTH OF FIELD
FOR 80MM, f:3.5, 2½ x 2½ CAMERA

| Focus in Feet | Lens Setting | | | | | | |
|---|---|---|---|---|---|---|---|
| | f:3.5 | f:4 | f:5.6 | f:8 | f:11 | f:16 | f:22 |
| Infinity | Inf–Inf | Inf–Inf | 68–Inf | 48–Inf | 34.9–Inf | 24–Inf | 17½–Inf |
| 60 | 38–Inf | 36–Inf | 32–Inf | 26–Inf | 22–Inf | 17–Inf | 13–Inf |
| 30 | 23–44 | 22–43 | 21–53 | 18–80 | 16–Inf | 13–Inf | 11–Inf |
| 15 | 14–17 | 13–18 | 12–19 | 11–22 | 11–26 | 9–40 | 8–Inf |
| 10 | 9–11 | 9–11¼ | 8.8–11½ | 8–12½ | 7.8–14 | 7–17 | 6½–23 |
| 5 | 4¾–5¼ | 4¾–5¼ | 4½–5½ | 4½–5½ | 4¼–5.8 | 4–6.3 | 3½–7 |
| 3.3 | 3.2–3.4 | 3.1–3.4 | 3.1–3½ | 3–3½ | 3–3.6 | 2.9–3½ | 2.7–4 |

TABLE 5-4
DEPTH OF FIELD
FOR 50MM, f:2, 35MM CAMERA

| Focus in Feet | Lens Setting | | | | | | | |
|---|---|---|---|---|---|---|---|---|
| | f:2 | f:2.8 | f:3.5 | f:4 | f:5.6 | f:8 | f:11 | f:16 |
| Infinity | 133–Inf | 95–Inf | 67–Inf | 76–Inf | 48–Inf | 33–Inf | 24–Inf | 17–Inf |
| 100 | 57–398 | 49–Inf | 43½–Inf | 40–Inf | 32–Inf | 25–Inf | 19–Inf | 14–Inf |
| 50 | 36½–80 | 33–104 | 30–144 | 29–197 | 25–Inf | 20–Inf | 17–Inf | 13 – Inf |
| 25 | 21–31 | 20–34 | 19–37 | 8–40 | 17–52 | 15–96 | 13–Inf | 10–Inf |
| 15 | 14–17 | 13–18 | 13–19 | 12½–19 | 11–21 | 11–27 | 9–38 | 8–125 |
| 10 | 9–11 | 9–11¼ | 8½–11½ | 9–12 | 8½–12½ | 7½–14 | 7–16½ | 6½–24 |
| 5 | 4¾–5¼ | 4¾–5¼ | 4¾–5¼ | 4¾–5½ | 4½–5½ | 4½–5¾ | 4⅓–6⅓ | 3½–7⅘ |
| 3.6 | 3½–3¾ | 3¼–3¾ | 3–3⅔ | 3⅓–3 | 3¼–3¾ | 3⅓–3¾ | 3–4 | 2⅘–4¼ |

Every lens barrel has the scale of depth printed in clear view. You should learn to use this handy guide to sharpness. It is always with your camera.

In function the normal-length lens can be used for 90 percent of all pictures you take. There is ample angle of vision, acceptable focus range from near to far, and f:stops or speed of the lens fit most lighting situations; lightness of weight with the lens/camera body combination will permit handheld operation; and depth of sharpness is suitable for most occasions.

There is less likeliness of distortion from being too close to the face of a person when using the normal-length lens because the lens angle of vision is not too great and the convex shape of the lens design restricts the bending of light rays. Everything from close-ups of faces to grand views of mountains can be photographed with the normal lens. In fact, this statement could be made of every lens length available for any and all cameras. It is not whether the lens can be used for a picture situation, but rather which lens will give the most interesting and/or exciting optical effect.

Familiarize yourself with the function of a normal lens for your camera. Know its smallest and largest f:stops. Be able to set these by feel and by sight. If the lens dial or index has a "click stop" or notched indicator that makes it easy to feel the change from one setting to the next, learn the direction you have to move to go either up or down in f:stop. Knowing that a turn to the left increases the f:stop will make it easy to change openings in even poor light.

wide-angle lenses

The wide-angle lens is just what its name implies. The lens sees at an angle of vision which is greater than a normal lens. The angle of vision for most wide-angle lenses is about 30 percent more than the normal-length lens. There are special wide-angle lenses that have angles of vision in excess of 160 degrees. Here we will concern ourselves with the "normal" wide-angle lens.

There are two main differences between wide-angle and normal-length lenses for the same camera: greater depth of sharpness and increased angle of view. Our concern will be for these two factors and how they are useful to the photographer.

A wide-angle lens is of greater convex curvature. The curve of the design is intended to bend the light rays and permit broader vision. Because of the convexity of the lens and its increased angle of vision, the lens is usually a much slower or smaller maximum f:stop than the normal lens. To get a fast lens would require a large diameter that

There are times when a simple device makes the difference in the success of the picture. A sun shade over the lens kept this picture from having excessive light flare.

would increase coverage and which would also include "seeing" the internal structure of the camera body. Such a lens would not only have a greater view but would also see too much. Most often the wide-angle lens for any given camera has a maximum f:stop of about two stops less than the normal length. For example, an f:2 normal-length lens would have a maximum f:3.5 lens for a wide-angle lens.

The wide-angle lens has many uses. Almost all subjects from people to plants to planets can be photographed. There are photographers who prefer using the wide-angle lens as most photographers would use a normal-length lens. Their rationale for using the wide-angle lens is that it enables them to be closer to the things they photograph — and that it reduces focusing practically to zero. (The technique, called "hyperfocal distance," is discussed in Chapter 8.)

The uses for a wide-angle lens are extending the overall view, greater depth at the same f:stop, restricted or confined shooting area, and intentional distortion. Let us take these one at a time to indicate how they will be useful to you.

*1 Extending the overall view*   Because the wide-angle lens sees at least 30 percent more than the normal-length lens, you can remain at the same shooting distance and take in one-third more of the scene you are photographing.

*2 Greater depth and sharpness*   When set at the same f:stop as the normal-length lens, the wide-angle lens will have more depth of sharpness because of the shorter focal length. This could be of particular service if the subject is both near and large. To get full coverage and sharpness would require both broader angle of vision and increased depth of field.

*3 Restricted shooting area*   It often happens that a picture must be photographed in close quarters. Even when backed up as far as possible, there is still not enough room to work. The wide-angle lens increases the working area by 30 percent or more. And there are times when working out of doors that it is physically impossible to retreat far enough from the subject to get the angle of coverage desired. In architectural photography the problem of adequate shooting area is a persistent one. The wide-angle lens is the one tool at the photographer's command that most often comes to the rescue.

*4 Intentional distortion*   As has been pointed out earlier, the convexity of the wide-angle lens causes distortion. The distortion can be controlled, or it can be exaggerated. Either use might well be an effective use. In an architectural study the controlled distortion could make a building more dramatic than it appears to the eye. If the same building were exaggerated in distortion, the effect could be more dramatic but might form a structure that exists optically only.

One frequent use of wide-angle distortion is in television commercials. When an automobile manufacturer wants to make his car seem longer, wider, and more roomy, the photography is done with an extreme wide-angle lens. The camera is distorting the facts.

The wide-angle lens offers optical manipulation that can serve the photographer in all applications of the medium. From necessity to innovation the wide-angle lens can and should play an important role in your photography.

There are two ways to control
camera perspective. One is
with a lens and the other is
shooting angle. Of course,
the two can be combined.
Lenses of different lengths
from the same shooting
position will alter the
perspective; as the perspective
is changed, there will be a
compression of distance and
shapes. Using the same lens
but changing the shooting
angle will also change the
perspective.

telephoto lenses

Unlike the normal-length and wide-angle lenses, which are essentially one focal length in their particular design, telephoto lenses are found in many lengths, ranging from an inch to several feet. For example, in 35mm lens design, the telephoto lenses for a 35mm body could range from 85 to 1,000mm and even longer. The telephoto lens is intended to magnify the image size just as binoculars do for the eyes.

It is not often that a photographer can afford a battery of telephoto lenses; the cost would be prohibitive. A telephoto lens usually costs a minimum of $1.00 per millimeter of length. Such expense restricts the number of lenses that even professionals purchase.

For most 35mm photography, four lengths of telephoto lenses will cover the greatest number of situations. These are 90mm (or 85mm), 135mm (or 100mm and 125mm), 200mm (or 180mm), and 400mm. For other film or camera sizes the telephoto lenses will produce approximately the same image increase but the length will increase in proportion to the camera size. The 4 x 5 camera would have a 135mm lens, but its image increase would be less than the 135mm lens with 35mm cameras. A 200mm lens on a 2¼ x 2¼ camera would produce an image smaller than a 200mm lens on a 35mm camera, but a larger image than would be possible with a 4 x 5 camera.

The telephoto lenses for whatever camera you are using are specific to that camera size. The image size, angle of vision, and f:stop are determined by the camera on which the lenses are used. You should check your instruction booklet to learn what telephoto lenses are appropriate for that camera.

**compression of distance**

One fact to remember when using either the normal, wide, or telephoto lens is that the increase or decrease in angle of vision will also either compress or widen the contents of the picture. If a wide-angle lens broadens the angle of vision, it also spreads or opens the distance between near, middle, and far ground. Conversely, the telephoto will compress and bring together, in closer association, all elements of the composition. The juxtapositioning of principal elements of the composition can be formed or controlled by the choice of lens. Let's take a situation and define what would happen with different lenses: The scene is a city street. People are on the street. The angle of position of the camera is slightly above normal eye level, pointing down the street. With a *wide-angle lens* the scene would be broad and the space between the foreground, the middle ground, and the far ground would be spacious. Everything would be sharp. The

*normal-length lens* would tighten the scope of vision and also bring the three major planes into closer association. The *telephoto lens* would narrow the scene to a small portion of the overall and compress the people, signs, cars, and other objects so tightly that they will appear on the same plane. Distance would be compressed optically, causing the foreground to appear on the same plane as the distant area. Unless a very small lens opening is used for long telephoto lenses, some objects will also be out of focus.

**questions for review**

1    What are the three basic parts of a camera? *body, lens, eyepiece*
2    How is the normal length of a lens determined for a camera? *50-55*
3    What are f:stops or lens openings? *the aperture opening*
4    How is the lens speed determined? *film*
5    What are shutter speeds? *time of opens & shuts*
6    How is focusing achieved? Why is it important?
7    What is depth of field? What role does it play in compositional design?
8    What is the equation for exposure?
9    What is an exposure meter and how does it work?
10   What is selective focus and how do you achieve it?
11   Define panning.
12   Name three kinds of camera stands.
13   Identify the filters used in black and white photography.
14   What is a filter factor and how is it used?
15   Identify normal-length lens, wide-angle lens, and telephoto lens. What function does each serve?
16   What is depth of field? How is it used?
17   What is the relationship between lens length and perspective? *Compression of distance & shape*

**selected readings**

Adams, Ansel: *Zone System,* Morgan and Morgan, New York.

Arnold, Rus: *Guide to 620/120 Cameras,* Chilton, Philadelphia, 1961.

Bakal, Carl: *Filter Manual,* Cameracraft, San Francisco, Calif., 1953.

Balish, Jacquelyn: *Leica World,* Amphoto, New York, 1957.

Cartier-Bresson, Henri: *The Decisive Moment,* Simon and Schuster, New York, 1952.

Clerc, L. P.: *The Camera and Its Function,* Amphoto, New York.

————: *Fundamentals: Light and Optics,* Amphoto, New York.

Coles, Charles H.: *Exposure Meter Guide,* Chilton, Philadelphia, 1955.

Cooper, Joseph: *Single-Lens Reflex Photography,* Amphoto, New York.

Crawley, G.: *The Nikon System,* Focal Press, London.

de Mare, Eric: *Photography,* Penguin, New York, 1968.

Deschin, Jacob: *Canon Photography,* Cameracraft, San Francisco, Calif., 1957.

——: *Rollei Photography,* Cameracraft, San Francisco, Calif., 1956.

——: *35mm Photography,* Cameracraft, San Francisco, Calif., 1953.

Dobell, Byron: *Creative Pictures,* Random House, New York, 1956.

Duncan, David Douglas: *Self-Portrait—USA,* Harry Abrams, New York, 1969.

Emanuel, W. D.: *All in One Camera,* Focal Press, London.

—— and Matheson: *Cameras: The Facts, How They Work, What They Will Do,* Focal Press, London.

Feininger, Andreas: *Feininger on Photography,* Ziff-Davis, New York.

——: *The World through My Eyes,* Crown, New York, 1963.

Foldes, Joseph: *Large Format Camera,* Amphoto, New York, 1969.

Jacobs, Lou, Jr.: *Konica Autoreflex Manual,* Amphoto, New York, 1972.

Kingslake, Rudolph: *Lenses in Photography,* Focal Press, London.

Mannheim, L. A.: *How to Use Your Exposure Meter,* Focal Press, London.

Matheson, Andrew: *Leica and Leicaflex Way,* Focal Press, London, 1972.

Morgan, Willard: *Leica Manual,* Morgan and Morgan, New York, 1950–1973.

Murphy, Burt: *Creative Camera Techniques,* Universal, New York, 1961.

Neblette, C. B.: *Photo Lenses,* Morgan and Morgan, New York, 1970.

Newcomb, H. S.: *35mm Photo Techniques,* Focal Press, London, 1958.

Russell, Ted: *Lenses: How to Choose and Use Them,* Amphoto, New York, 1960.

Simmons, Robert: *Telephoto and Wide Angle Photography,* Chilton, Philadelphia, 1959.

Wahl, Paul: *Press and View Camera Techniques,* Chilton, Philadelphia, 1962.

Weisbord, Marvin: *Basic Photography,* Chilton, Philadelphia, 1959.

Woolley, A. E.: *Beseler Topcon Auto 100 and Unirex Manual,* Ampoto, New York, 1972.

——: *Creative 35mm Techniques,* A. S. Barnes-Amphoto, New York, 1963, 1970.

——: *Photographic Films and Their Uses,* Chilton, Philadelphia, 1960.

Wright, George: *Guide to Perfect Exposures,* Amphoto, New York.

# chapter 6

## film

Viewing the contents of a display case in any camera store today, one finds it inconceivable that there was ever any difficulty in obtaining films for photography. But consider what it was like for photographers over a hundred years ago. Photography then involved three steps: preparing the individual film plate, shooting the picture, and processing the exposed plate; and all three operations had to be accomplished in minutes. The creative aspect—shooting—was wedged between two procedures that required a basic knowledge of chemistry and a strong back. For a weekend photographic safari into a nearby county, the photographer of a century ago needed enough equipment for a major camping trip. Happily, today's films relieve us of much of that burden.

**the silver image**

At one time the darkroom was as much a part of the photographic process as the camera, for the film plate had to be coated with a light-sensitive emulsion immediately before it was inserted into the camera. Because a darkroom was needed, field photography was seldom attempted. Almost all photography took place in the studio. When Talbot and Daguerre were experimenting with photography, film emulsion was a primary concern. Daguerre's first film was a light-sensitive, silver-coated copper plate that he developed in a mercury vapor bath. Sodium thiosulfate was later used to fix the image. Sodium thiosulfate—or "hypo," as it is called now—is still the chemical fixing agent.

[1]In art, "support" is used to describe the surface on which a painting or drawing is placed; thus canvas, metal, wood, or paper are supports.

Metal was the support[1] for film emulsions until 1847, when Niépce de Saint-Victor invented the albumen process whereby the first glass negatives were made. A major advance in the development of film plates occurred in 1851, when Frederick Scott Archer introduced the wet collodion process of making negatives. This process produced what was commonly called "wet-plate film." During the sixteen years that wet plates were the primary film material, some of the greatest photographs were taken. Mathew Brady covered the Civil War with his "Whatsit Wagon" darkroom and wet plates. Timothy O'Sullivan and Alexander Gardner both covered the Civil War and the migration to the West that followed. The inconvenience and difficulties that photographers of the period encountered did not deter them from recording their world.

In 1867 the Liverpool Dry-Plate Company in England introduced gelatin-bromide "dry plates," the film emulsion material that became the basis of contemporary films. George Eastman of Rochester, New York, an amateur photographer, disliked the trouble and inconvenience of having to coat his own film plates. When he heard about the dry-plate emulsion he went to England to buy the process. In 1879 Eastman invented a plate-coating machine for mass producing emulsion-coated glass plates. The next year he launched his dry-plate business, the Eastman Dry Plate and Film Company.

In 1885 the first flexible roll film was marketed. This process resulted from research by Eastman and an associate, William H. Walker. Four years later, in 1889, the first commercial transparent roll film on nitrocellulose base was introduced. This film material has undergone alterations in the last nine decades but remains essentially the same as it was originally. Special coating to prevent curling and to control inflamability have been added and, of course, light sensitivity has been improved.

The first Kodak was introduced in 1888. This camera was the first to use the roll-film principle. A film length of 100 exposures was loaded in the camera, which cost $25. When all the film was exposed, the camera was returned to the Rochester processing plant, where the pictures were developed. Processed pictures and a refill of film were returned to the customer for a service charge of $10.

Because the process was no more complicated than pointing the camera in the right direction and pressing the shutter release, the phrase "You push the button, we do the rest" was coined to promote the camera. The Kodak was thus responsible for the increased and widespread popularity of photography. Anyone could take pictures quickly and easily. There was no more heavy gear to carry; and chemical mixing and coating of plates no longer interferred with the pleasure of photography.

In the early days of photography a photographer needed a strong back and enough equipment for a major camping trip to picture scenes such as Oak Alley, Louisiana. Film had to be prepared on the scene. Today the photographer has practically an endless selection of films for all occasions.

The studio has been the location for most photography. Even today a very large percentage of all photographs are made in studio conditions. Orthochromatic emulsions, which were the early type of films used, have been replaced with panchromatic films.

The flexible film base was used for making the first motion picture material used by Thomas A. Edison of Tenafly, New Jersey, in 1889. And in 1908 Eastman made the first safety film, cellulose acetate. In 1951 this material replaced all film bases made of inflammable cellulose nitrate.

Perhaps one of the most significant events in the development of photographic films occurred because of a camera. In 1924 Oskar Barnack, an employe of E. Leitz of Wetzler, Germany, designed a small camera for testing 35mm motion picture film. The camera proved more useful than its original purpose, and Leitz introduced the first Leica.

**the Leica camera and available light**

Fast films have taken the camera out of the studio and also permit greater freedom photographing indoors with low lighting levels. **Wendy Woolley.**

The author had to work with caution and use available light for pictures taken in prison. Fast film emulsions combined with fast lenses on 35mm cameras permitted using a variety of lens lengths. This picture was made with a 135mm medium telephoto lens.

*Photo on opposite page:*
The first flexible film base was introduced in 1889. All films produced now are on an acetate base. Sizes from 16mm to 20 x 24 inches are manufactured with other sizes on special order. In this picture of Ilya Bolotowsky, a world-famous painter, Plus X, a medium speed, medium-grain film was used.

The 35mm camera introduced a new concept in photography. No longer was the photographer bound to picturing subjects and scenes that would stay still. The first Kodak had liberated the tripod-bound photographer. Now the Leica enabled taking pictures in almost all kinds of lighting conditions, indoors or out. The age of available-light photography had begun. Dr. Erick Saloman, Alfred Eisenstaedt, Thomas McAvoy, and others quickly joined the Leica with their approach to photography. Thus available-light photography grew out of the need to test film; today it has been developed to full-grown maturity with worldwide application. Though the Leica was invented to test film performance, the camera and approach of available-light photography have long outlived the need that fostered them.

**the Rolleiflex**  Another camera design opened new horizons. In 1927, the first twin-lens-reflex camera using roll film was introduced by Rolleiflex. The camera was small and light, with a lens which was fast for its time. The f:3.5 lens was also sharp. And the film size of 2¼ x 2¼ inches produced a negative that was large enough for consistent image quality, even for the not-so-careful technician. Acceptable qualities of sharpness and grain were possible with the film size. The 35mm film size with its inconsistent image quality—when used by sloppy technicians—was unacceptable to many photographers, and the 2¼ inch film size enjoyed faster success with big-camera users. Many of the traditional photographers adopted the Rolleiflex as their "walking camera." The square format of the film size became a challenge. Photographers who had been accustomed to the rectangle format found the square shape useful and interesting to work with.

Having 12 exposures on a roll of film also encouraged photographers to use more film. The large tripod-bound cameras using sheet film restricted the number of exposures the photographers would take because of the demands of loading film holders. The roll film of the Rolleiflex could be carried in one's pocket. Enough exposures for days of shooting could be carried without any thought of returning to the darkroom to load film.

The Rolleiflex enlisted big-camera users in the move toward smaller, more portable cameras and resulted in a more spontaneous approach to photography.

**other influences**  1936 was an important year for photography. Two great publications issued their first volumes: *Life* came out in November, and *Look* followed six weeks later. Both were based on an editorial philosophy of communication through photographs. The age of photojournalism had begun.

Even though new sensitizing emulsions had been marketed in 1931 and faster, more modern high-speed films had been reaching the consumer, the requirements of photojournalism hurried the search for faster films. With the success of *Life* and *Look,* other magazines with even greater use of photography were published, and established magazines began using more photography. Talented photographers filled page after page in magazines; it could even be said that magazines subsidized the development of photography.

Negative-color film, called "Kodacolor," was offered to the photographer by Eastman Kodak in 1941. It enjoyed only partial success

All roll film that is backed with protective paper is numbered for more than one use. Most rolls have three sets of numbers. The design of the camera will determine which set of numbers will be used. The size of the negative is directly related to the set of numbers used. For a 120 size roll of film, the outside numbers will fit a camera format of 2¼ x 3¼ inches; the inside numbers will fit a format of 2¼ x 2¼; and the other outside numbers will fit a 1¾ x 2½. There will be eight pictures for the first set of numbers, twelve for the middle, and sixteen for the last.

because of the shortage of films for consumers during World War II. Ansco Company introduced Anscocolor, the first transparency color film that could be processed by the photographer. It too suffered from the shortages caused by the war. But both products gained slowly in popularity and quality in the postwar years.

The postwar years were boom years for photography. Photographers who had been deprived of films and materials by war shortages were able to get their favorite products again. Experimenting with chemicals and techniques resulted in faster films and a greater picture-taking scope. These years also saw an entirely new kind of photographic

product: the Polaroid picture. Initially placed on the market in 1948, the Polaroid was slow to gain popularity. Its sepia-colored print was not of the highest quality, and serious photographers considered the Polaroid a fad. But the fad did not pass, and today Polaroid is a prime force in photography.

Other new film products that came out of the research laboratories during the 1950s included Kodak's Ektachrome color film, a color negative material that the photographer could process himself. Then

The quality of the image is directly related to the quality of the film used. A medium-fine, medium-speed film was used for this picture of a Vietnamese mother and child. **David Epstein.**

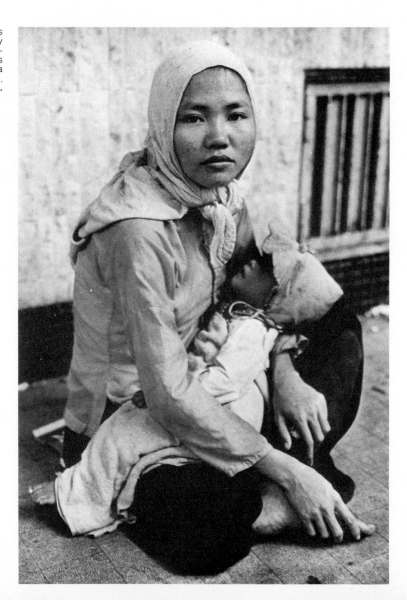

Square-format (2¼ x 2¼) negatives of medium speed and grain were used in this advertising photograph. Care in processing enabled optimum quality in the completed prints. **Edward Pfizenmaier.**

came Flexichrome color, a method of making prints and transparencies in full color from black and white or color originals by applying dyes to a special gelatin print.

Since the introduction of flexible film bases, the light sensitivity of materials had been orthochromatic, that is, sensitive to all colors but

red. In 1906 film emulsion was produced which was sensitive to all colors—"panchromatic" film. All films were either orthochromatic or panchromatic until late in the 1950s, when the only films offered to the public were panchromatic. (To get orthochromatic film one must place a special order, and the film is only available in sheet sizes.)

In the 1950s consumers experimented with films; through their efforts existing films were altered from their basic sensitivity or film speed to increased light sensitivity. Through uses of chemicals and processing changes, photographers effectively extended film speeds to the outer limits. The term used to describe the increased film speed actually described the philosophy of the photographers—film was being "pushed" beyond its recommended ASA. All alteration of the basic film speed fell under the heading of "pushed." Film was pushed for higher sensitivity by processes that included prefogging the film to increase the base density, using mercury vapor, mixing hyperactive accelerators in developers, employing unusually high temperatures for the developers during film processing, and developing in developers that were not intended for film processing. There were almost as many combinations of these alterations as there were photographers to experiment.

The fastest films available to photographers during this period ranged about ASA 125. These ASA speeds were not fast enough for available-light cameramen who were beginning to take their place as the dominant force in innovative image making, and through chemicals and processing techniques film speeds were extended to speeds of ASA 400 and 800. As photographers were pushing the light sensitivity of films, camera and lens manufacturers became aware of the need for higher f:stops. The combination of these two forces enabled available-light photography to enjoy a popularity unlike that of any other approach to photography.

*Photo on opposite page:* The Rolleiflex using 120 film with the 2¼ x 2¼ inch negative size was introduced in 1927. It was a good compromise for photographers who wanted a larger film size than the 35mm but still wanted mobility. The boy and his dog were photographed with a fine-grain film which was processed in fine-grain developer.

**the characteristics of film**

One should know the basic characteristics of contemporary photographic films. These features are *speed* (as identified by the American Standard Association, or ASA), *size, light sensitivity, packaging,* and *markings* for identification.

speed

All photographic films are rated for the intensity of their response to light. This response is film speed, or ASA, and is published on the carton in which the film is sold. While ASA is becoming universally

used, the German DIN rating is still used in Europe. Most films sold throughout the world contain both the ASA and DIN ratings. This film-speed index is used with the exposure meter to obtain accurate lens and shutter settings.

*Film speed* is an established range, or latitude, for the light sensitivity of the material. Because the rating is a norm, there is automatically a safety range or margin-or-error zone. For black and white films this margin is at least one lens opening or f:stop over and one opening under the meter reading. For slow color films the margin is not more than plus or minus a half-stop. For fast color materials the range is like the black and white films of comparable ASA speeds.

If the published film speed is used, the exposures will be of average density. This density is more often about nine-tenths the gray tones that existed in the original scene.[1] For many photographers this tonal density is too heavy for quality image control, and they prefer density of eight-tenths the original scale. If the published ASA is used, the exposure will be deeper than the more controllable density, and so few professional photographers use the established ASA for normal shooting; instead, they alter the ASA to meet their desired negative density. Processing would not be affected by this alteration in film setting, because the functional ASA is based on standard processing.

[1]See "gamma," page 192.

There are other times when the ASA might be altered to push the film speed for special purposes, such as shooting in very low light. In such cases, the film speed would be estimated in advance and would be directly related to darkroom processing. If the film is given a higher ASA (an ASA 400 is used at ASA 1200) the developing will be increased to push the film sensitivity to its optimum. If a film is under-rated (an ASA 400 used at ASA 160) the development is decreased to reduce the density buildup and light sensitivity.

The function of the film speed is to guage a correct exposure. The ASA index is set on the exposure meter. From that point, all light readings are measured according to the sensitivity of that film. The footcandle registrations on the meter are recorded and the lens/shutter combinations are matched for proper exposure. Unless the ASA has been correctly adjusted on the meter for the film in use, incorrect exposures will result.

size

Film is marketed in all sizes from miniature to huge sheets. The most common sizes are those seen on shelves of camera shops and drugstores. Popular sizes found all over the world are 35mm, 828, 120 or

Daylight through the door was the only lighting for this Rolleiflex picture inside an old plantation home. Even though the 2¼-square cameras were equipped with slower lenses than 35mm cameras, the f:3.5 lens on the Rolleiflex was faster than lenses on view and press cameras.

620, 127, and 126 in roll film packaging; and 2¼ x 3¼, 3¼ x 4¼, 4 x 5, 5 x 7, 8 x 10, and 11 x 14 in sheet or cut film packaging. All film-manufacturing companies in the world—including German, Spanish, Belgian, English, Japanese, and American—standardize with these sizes. Cameras are, and have been, designed and manufactured for decades to these shapes. No matter where the photographer travels he can find film to fit his camera.

light sensitivity Not to be confused with film speed, *light sensitivity* is the characteristic of the film which responds to various frequencies of the color spectrum. Until the late 1950s there were two types of film available in all roll and sheet film sizes. These two types were *panchromatic* and *orthochromatic.*

Panchromatic films are the only films in general use today which are sensitive to all colors. A full range of tonal values is possible when using any of the films presently on the market. No matter what color the light illuminating the subject is, panchromatic film is sensitive to it. The film is also responsive to controls through the use of different colored filters.

Even though orthochromatic films are not readily available to the photographer today, it is worth noting that these films serve a good purpose. Because they are insensitive to red, the film can be handled in a darkroom illuminated with a red safety light. For developing by inspection, this film is very good material because one can clearly see the developing image. It is regrettable that at least one size of roll film in this material is not available, as developing film by inspection would be easier to learn. The film is still available in selected sheet film sizes.

Color films that produce color transparencies and color negatives are *polychromatic.* Though this book is intended to serve as an introduction to black and white film materials, all the principles of photographic thinking will apply fully to working with color materials.

packaging and
identification

Each film product is packaged to fit the cameras in which it will be used. To understand how these films are packaged, let us identify the different films.

Films for 35mm cameras are prepared in lengths of 20 exposures and 36 exposures. Both lengths fit all 35mm cameras. The film is wound inside a metal cartridge, or cassette, with a short leader of about 5 inches. After the film has been exposed, it is rewound into this cassette for safe handling. If the cassette is opened anywhere but in a darkroom, the film will be ruined.

Roll film is protected by a paper backing. There is a lead of several inches before the film is attached to the paper. From that point the paper is numbered on the side visible to the photographer in the film window. Each paper backing is numbered for three sizes of pictures. One set of numbers on the edge of the paper will show sixteen numbers; the set in the center of the paper will show twelve numbers; and the third set on the other edge of the paper will have eight numbers.

All but one set of numbers is hidden when the film is in the camera. The format of the camera will determine which set of numbers, and subsequently which negative format, will be used. The sixteen pictures will be rectangular and vertical on the roll; the twelve pictures will be square; and the eight pictures will be rectangular and horizontal on the roll.

Sheet film is packaged in boxes of two dozen pieces. The films are notched on the edge for identification and loading purposes. Notching also is used to ensure loading the film correctly in special holders which are used to house the film as it is placed in the camera. (The notches touch the right index finger as the film is threaded into the holder.) Film holders are made in sizes to fit the camera designs. Loading a sheet of film in one of these holders involves placing one piece of film in proper position on one side of the holder and another piece on the opposite side of the holder. Two sheets of film are housed in one holder. If the film is loaded upside down there will be problems, not the least of which will be incorrect exposure of the film. Notching helps to prevent improper loading.

One other method of packaging films, limited to a few sizes, is the film pack. In this form, a dozen pieces of film are housed in one metal pack. This pack fits a special adapter that fits the camera. All twelve films can be exposed before processing. Or, with care, individual sheets can be removed in the darkroom with the remainder of the film left intact and ready for use. Because they eliminate film holders, film packs are useful in extensive shooting situations where larger film size is required.

Tables 6-1 (page 194) and 6-2 (page 196) list most available films, their sizes, and their speeds. It is highly recommended that the instruction sheet packaged with every film be read for any alterations in the speed or characteristics of the film selected.

**film as creative tool**

Film is one of three basic ingredients necessary for accomplishing the photographic image. Camera and light are the first two. But without the third, film, there is no photograph. The level and quality of lighting are influenced by the film chosen, and the photographic image is a creative union of light, camera, and film.

To use a film material creatively one must know the characteristics and latitudes of the selected film. The maximum and minimum ranges of sensitivity to light, filter controls, latitude of film speed, or ASA flexibility, and development variations are some of the external controls the photographer has. The internal characteristics of film must also be considered if the optimal creative controls are to be exercised. Internal properties of black and white negative film are *grain, sharpness, resolution, density, overexposure, underexposure,* and *high or low key.* Each of these, and combinations, is a functioning tool when used at the right time with the right subject.

Film emulsions are divided into three categories of grain quality or pattern: *fine, medium,* and *coarse.* Grain is the grouping together of minute particles of silver in the film emulsion. If these groupings get large enough, they create a graininess, or stippled effect. Graininess reduces the sharpness of the image itself. Overexposure will increase the density of the negative, causing increased graininess. Overdevelopment will also increase graininess. Certainly the combination of overexposure of the film and overdevelopment of the overexposed image should be avoided. Excessive graininess always results from this combination. But there are times when excessive graininess is used as a creative characteristic because of the textured effect, and it is useful to know that the overexposed image that is also overdeveloped will produce a heavier than usual grain pattern.

Conversely, a medium-low grain pattern permits the use of medium and fast films. When low light is available, ultrafast ASA film must be used and will produce a coarser grain pattern.

Personal taste determines the grain quality that a photographer uses. If a moderate amount of grain is acceptable at all times, a medium-grain film is the ideal choice. There is practically no situation that a medium-speed, medium-grain film will not cover. The few occasions when greater film speed is needed can be handled with an acceptable fast-speed, coarse-grain film.

grain

The linear sharpness of the film is measured in terms of grain structure and the number of lines per millimeter. This is usually determined by the acetate film base and the resolving power of the lens. It must be understood that a grainy film is going to have a less sharp image than a fine-grain film. The fine-grain films are almost always coated on thin, even ultrathin, film bases, while heavier bases with higher fog level, or base density, are used to support the faster, grainier films.

sharpness

Photographers believed for many years that film resolving power was just another form of grain, but this is not so. Resolving power is a characteristic of the thickness of the film emulsion coating: The thinner the coating, the better the resolving power. The explanation of this lies in the theory that the thicker emulsion coating will cause less separation between grain groupings, and resolution would be undesireable. The grain quality of a film is directly related to the film speed. As a rule of thumb, it can be said that the slower the film, the finer the grain pattern. Fine-grain films have ASAs of 32 and under; ASA 50 to 200

resolution

are medium-grain films with fast ASA ratings; ASA 250 and up are coarse-grain films. If a film is correctly exposed and properly processed, the grain characteristic will be consistent with the ASA. High quality grain patterns require fine-grain films.

density   The amount of silver deposited in a film, in terms of the amount of light that may pass through it after the film is exposed and developed, determines the density of the negative. A dense negative is one that is dark and restricts light travel. A thin negative is more transparent, allowing easy passage of light. Dense negatives have less opacity and, because of looser grain grouping, are less sharp. Dense negatives are grainier, with reduced separation between the grain particles, which reduces the resolving power and alters their sharpness. Film has a base density, or fog level, which is part of the film-speed determinants. The *base density* is the degree of gray in the film emulsion before it is exposed in the camera. The exposed and processed image is an increase of this base density. Slow, fine-grain films have weaker base densities than faster, coarse-grain films do.

high and low key   In addition to density, tonal ranges of negatives are also evaluated in terms of their key. High key values are the presence of very light or white tones. The gray scale is well above the midway point. Low key is the opposite, with a large proportion of the picture in tones of dark gray or black. Density does not always determine the key. High-key compositions are possible when the density of the negative is normal. The nature of the original tonal values of the subject determines the key. Yet, alterations of tonal key are possible by control of the negative's density. A medium-gray subject can be overexposed to increase the overall density and consequently the key of tone. Underexposure can reduce the gray scale and lower the tonal graduation.

Each and all of these film properties can contribute to the photographer's working scope. Two additional film characteristics which one should be aware of are *contrast* and *gamma.*

contrast   The degree of difference in tone between the lightest and darkest areas in a negative is called "contrast." Negatives that contain a close range of tone from the lightest to darkest are dense, or heavy, images. Negatives with a wide separation of tones or contrast are referred to as being thin. Normal negatives have a contrast range from pure black to pure white, with a full scale of gray.

The view camera with its larger film size is by far the best choice for sharpness, clarity, and grain quality. When the picture composition permits the luxury of time necessary for view-camera technique, the resulting photograph will contain the highest photographic quality.

Photojournalism has had a lasting influence on photographers and the films they use. In Mathew Brady's time, the film plates had to be prepared on the spot. A photographer using 35mm or 2¼ inch film today can carry enough rolls in his jacket pocket to take several hundred pictures. This picture of Omaha Beach, France, where the invasion of Europe during World War II was launched, is one of 200 pictures the author made during a two-day assignment.

No longer does the photographer have to select his situations to fit his equipment and materials. He can take advantage of all picture possibilities by choosing the film that combines with his camera and lighting to cope with the situation.

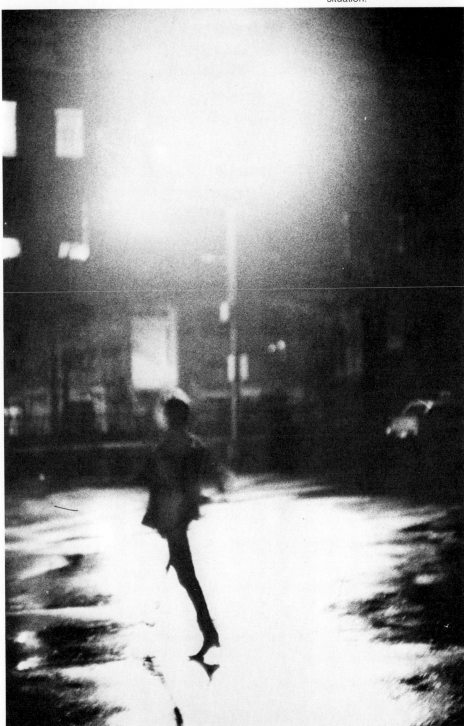

Thin-based film emulsions are fine-grain, and when used with a fine-grain developer, they will record with infinite detail and sharpness compositions such as this bell and brick wall.

gamma   Gamma is the degree of contrast in a negative when judged in relationship to the original subject's tonal values. When a negative is said to be 0.8 gamma, it means the film contrast is eight-tenths the original contrast of the subject. A 1 gamma indicates that the film contrast and the subject contrast are equal.

Film materials exist for the one purpose, to make photographs. Knowing the limitations and characteristics of the film in use equips the photographer with full control of his materials. Failure to learn these features restricts the photographer both creatively and mechanically. The best method for learning how a film responds is to use it. Whether the properties are equal to the uses one wants to make of it is determined by using the film. Try it in all situations. Evaluate the images. Extensive use will let the photographer determine whether a film suits his purposes or not. It is advisable to fully explore a film before moving on to another one.

1    What was the "Whatsit Wagon" and why was it important?    **questions for review**

2    Who introduced dry-plate films?

3    When was the first flexible film introduced and what was its effect?

4    What two cameras influenced the evolution of film?

5    What does the term "panchromatic" mean?

6    Name the characteristics of film.

7    What is ASA and how it is used?

8    What is grain in film and how is it important?

9    What is meant by "resolving power" in film emulsions?

10   How does film density influence the quality of a picture?

11   What is contrast in film images?

Caulfield, Patrica:  *Complete Guide to Kodachrome II,* Universal, New York, 1962.    **selected readings**

Crooms, R. J., and F. G. Clegg:  *Photographic Gelatins,* Focal Press, London, 1965.

Deryagin, and S. M. Levi:  *Film Coating Theory,* Focal Press, London.

Gorokhonshii, and Levenberg:  *General Sensitometry,* Focal Press, London, 1965.

*Life* Magazine, vol. 36, no. 17, p. 158, Time, Inc., New York.

Mees, C. E. Kenneth:  *From Dry Plates to Ektachrome Film,* Ziff-Davis, New York, 1961.

Neblette, C. M.:  *Fundamentals of Photography,* Van Nostrand, Reinhold, New York, 1969.

Newhall, Beaumont:  *The History of Photography,* Museum of Modern Art, New York, 1949.

photographic equipment

TABLE 6-1
BLACK AND WHITE FILM

| Name | Manufacturer | ASA | Size |
|------|-------------|-----|------|
| Isopan Portrait | Agfa | 80 | Sheet |
| Isopan FF | Agfa | 20 | 35mm; roll |
| Isopan Ultra | Agfa | 250 | 35mm; roll, sheet |
| Isopan Record | Agfa | 650 | 35mm; roll, sheet |
| Isopan ISS | Agfa | 100 | 35mm; roll, sheet |
| Arrow Pan | DuPont | 160 | Sheet |
| High Speed Pan | DuPont | 160 | Sheet |
| Superior Press | DuPont | 200 | Sheet |
| X-F Pan | DuPont | 64 | Sheet |
| Commercial | DuPont | 25 | Sheet |
| Verichrome Pan | Eastman | 80 | Roll |
| Plus X | Eastman | 125 | 35mm; roll, sheet |
| Tri-X | Eastman | 400 | 35mm; roll, sheet |
| Panatomic X | Eastman | 32 | 35mm; roll, sheet |
| Royal-X Pan | Eastman | 200 | Roll |
| Royal Pan | Eastman | 200 | Sheet |
| Panchro-Press B | Eastman | 125 | Sheet |
| Super XX | Eastman | 100 | Sheet |
| Portrait Pan | Eastman | 50 | Sheet |
| Royal Ortho | Eastman | 200 | Sheet |
| Superspeed Ortho | Eastman | 50 | Sheet |
| Commercial | Eastman | 20 | Sheet |
| Neopan SSS | Fuji | 200 | 35mm; roll |
| Neopan SS | Fuji | 100 | 35mm; roll, sheet |
| Neopan 8 | Fuji | 50 | 35mm; roll, sheet |
| All-weather | GAF | 80 | Roll |
| Superpan Press | GAF | 125 | Sheet |
| Super Hypan | GAF | 500 | 35mm; roll, sheet |
| Versapan | GAF | 50 | Sheet |
| Super Hy-Ortho | GAF | 250 | Sheet |
| Triple-S Pan | GAF | 200 | Sheet |
| Pan F | Ilford | 50 | 35mm |
| HPS | Ilford | 400 | 35mm; roll, sheet |
| HP-4 | Ilford | 200 | 35mm; roll, sheet |
| FP-4 | Ilford | 125 | 35mm; roll, sheet |

Rothstein, Arthur: *Creative Color,* Chilton, Philadelphia, 1963.

Rott, Andre, and Edith Weyde: *Photographic Silver Halide Diffusion Process,* Focal Press, London, 1972.

Woolley, A. E.: *Photographic Films and Their Uses,* Chilton, Philadelphia, 1960.

Zelikman, V. K., and S. M. Levi: *Making and Coating Photographic Emulsions,* Focal Press, London.

The functional characteristics of film are grain, contrast, resolution, density, sharpness, overexposure, underexposure, high key, and low key. A creative photographer must be aware of all these tools. The apple shown here on a child's slide is a high-key effect—the tonal scale is toward the light-to-white range.

TABLE 6-2
COLOR FILMS

| Name | Manufacturer | ASA | Size |
|------|--------------|-----|------|
| Agfachrome 50s | Agfa | 50 | 35mm; roll, sheet |
| Agfachrome CT18 | Agfa | 40 | Sheet |
| 64 Color Slide | Ansco (GAF) | 50 | 35mm; roll, sheet |
| 500 Color Slide | Ansco (GAF) | 500 | 35mm; roll, sheet |
| Kodachrome II | Eastman | 25 | 35mm; 828, 126, sheet |
| Kodacolor | Eastman | 32 | 35mm; roll |
| Ektacolor | Eastman | 32 | Sheet |
| Ektachrome | Eastman | 32 | 35mm; roll, sheet |
| Ektachrome HSP | Eastman | 160 | 35mm |
| Dynachrome 25 | 3M Films | 25 | 35mm |
| Dynachrome 64 | 3M Films | 64 | 35mm |

Claude Rains is shown photographed in low-key lighting on fast film. The creative photographic image is the union of film, lighting, exposure, and space usage.

# chapter 7

## lighting and how to control it

Light is the most essential element of photography. Everything else—the camera, film, composition, subject—is meaningless without the availability of light to activate the process. If you doubt this statement, try taking a photograph of any subject in a completely blackened room. No light, no picture.

The photographer must learn to recognize and actually master lighting to use photography creatively. Daylight, nighttime, and artificial light each create exciting designs, patterns, and compositions. But one has to recognize the values of lights and shadows formed by the source of lighting to use them effectively.

**daylight**  Without doubt, the lighting most used in photography is daylight. The sun is the one source that everyone recognizes as bright enough to take pictures. But even the sun is a light source over which considerable control might be exercised. The first concept of using sunlight for photography is to place one's back to it. With the sun behind the photographer, the light produces a near shadowless image. This idea of putting the sun behind the camera was conceived when lenses were not of good quality nor corrected for color saturation. In fact, the use of sun shades was not practiced. If the sun accidently entered the lens as the picture was taken, the flare usually ruined the image. The purpose of placing the sun behind the photographer was twofold: It was a safe lighting technique, and it gave protection from pictures ruined by flare. But its limitations drastically reduced the creative applications of lighting by sun.

There are two kinds of sunlight: bright and shaded, or diffused. Both are good light sources that should be mastered by photographers who want to work out of doors.

bright sunlight  Bright, or direct, sunlight is intense and harsh. The brilliance of the sun penetrates dark regions and highlights light areas. From sweeping landscapes to close-ups of faces, sunlight wraps the subject in highlights and shadows. The control of these lights and darks is of primary concern for the photographer. Too much sun will eliminate tone and detail in the highlight areas of the picture and possibly overexpose the film. Too little light in the shadow areas will minimize the details and cause a blackening of areas which need some tonal detail. There are, of course, times when both the overexposure and underexposure might be useful, but generally one must achieve a balance between highlight and shadow.

In addition to placing the sun behind the photographer, two other positions of the sun will produce quality effects: crosslighting and backlighting.

crosslighting  The pattern of light formed when the sun is to the side, or at a cross angle from the camera, is primarily a highlight design with the shadows being used to model contours. With the light hitting the subject at an angle, the texture of the surfaces is more visible. Crosslighting depends on the play of lights and darks for its lighting motif. To determine the angle from camera to sun to subject, draw an imaginary line to the three points. This angle must be at least 45 degrees for the proper effects of crosslighting. Of course, if the angle goes to 90 or

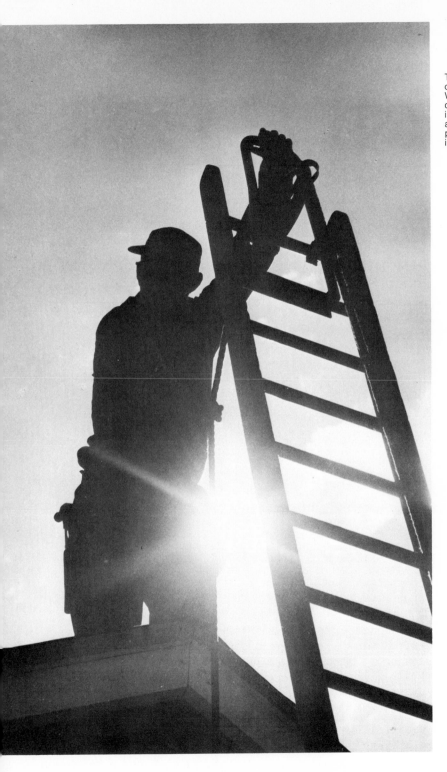

The sun is the greatest source of lighting for photography. Whether used as part of the composition or for illumination, sunlight has been and will continue to be the photographer's most important lighting ally.

When the sun has set into an afterglow at twilight, there is enough light for photography. Combine the quality of twilight with night lights and you have the makings of good pictures. This scene of the pyramids in the distance and Cairo, Egypt, in the foreground is enhanced by the combination of lighting sources.

130 degrees, the lighting will change. For example, if the angle is 90 degrees, the sun is overhead, and its effects usually are not pleasing — the shadows are short and uninteresting. When the angle increases to 130 degrees, shadows are longer and more dramatic. Texture is stronger, but the shaded areas increase to dominate the tonal design of the picture. Crosslighting, which is intended to show the strength of both highlights and shadows, should fall within a 45 degree angle.

With crosslighting, care must be taken to expose the film properly. Underexposure or overexposure can cause undesirable alterations in

the ratios of light and shadow. Overexposure of the film will cause the highlights to "wash out," voiding both details and tonal values. Underexposure will deepen high tones and cause shadows to become less transparent so that no details are visible. There are times when either of these effects could be dramatic, but usually highlights should be properly exposed when crosslighting is used.

The most dramatic sunlight effect is backlighting. It is a direct violation of the idea that the sun be placed in back of the photographer. For backlighting, the sun is directly in front of him. The subject of the picture is between the camera and the sun and is backlighted. There are many motifs of lights and shadows which might be accomplished with backlighting.

backlighting

The silhouette is the obvious result when putting the subject between the sun and the camera. There are degrees of tonal values even with a silhouette. The sun might tip over into some area of the subject, producing a highlight on the near side of the camera. Or a reflecting surface might cast light on the near side of the subject, thus allowing the dark side to become transparent and detailed. By moving either the subject or the camera only slightly, a rim of light could be formed along the profile of the subject. The sun is still in front of the camera, but the silhouetted shape is rimmed with light, or outlined with highlight.

Another variation of the backlighting approach is to allow the light to burst into the composition. Very strong and dramatic effects are possible when employing the sun as one of the elements of compositional design. The bright burst of light might be used to outline the subject, to fill an empty sky, or to create a mood.

Exposures for backlighting are at best difficult. One must determine the most significant statement to be made and expose for the compositional elements which communicate that statement. If the silhouette is the most important design, the exposure would be for the sun. If the semisilhouette is the objective, exposure will be determined from the reflected light on the shadow side of the subject. Using the sunburst as part of the picture makes the choice of exposure difficult. The safe approach is to make several exposures at different settings.

In addition to using the direct rays of sunlight for lighting, there is also the choice of using indirect, or diffused, sunlight. It produces soft shades of gray and a flat effect.

diffused shade

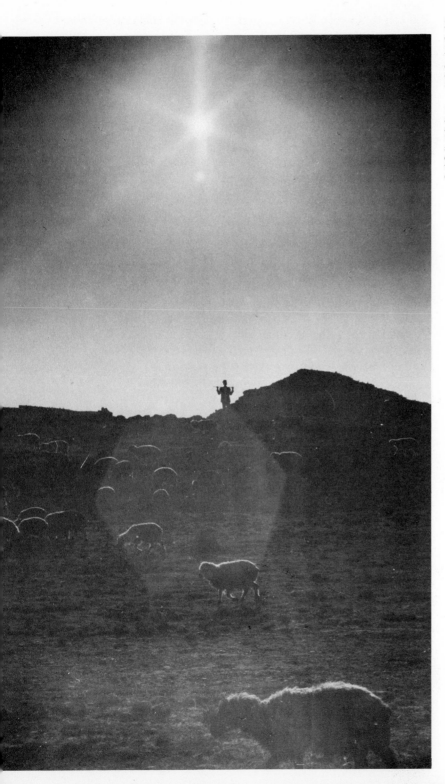

*Photo on opposite page:* A very dramatic picture of a little girl and her dog, made by using a line lighting effect. The light source is from a cross angle and almost constitutes backlighting. **John Sanford.**

Underexposing slightly to achieve a night effect, the author photographed this Iranian shepherd using the sun as part of the composition. A deep-orange filter helped create the night effect.

shaded light   The soft light which is to be found beneath the limbs of a tree is a prime example of shaded light. Even on days when the sun is unusually bright, a soft contrast of lighting is easily accomplished by moving into the shade of a tree. The same kind of light is also to be found on the shaded side of a building. Any overhead covering will stop the direct light rays. The light will then enter indirectly and softly. If there is no existing overhead cover, it would be a rather simple task to make one. Cheesecloth, for instance, can be stretched over a frame and held between the sun and the subject to diffuse the light. If nothing else is handy, cut some branches from a bush or tree and bundle them together over the subject to soften the light.

Sunlight may also be used in diffused form when photographing an area where the sun enters indirectly, such as doorways, archways, porches, and windows. If the light entering through these areas is direct, it must be handled as direct light; but if it is soft and flat, it will possess the same qualities of tone as shaded light.

Exposure for shaded or diffused sunlight is determined by an exposure meter. If the meter is attached to the camera, extreme care must be taken not to let the reading include the brightness of the sun outside the shaded area. For example, if the subject of the picture is sitting beneath a tree and the light is shaded, the area behind the subject will probably include the space between the bottom tree branch and the ground, where the sun is very bright. The meter is looking beyond the subject to the strong sunlight, and it will register that light, too. To avoid including unwanted light, move close to the subject and read only the light reflecting from its surface.

Every subject can be photographed in shaded light, and for many it is the preferred light source. The flatness of the light reduces reflections, which is desirable in many situations. The softness of diffused light is flattering to a young face, as there are no major problems with overly harsh shadows which might cause the illusion of long noses, fat chins, or rough skin.

**available light**   Available light refers to light sources which are present and over which the photographer has no control. It may or may not include the sun or studio lights. The chief factor is whether or not the photographer must make his pictures using the light available to him without controlling its source.

Available-light photography might be accomplished outside or inside, day or night. The source of light could be anything: car headlights,

candles, matches, flashlights, ceiling lamps, or even radioactive isotopes. The usual sources of light include lamps, tungesten lighting, sunlight, streetlights, and stage or studio lighting. The photographer must work within the limitations of the existing lighting. Composition and exposure will be determined by the effect and adequacy of that lighting.

When photographing with available light, the compositional design is more often than not based on the lighting itself. How the light affects the subject, how it forms patterns or designs, and how it illuminates the dimensions of the area are all important to the photographer as he makes his selection of elements which will compose the picture. Of course, the most important factor is the intensity of the light. Is it adequate for exposure? Only an exposure meter, or years of experience, will answer that question. If the exposure meter is used, the low light level must be taken. If the reading indicates that an exposure is possible, fine; but if the meter does not respond and an attempt at the picture is still desired, one takes his chances.

In low-light situations where the meter does not record enough light for a reading, the only way to photograph the scene is to take several exposures with various settings of lens and shutter in the hope that one will be right. All photographers have experienced this situation. By attempting the picture, nothing much is lost, but much could be gained. If it is tried, the results could be creatively and emotionally satisfying. When exposures for a low-light situation are attempted, the largest lens opening on the camera should be used. The shutter speeds should be progressively slower. For example, if f:2 is the fastest lens, that setting should remain constant. The first shutter speed combined with the lens would be 1/10 second. The next setting would be 1/2 second, followed by 1 second. If the lighting is really weak, a longer exposure could be tried.

Today cameras and lenses are designed with available-light shooting in mind. Fast lenses and slow shutter speeds are even to be found on inexpensive cameras. Combine the lens and shutter settings with the large variety of fast films available, and available-light photography is about as easy as outdoor photography was a couple decades ago.

Available light is not always low level and difficult to use. Because it encompasses all light that exists, its range is great. In most instances available light will be measurable with an exposure meter. Because light intensity will be high enough for instanteous exposures, the use of available light for taking portraits, still-life studies, and copying flat material such as paintings is frequently used.

How does one learn available-light photography? There is only one answer: Take pictures. Take pictures in as many lighting situations as possible. Make mental and perhaps written notes of the conditions that exist. Remember how the lighting affected you. Later, see how the light affected your film. Compare the image you had mentally recorded to the one the film recorded. If there is a great separation between the two, analyze the film product to determine where the differences might be. The real image of the film must be compared with the imaginary image. Only then can the experience be useful in the future. After several attempts, and probably as many failures, the photographer builds a base on which to make judgments about lighting and the projected results. But the photographer must not be inhibited by the fear of failure—from failure the knowledge for success will emerge.

**nighttime photography**

Probably no other lighting and photographic experience offers as much pleasure of discovery and success than night photography. When the sun can no longer be the source of illumination, it is not necessarily the end of the photographic day. As the lights of night are turned on to illuminate everything from the corner of your neighborhood street to the vastness of Times Square, fascinating things happen. Scenes and places which were unnoticed in daylight become strangely interesting.

There are several techniques which enable successful night photography. Three of these techniques are the most used and produce the best results with the least difficulty. They are (1) depth of field, (2) shoot and double, and (3) overexpose and underdevelop.

depth of field

Using the depth-of-field technique is not unlike available-light photography. The exposure will be short, even a fraction of a second. The desire is to have as much sharpness in the main area of the composition as possible. Focus on the important point in the picture. By checking the depth-of-field scale on the lens in use, it is possible to select a lens opening that will give a maximum depth of sharpness. If a scene is in an adaquately lighted commercial part of town, the main point of the picture might possess better than average lighting. If the main point is at 10 feet or more, there is a strong possibility that a fast lens setting can be used and still produce a good depth of sharpness. By checking the depth scale on the lens, it is possible to determine that f:4 will give a depth of sharpness from 7 to 12 feet, if the lens is a 50mm f:2. The shutter speed will be selected to match the lighting and the f:4 setting.

Seven styles of lighting are shown here and on the three following pages: flat, 45-degree, loop, 90-degree, line, glamour, and back.

Frontal Lighting

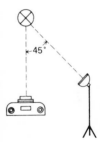

45-degree Lighting

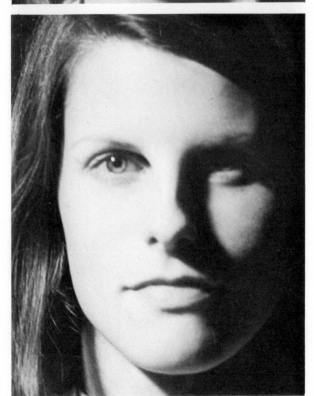

Glamour Lighting

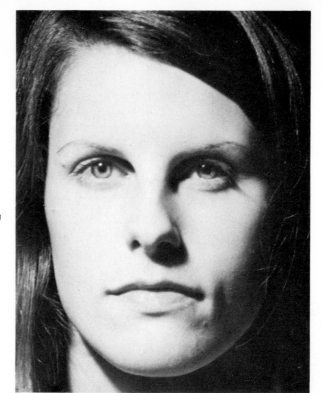

90-degree Lighting

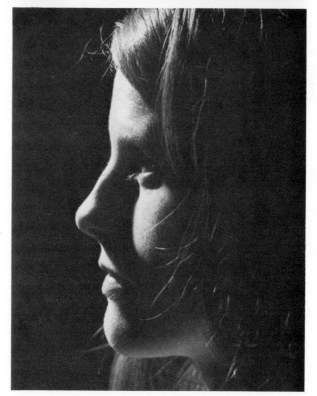

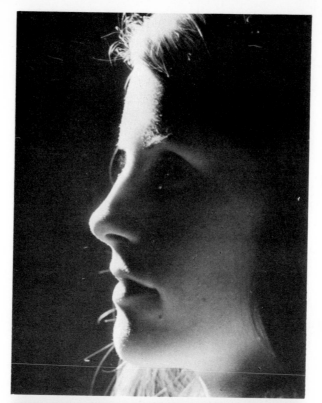

Rim Lighting

Glamour Lighting

Backlighting

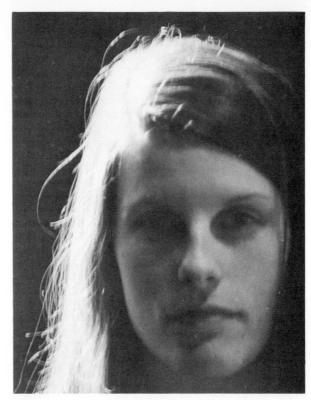

shoot and double

If the depth-of-field technique seems inadequate for a wide variety of situations, the second technique (which can be combined with the depth-of-field technique) will broaden the scope of coverage. This is the shoot-and-double technique: One exposure is taken, and the next one is double that of the first; the third exposure is double again, and so on. If the first exposure is 1 second, the second would be 2 seconds, the third would be 4, and so on. When the exposures grow to many seconds, the technique requires patience. There are even times when a situation might require a full minute for the first exposure.

This technique makes no attempt to control the processing of the film. Normal development is used. If all has gone well, there will be at least one exposure that is proper.

When the shoot-and-double technique is used, one additional piece of equipment is required, a tripod, or support for the camera. The camera must be steady. A small tripod, which is easily carried, is excellent for work with small cameras such as 35mm, 2¼ x 2¼, or even 4 x 5. For the larger cameras a bigger, more burdensome, tripod will be necessary. Unless there is some reason that a large film size is required, nighttime photography is more fun and more easily accomplished with small-format cameras.

A tripod is also necessary for the third nighttime photographic technique—which is probably the most demanding—the overexpose-and-underdevelop technique.

The overexpose-and-underdevelop technique combines two approaches. The scene is exposed to the maximum, taking advantage of all available light. In practice this would mean that a scene which could possibly require an exposure of ½ second at f:2 would be exposed at an exposure of several minutes at f:22. In this technique one of the prime objectives is a maximum depth of sharpness. Therefore it is mandatory that a small lens opening be used. F:stops of 2 or 4 or even 5.6 will not produce the depth of field for optimal sharpness. Unless the light is either concentrated or intense, this technique never uses

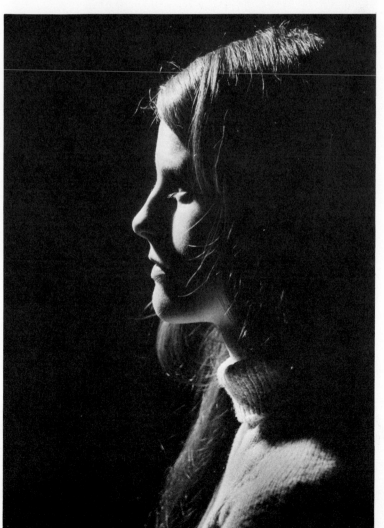

90-degree (cross) lighting. Notice how the light-colored sweater reflects light under the chin. The sweater serves as a fill-in light source.

Cross Lighting

Soft, more even lighting may be accomplished by bouncing the light source off a nearby surface. The reflected light reduces shadow density while retaining brightness of the illumination. A slight adjustment in exposure is necessary to compensate for the softer light volume.

Bounce Lighting

exposures of only a few seconds. The use of a small f:stop necessitates at least a minute of exposure time. Actually, the exposure time is of consequence only so long as it is enough to record everything within the compositional scope of the lens angle. The more exposure, the more successful will be the second half of the technique.

A film that has been fully exposed under nighttime lighting conditions is developed by inspection. The film is processed in controlled darkroom conditions, and the photographer can inspect the density of his film as it is developed. Development by inspection is fully discussed in Chapter 10. For now, remember that the overexpose-and-underdevelop technique requires more than merely making exposures. Of the three nighttime photographic techniques, this one produces photographs of greater detail and wider tonal value than the other two techniques do.

Any of these three nighttime techniques can produce quality pictures, but be advised that the negatives will appear thin or lacking in tone and detail. When looking at the processed film one should not be discouraged by the lack of image in a large portion of the composition.

Unless there was intense light on the scene, a large percentage of the composition will be blank.

A photographer can learn to structure lighting styles so that various light and shadow patterns are created by the placement of lighting sources. And he can create styles by his placement of the model when the lighting source is stationary, as the sun is. The styles can also be created with existing or available light. The ability to structure lighting to one's own needs and desires is perhaps the single most important characteristic that a photographer can develop. And when the structuring of light is restricted, the ability to recognize the play of light and shadows and what they form becomes the photographer's next best asset.

**how to control lighting**

A Finnish reindeer race is given a stronger lighting effect because the photographer used backlighting. The snow has texture and the reindeer and skier have depth because of the shadows.

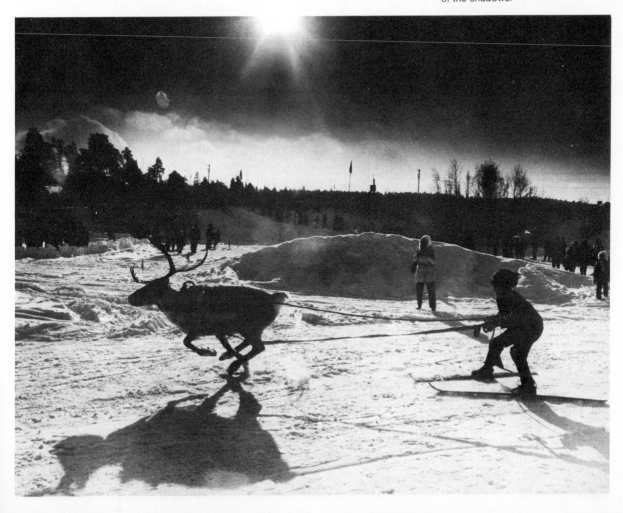

**seven styles of lighting**

We will now identify and define the basic lighting styles that serve photographers most frequently and usefully.

frontal lighting

When the light is directly in front of the subject and at about the same elevation, the lighting style is frontal. A flash on the camera is an example of frontal lighting. To construct this style of lighting the light source is placed in front of the subject and pointed full strength toward the head. All shadow or modeling of the face is eliminated by the fullness of the light. If the subject is close to a background, its shadow will be projected onto the background. Frontal lighting is not the most flattering style of lighting, but it is useful in situations where the drama of light and dark tones can be ignored. There are times when frontal light serves as fill-in light for another main source of lighting, such as backlighting or sidelighting.

Available light is any light present when the photographer wants to take pictures. Hands of a mental patient are given increased texture because of the backlight effect from available room light.

Light that comes from behind the subject is backlighting. The effects of backlighting can be total silhouette or a circle of light around the head. The lighting style can be used independently or in association with another style. In portrait photography backlighting is usually a supportive light rather than a principal light. The light source can be on the same elevation as the subject or it can be higher or lower. This style of lighting is formed by having the subject between the light source and the camera.

<div style="text-align: right">backlighting</div>

A light source that is to the left or right of the subject and that strikes the subject at an angle is sidelighting or crosslighting. The light source can be above, below, or level with the subject. This style of light is most often used independently; or, when used with other lighting, it is the main source of illumination. The important effect of sidelighting is the accentuation of textures. The angular position of the light emphasizes the textural effect of the subject. This style of lighting results in strong play between light and dark.

<div style="text-align: right">sidelighting or crosslighting</div>

This style of lighting is a specific application of sidelighting. The position of the light source is at the same level as the subject and at a 90-degree angle from the camera. The pattern of highlights and shadows formed by this style of lighting will vary as the head is turned. If the head is straight to the camera, the light and dark pattern will cut the face in half. The side nearest the lamp will be highlighted, while the side away from the lamp will be in shadow. This effect is called "hatchet light" because it cuts the face in half tonally. Another interesting effect is achieved by facing the subject toward the lamp. Still another effect results from turning the face one-quarter toward or three-quarters away from the lamp. Each of these produces strong shadow and light patterns.

<div style="text-align: right">90-degree lighting</div>

This is one of the basic and most useful styles of lighting. To form it, the lamp is placed at an angle 45 degrees from the camera via the subject. The lamp is above the head at about a 45-degree angle from the floor to the subject to the lamp. When the lighting is correct, there is a small triangle of highlight on the cheek away from the light. The triangle should extend from just below the eye to just above the corner of the mouth. If the highlight does not form this triangle, the lighting is incorrectly placed. The side of the face nearest the lamp will be fully illuminated. The far side of the face will be in shadow except for the triangular highlight. To soften or lessen the depth of the shadow area

<div style="text-align: right">45-degree lighting</div>

Studio lighting over which the author had complete control was used to create this line-lighting portrait of a man and his pipe. A fill-in light was used to achieve a 4-to-1 ratio of dark tones to main-light brightness.

another light is used. This light is called a "fill-in" and will be discussed later in this chapter.

glamour lighting  The lamp is placed near the camera and elevated to form a small shadow beneath the nose. This eliminates all shadow but the minimum of tone that lies beneath the nose and under the chin. The face

is fully lighted but is modeled by the nose shadow. Cheekbones are usually accentuated with this style of lighting. Care must be taken not to have the lamp too high. This will form dark sockets around the eyes. Glamour lighting is effectively used with backlighting, when backlighting contributes highlights.

This is another variation of sidelighting. The lamp is beyond the 90-degree angle and more toward the 120-degree angle. The subject is facing about 45 degrees away from the camera in the direction of the lamp. The lamp is head high. Light falls on the part of the face profile that is visible to the camera, and it forms a strong highlight along the features. The light is "rimming" the profile, and the remainder of the face is in dark shadow. To "open" the shadow and show detail, a fill-in

rim, or line lighting

No fill-in of any kind was used in this backlighted line effect of two teenagers nose to nose. **John Bauer.**

light is necessary. Other lighting styles may be combined with this one for interesting effects. Backlighting, 90 degree (on the opposite side from the rim-lighting source), or sidelighting (also from the opposite side) can offer supportive lighting effects.

fill-in lighting A fill-in light is a lighting source that is supportive to the main source of illumination. True to its name, its role is to add light when the main lighting source has formed a dark shadow. The fill-in light is used to "open" the dark tones and permit detail to be visible. The amount of fill-in light needed depends on the photographer and his intent.

There are two ways to determine the fill-in light level. One is by sight; the second is with an exposure meter. Because of the wide latitude between what the eye sees and the sensitivity of film, filling-in by sight is at best haphazard. With experience, though, one can develop it to a level of accuracy that is as good as the second method. But it takes time to perfect, and one should not expect to master it in one or two sessions with lights.

*Lighting ratio* Using an exposure meter to determine the percentage of fill-in lighting needed is both simple to do and accurate. The ratio between the brightness of the highlights and the degree of shadow is measured. For example, if the ratio for a lighting structure is 4 to 1, the highlight is four times stronger than the shadow. A ratio of 2 to 1 means that the shadow is only 50 percent less bright than the highlight. To arrive at a particular ratio, the highlighted side of the subject is measured with the exposure meter with only the main light on. Let's say the footcandle level is 16 on the meter. The fill-in light will have to measure 4 if a lighting ratio of 4 to 1 is wanted. After the highlighted side is read, turn off the main lamp, and turn on the fill-in lamp on the shadow side of the subject. The light is head high. Move the lamp toward or away from the subject until the exposure meter records a light level of 4. Turn the main light back on. There will now be a strong highlight and a shadow side that is dark but transparent, showing detail. This same procedure is used to calculate any ratio of dark to highlight.

bounce lighting In addition to the lighting styles already discussed, one other approach is of significance: bounce lighting. As the name implies, the lighting source is bounced or reflected from a surface onto the subject. The reflective surface can be a wall, ceiling, a sheet of cardboard or newspaper, or a special reflector of aluminum foil.

A sampan shelter in Hong Kong is given a glistening effect by diffused sunlight. Slightly overcast clouds served as a natural diffusing screen.

The purpose of bounce lighting is to soften the contrast and harshness of direct lighting. By bouncing the light off another surface, one reduces both the contrast and the brilliance of the light. An overall soft quality that is highly complimentary to portraits results from bouncing the total illumination. Some photographers will use several lamps and bounce all of them from the walls and ceilings. There are studio photographers who build housings with wide seamless paper in which the subject sits. The housing is used to reflect all the light sources.

Whether the light source is photoflood, flash, electronic flash, or the sun, bounce lighting is a useful tool.

The styles of lighting which have been identified in this chapter are most often constructed with lighting sources of photoflood or elec-

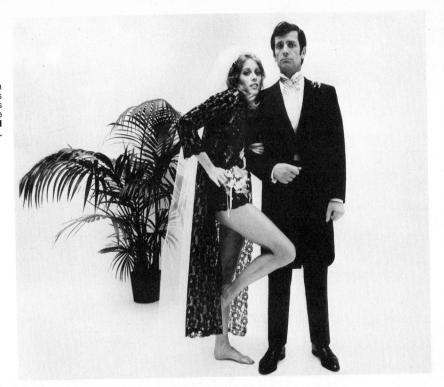

Diffused sunlight through studio skylight windows was used to illuminate this illustration for a magazine article on marriage. **Edward Pfizenmaier.**

tronic flash. They can be formed with ordinary house lamps or with the sun. Perhaps the most convenient and least expensive equipment with which to learn photographic lighting is photoflood bulbs. An expensive metal reflector or a flood bulb with a built-in reflector supported on a lightweight metal stand is all that is necessary for constructing the lighting styles discussed. One lamp is the main light, and the second light is the fill-in. Additional lamps can be used to support the effects of the first and second lights.

These styles of lighting are associated with portrait photography, but they are not used exclusively for that. Photographs of still-life subjects can also be taken with these lighting styles. The effect of texture from sidelighting is as dramatic with a flower as it is with a face. And backlighting a machine is perhaps even more dramatic than backlighting a face, especially if the fill-in ratio opens up the details of the machine.

Lighting construction, like most tools of photography, is under the photographer's control. The descriptions and diagrams for the lighting styles outlined here are for your information and understanding; they are guidelines of good lighting with scores of variations and combinations. Use and application will help you to decide which styles and

Night photography is one of the most challenging lighting effects a photographer may undertake. The author supported his camera against a lightpost to take this Parisian scene.

A tripod was necessary for this double exposure of fireworks and the Eiffel Tower. The shutter was opened, and a long exposure was made of the tower. During exposure, the fireworks were exploded and recorded. The negative was developed by inspection to ensure correct density.

A handheld 35mm camera used with fast film and a fast lens enabled the author to picture the Tokyo Ginza on a rainy night. The added element of wetness picked up highlights and brightened dark areas.

Lighting and the understanding of lighting are major assets in the photographer's assortment of tools. Mastery over lighting is absolutely necessary if one is to succeed creatively with photography.

combinations work best for you. But do not make final decisions about lighting until all styles of lighting have been used many times.

Be aware that lighting is all around you. When you are watching television, pay close attention to the formation of lights and darks on the performers. When attending a movie, observe the mood and design of the lighting. Or when you are sitting in a tavern be aware of the effects of the usually low light level. It is up to you to learn to use all lighting sources to your advantage.

**exposure and artificial lighting**

Determining the exposure for artificial lighting sources is both easy and important. Pointing the meter in the direction of the subject and reading the reflected light level is all that is required for overall light measurement. For more critical readings, the light sources are measured individually. First, the main light is metered; then, fill-in light is measured without the main light on. If supplementary lights are used, they too can be read separately. Measuring each light individually enables the photographer to know where the strength or weaknesses of his lighting arrangement might be. When all lights are metered, the overall reading is taken to establish the exposure setting for lens and shutter.

Care must be taken with particular lighting styles when reading the light level. When the light source is directed toward the camera and meter, the reading could be deceiving. The spill of light directly into the meter will cause an increased light level that is inaccurate for the amount of light that is actually hitting the subject. In situations such as this, the meter should be held close to the subject. Incident-light meters record the overall light level more accurately, but your incident attachment might not be available when needed.

If you ever have doubts about the accuracy of the exposure, shoot one exposure at the setting indicated by the meter. Shoot a second exposure one f:stop above the setting, and a third exposure one f:stop below the setting. Bracketing the exposure in this manner ensures a good negative.

**questions for review**

1    Name the three lighting effects most used with sunlight.
2    Identify the seven lighting styles which are possible both with sunlight and with studio lighting.
3    How can you soften direct sunlight? Why would you want to?

4    What is available light? How do you expose for it?

5    List three techniques of night photography.

6    Explain lighting ratio and why it is important.

7    How is a bounce light used?

8    Explain the roles of a main light and a fill-in light.

**selected readings**    Archer, Fred: *Archer of Portraiture,* Cameracraft, San Francisco, Calif., 1954.

Bischof, Werner: *Japan,* Simon and Schuster, New York, 1955.

Cartier-Bresson, Henri: *The Decisive Moment,* Simon and Schuster, New York, 1952.

——: *The Europeans,* Simon and Schuster, New York, 1955.

Deschin, Jacob: *35mm Photography,* Cameracraft, San Francisco, Calif., 1953.

Falk, Edwin A., and Charles Abel: *Practical Portrait Photography,* Amphoto, New York, 1959.

Jacobs, Lou, Jr.: *ABCs of Lighting,* Amphoto, New York, 1962.

Keepler, Herbert: *How to Make Better Pictures in Your Home,* Amphoto, New York, 1960.

Kinzer, H. M.: *Available Light,* Universal, New York, 1955.

Latham, Sid: *Available Light Guide,* Amphoto, New York, 1955.

Mannheim, L. A.: *Exposure,* Focal Press, London.

Mortensen, William: *The Model,* Cameracraft, San Francisco, Calif., 1956.

Murphy, Burt: *Complete Lighting Guide,* Universal-Amphoto, New York, 1962.

Parks, Gordon: *Camera Portraits,* Franklin Watts, New York, 1948.

Satow, Y. Ernest: *Taking Pictures after Dark,* Amphoto, New York, 1960.

Simmons, Robert: *Lighting in Photography,* Chilton, Philadelphia, 1959.

Stagg, Mildred: *Hal Reiff's Glamour Manual,* Amphoto, New York, 1960.

Stettner, Louis: *35mm Photography,* US Camera, New York, 1956.

Theisen, Earl: *Photographic Approach to People,* Amphoto, New York, 1966.

Williams, Herbert: *Camera Portraiture,* Focal Press, London.

Woolley, A. E.: *Night Photography,* Amphoto, New York, 1955.

——: *Photographic Lighting,* Amphoto/Hastings House, New York, 1970.

Wright, George B.: *Available Light and Your Camera,* Amphoto, New York, 1958.

# chapter 8

## preparing for action

Perhaps it would be appropriate in this chapter to indulge in a bit of personal reference. Operating the camera, with all the involvement that suggests, is a very personal thing. By offering some of my own methods of operation and philosophy of approach, you might understand the very individual nature of camera selection and operation.

In photojournalism, where the photographer is a reporter of news, there cannot be pure objectivity. The photographer's individual knowledge, education, and point of view—collectively or individually—dictate how he will see and photograph. Even the size of the camera he uses will direct, in a measure, the kind of pictures he will take.

Photography is a highly subjective art. Subjectivity begins with the choice of camera and continues through the selection of subjects to the making of the final print. The choice of one's camera and how he handles it when taking pictures certainly has a major influence on the kinds of photographs that will be made. The photographer who works with an 8 x 10 view camera mounted on a tripod is not going to photograph fast-moving action in a football game.

**let the camera speak**  I have always believed that photography required little or no verbal amplification. Either the photographer succeeds in recording a statement on film, or he fails. Either way, no amount of words would alter his attempt. Apologies for the fish that got away might console the angler, and the fish could take on dimension and interest in proportion to the story-telling ability of the fisherman. But the photographer— even if blessed with the oratory of Socrates—cannot disguise the success or failure in his pictures. The photograph is a physical product that can be studied in detail long after its subject has passed into history. Errors of judgment, timing, design, and technique are there for the viewer to see. Likewise, the qualities of success are visible. There is no hiding place, no embellished image, and no chance to create the picture after the moment is gone. One cannot return to the instant of interest. The photographer is totally dependent on his response to the event *at the moment it happens.* He must muster all his talent together in fractions of seconds to record the event. Mental and physical reflexes must be in perfect harmony; slowness of either can allow an occasion to pass unfilmed. Man and machine must function instanteously, or photography is reduced to simple likeness.

When I first became interested in photography, I was restricted in both knowledge of the process and money to spend learning. But neither of these detered my desire. The first camera I owned cost 69 cents, and film for it cost 15 cents a roll. The camera was an Eastman Baby Brownie. My early efforts as a teenager with this camera were at best poor records of the things I photographed. Within a few months after learning how to shoot and develop film, I had an opportunity to help a professional photographer who worked with an 8 x 10 view camera. Compared with my 2¼ x 2½ inch negatives, the 8 x 10 inch negative looked as big as a screen in a movie theatre. I learned how to use the big camera; filling the entire negative format, composing for just the right contents, and exposing correctly—the cost of film prohibited more than one or two shots of a situation. And discipline and control in all facets of camera operation developed with increasing confidence as I worked with the 8 x 10 camera.

**discipline and control**  The discipline of the big camera remained with me for a long time after. When work in portrait photography required a small-format film, the 5 x 7 inch negative became my choice. The 5 x 7 camera was not as big as the 8 x 10, but it had all of the controls: Focusing of the image was still done on the ground glass; both cameras demanded a tripod and were bound to the spot where the picture was to be taken;

The photographer's success depends totally on his response and reaction to an event at the moment it happens. Failure to be ready for action can mean lost images. Unlike the writer who has the opportunity to recreate, the photographer is restricted to a moment in time that will never exist again.

quickness of movement from one spot to another was impossible when working with either of these cameras.

The several years I worked with these two cameras helped develop a discipline for design and composition that is still very much a part of my photography. Having to fill the negative area in the big film was great training for filling the negative area of 35mm or other film formats. If it were possible to require all students of photography to begin efforts with the demands and discipline of the big-film cameras, I would. The training which these cameras impart is invaluable when the student finally selects the camera that he feels most comfortable working with.

Photographers trained to use a big-view camera retain the discipline and concern for design and space management regardless of the camera format used later.

**care of the camera**

You will never have greater frustration as a photographer than when a camera malfunctions at the precise moment you want to take a picture. The flash that does not flash, the shutter that refuses to trip, or the film that will not wind—these and many other minor but equally disastrous camera malfunctions can and do happen repeatedly. But they happen most often to photographers who do not take good care of their equipment. Your camera is a precise instrument, and it takes only a little abuse to make it misfire. Here are ten precautions which you can take to help guard against minor malfunctions of your camera.

1    Clean and dust both the inside and outside of the camera with a brush or soft cloth.

2   Exercise all shutter speeds at least once a month to ensure continued spring tension. If your camera has an automatic diaphragm, the exercise will aid lens controls.

3   Check the range finder.

4   Check built-in exposure meters by comparing them with a meter that is not attached to the camera.

5   Clean the flash contacts.

6   Keep the camera in a plastic bag when exposed to sand or salt water. Clean it immediately after returning from such exposure.

7   Fit a wool sock to cover the camera body for winter use. Wool will retain warmth inside the camera to keep the shutter from sticking.

8   Keep the lens cap on single-lens-reflex cameras with built-in exposure meters. This will preserve the battery.

9   Make sure the camera strap or shoulder strap is in good condition. A broken strap means a dropped camera.

10  Never force any lever or release. Forcing the shutter release or winding crank can cause major damage.

*1 Clean and dust camera*   It takes but little dust or foreign particles to cause a camera to malfunction. One speck of dust in the right place can produce a scratch on the film lens. A good habit is to dust both the inside and the outside of the camera at least monthly. If the camera is used a great deal, it should be cleaned weekly. A soft brush or cloth can be used on the outside, but a brush is best for the inside. When the camera is not in use, it should be in a protective case or plastic bag. Silicon bags are excellent to keep moisture at a minimum when the camera is in its case or bag.

*2 Exercise shutter*   One of the greatest causes of inaccurate shutter speeds is inactivity. If a shutter is not used, the spring tension is altered. Even if the camera is in use frequently, it is possible that *all* shutter speeds are not used, especially the slow speeds. Nonuse can cause the speed to change or the shutter to stick. One way to safeguard against sticking or incorrect shutter speeds is exercise. At least once a month you should work every shutter speed ten or fifteen times. Set each speed in rotation and trip the shutter. Then alternate or interchange the speeds so that a fast, then a slow, speed is set and tripped. This operation only takes a few minutes but it can save weeks if the camera has to go to a repair shop. One last word of caution: Never leave the shutter cocked. When you have finished taking pictures,

Handheld small-format
cameras offer a greater
mobility. Concept, vision,
selection, and response take
only a fraction of a second.
A camera that is mechanically
ready enables recording
instantaneous reactions like
this woman in her
environment.

press the shutter to release the spring tension. If the roll of film is not fully shot, don't advance the next exposure, which will automatically cock the shutter. When the roll is fully shot and taken out of the camera, press the shutter before storing the camera. If you use your camera a lot, it is also a good practice to have the camera checked every eighteen months.

*3 Check range finder*   The range finder is one of the moving parts of the camera that continues to function even when it is faulty. A hard knock will make it incorrect. There are lens-testing charts to aid the job of determining the accuracy of focus. But if these are not available, a sheet of newspaper will serve the purpose. Spread a double sheet of newspaper and attach it firmly to a wall. Set the camera at the closest focusing point for the lens to be tested. Focus critically. Move the camera back 10 feet and focus sharply. Each time the point of focus is the center of the paper. After processing, the negatives are inspected with a magnifier, or printed, to determine if the image is sharp from corner to corner. If it is not, one of two things is wrong: Either the range finder is working incorrectly, or the lens is not properly seated to the camera body.

*4 Check built-in exposure meter*   Periodically you should check the readings of the built-in meter with the readings of another meter. Because built-in meters directly affect the exposures, they must be accurate. Frequent comparison to a standard meter will safeguard against incorrect exposures. Meters are very sensitive and subject to damage by slight knocks. Bumping into a door with the camera can be enough of a shock to render the meter inaccurate.

*5 Clean flash contacts*   Occasional rubbing of external flash contacts with a fine emory cloth will remove foreign particles which could insulate the contacts. If flash pictures are taken only rarely, there is more reason to clean the contacts.

*6 Keep camera in plastic bag*   Sand and salt water are two of the greatest causes of camera damage. It also happens that the beach is one of the places where photographers like to work. When the camera is not in use, it should be protected by a plastic bag. If the camera is subjected to sand or salt water while in use, it *must* be cleaned immediately. Sand can affect all moving parts, and salt will corrode all metal parts. Either will produce enough damage to send the camera into repair for weeks.

*7 Fit wool sock on camera body*   Winter weather will make a shutter freeze and film break. Very cold temperatures will make both happen quickly. To protect against these hazards, a wool "coat" can be cut from a sock. Fit the coat snugly so that it does not interfere with the camera controls. The wool will help hold the heat from your hands and slow down, if not eliminate, shutter freezing and brittle film. One additional measure for winter protection is keeping the camera inside your coat and next to your body until immediately before use.

*8 Keep lens cap on*   For single-lens-reflex cameras, the lens cap protects the lens while eliminating the danger of trying to take pictures with it in place. Range-finder cameras do not focus through the lens as do single-lens-reflex cameras, and the lens cap can be in place without the photographer's realizing it is there. Many "great pictures" have been taken with the lens cap covering the lens. The caps are protection for the lens. They can also be nightmares for photographers. Always be aware of the lens cap whether you have a range-finder or a single-lens-reflex camera. For the single-lens-reflex camera with a built-in exposure meter, the lens cap serves another very important role: It closes out light to the meter and preserves the photoelectric battery, which is the energy for activating the meter. Left uncapped, the battery will exhaust its strength quickly. The unprotected battery could go dead in the middle of an important photographic session.

*9 Check for sound camera straps*   Many fine cameras have dropped to the bottom of the river because a camera strap broke. (I have one resting in the Pacific Ocean just off Oahu.) But a fall from your shoulder to the sidewalk is enough to send the camera into the repair shop. Both the connections and the strap should be checked periodically to eliminate the possibility of accidentally dropping the camera.

*10 Never force levers or releases*   If one of the working parts such as the shutter release or winding levers suddenly becomes tight and very difficult to move, do not force it. There is probably good reason that it is tight. Forcing it will only compound the trouble and lead to further damage. Inconvenient as it might be at the time, take the camera out of use. The repair shop is the only place for a camera with damaged parts.

**the ready camera**   Many photographers carry a camera everywhere they go. A camera over their shoulder is as natural to them as their clothing, and they feel only partially dressed without their cameras.

On the other hand, some photographers never carry their cameras unless they are out to take pictures. Once the assignment is finished, the creative energies are cut off.

Somewhere between these two examples of photographers fall the majority. The camera is with them most the time, but not all the time. When it is carried, it is ready for use. Here are some guidelines for having the camera ready and some techniques for operating it with a minimum of adjustments at the moment of exposure.

The first act is to load the camera. When starting out, the camera should be loaded with the film you intend to use. Never wait until something is happening to put film in the camera. Load the camera in shaded or indirect lighting. The film can fog if you load it in direct sunlight. If you have no choice but to load the camera in sunlight, reduce the danger of fogging by turning your back to the sun and forming a protection for the camera with your body. Hold the camera close to your stomach while loading.

**load and preset**

For cameras without automatic exposure meters and lens controls, the exposure controls of lens and shutter are preset before starting out. A meter reading for the average light is taken and the corresponding lens and shutter readings are set. For automatic-lens cameras, the exposure-meter ASA is set, and the desired shutter speed is selected. That leaves only the lens to be set, which is done automatically.

Focus is the next concern. With single-lens-reflex cameras, viewing and focusing is done through the same lens. It is not too difficult to see, select, focus, and shoot when all are contained in one housing. For range-finder cameras or for twin-lens-reflex cameras, where viewing and focusing are not in the same housing, the task of shooting quickly is more difficult. In such cases the technique of hyperfocal-distance shooting is the answer.

*Hyperfocal-distance shooting*  The principle of hyperfocal-distance shooting is the presetting of all camera controls: lens, shutter, and focus. Elimination of concern for these controls permits total concentration on the composition of the picture. Attention to the action of the picture is particularly important if the scene is a street scene, such as a parade or a demonstration.

With hyperfocal-distance shooting you are presetting the camera in order to eliminate focusing everytime a picture is taken. Actually you are making a fixed-focus box camera. The technique is intended to give optimal sharpness for the greatest amount of picture situations.

Street photography depends on an alert eye and an activated camera. Presetting the camera for exposure and focus reduces the chances of missing a picture due to camera adjustments.

Using the hyperfocal-distance
technique will make a camera
function as a box camera.
Pictures such as this Iranian
woman hiding behind her
chador are lost if time is
wasted setting exposure and
focusing.

Henri Cartier-Bresson is the master of street photography. He works quickly and confidently. There is no lost time with camera adjustments. Cartier-Bresson's eye is in perfect tune with his camera action. A successful street photographer and his camera must function instantaneously. **Henri Cartier-Bresson.**

Whether the photographer uses a big camera or a small one, he should have a checklist of things to examine to ensure that his equipment is always working properly.

The principles of
hyperfocal-distance shooting
are just as applicable at night
as during the day.

Some photographers carry a
camera everywhere they go.
A camera over their shoulder
is as natural as the clothes
they wear. Many great
pictures have been made by
photographers who happened
to have the camera with them
on the scene when an event
occurred.

For fast-moving action that is repeated at a specific point, focus on that point and wait until the action returns. Subjects such as this motorcycle race lend themselves to this kind of camera readiness. **Harvey Osterhoult.**

The stimulation of being in a new environment is frequently enough motivation for taking pictures. These children are seen as they pull a newly cut Christmas tree from the field of a farm they recently moved to.

To use the hyperfocal-distance approach you first determine the light level with the exposure meter. The smallest lens opening possible is selected. Outside, the lens setting will probably be f:16 or smaller. This f:stop is set on the depth-of-field scale on the camera opposite the infinity index. This will be the farthest point of focus. The closest point of focus will line up opposite the same f:stop on the near side of the focus scale. The critical point of focus will line up opposite the index that indicates sharp focus. This is the index that is between the near and far side of the depth-of-field scale.

To demonstrate the operation, let's take an outdoor situation such as a parade. The meter indicates that we can shoot at f:16 at 1/250 second. The camera has the depth-of-field scale on the focus ring. We line up the f:16 opposite the infinity mark on the depth-of-field scale. On the other end of the depth-of-field scale, which shows the same f:16, the nearest point of focus will be lined up. Let's assume this is 8 feet. You now have a depth of focus that ranges from 8 feet to infinity. The critical point of focus will be indicated by the marker that divides the near and far depth-of-field settings. The point of critical focus is 15 feet. Without again focusing, the camera will now record critically anything that is in the 15-foot range, and everything from 8 feet to infinity will be acceptably sharp.

Using hyperfocal distance is not awkward with the range-finder camera. The confusion of out-of-focus objects does not disturb the photographer. Seeing the action in an eyepiece that is not the same used for focusing reduces the urge to focus. With single-lens-reflex cameras the urge to focus is a handicap, because the unsharpness is clearly visible. One must resist the compulsion to focus or the hyperfocal-distance technique is wasted.

**questions for review**

1   Why is photography subjective?

2   Why is the discipline of composing the negative at the instant of exposure important?

3   How can you safeguard against camera malfunction?

4   List ten steps to camera care.

5   What is hyperfocal distance?

6   How and when is hyperfocal-distance shooting useful?

Capa, Cornell: *The Concerned Photographer,* Grossman, New York, 1968.

**selected readings**

Cartier-Bresson, Henri: *The Decisive Moment,* Simon and Schuster, New York, 1952.

——: *The Europeans,* Simon and Schuster, New York, 1955.

——: *From One China to Another,* Simon and Schuster, New York, 1954.

——: *The People of Moscow,* Simon and Schuster, New York, 1955.

Coles, Robert, and Jon Erickson: *The Middle Americans,* Little Brown, Boston, 1971.

Duncan, David Douglas: *Self Portrait—USA,* Harry Abrams, New York, 1969.

Frank, Robert: *The Americans,* Grossman, New York, 1969.

Goodman, Robert B., Gavan Daws, and Ed Sheehan: *The Hawaiians,* Walker and Co., New York, 1970.

Goro, Herb: *The Block,* Random House, New York, 1971.

Griffin, Arthur: *New England,* Griffin Publishers, Winchester, 1962.

Haas, Ernst: *The Creation,* Viking, New York, 1971.

Keppler, Herbert: *Eye Level Reflex,* Amphoto, New York.

Kerteze, Andre: *On Reading,* Grossman. New York, 1971.

Lange, Dorothea, and Nancy Newhall: *Dorothea Lange Looks At the American Woman,* Museum of Modern Art, New York, 1969.

Levitas/Magnum: *America in Crisis,* Ridge/Holt Rhinehart, New York, 1969.

McGhee, Reginald: *World of James VanDerzee,* Grove, New York, 1969.

Miller, Wayne: *The World Is Mine,* Ridge Press, New York, 1958.

Morgan, Willard: *Graphic-Graflex Photography,* Morgan and Morgan, New York, 1958.

——: *Leica Manual,* Morgan and Morgan, New York, 1950–1973.

Newhall, Nancy: *The Daybooks of Edward Weston,* Horizon Press, New York, 1961.

Schnell, Fred: *Rodeo, the Suicide Circuit,* Rand McNally, Chicago, 1971.

Steichen, Edward: *Family of Man,* Maco, New York, 1956.

Stock, Dennis: *California Trip,* Grossman, New York, 1972.

Wahl, Paul: *Press/View Camera,* Amphoto, New York, 1962.

Woolley, A. E.: *Creative 35mm Techniques,* A. S. Barnes/Amphoto, New York, 1963, 1970.

——: *Persia/Iran,* Chilton/Amphoto, New York, 1965.

# part 3

## the darkroom

# chapter 9

## chemicals and their function

Photographic chemicals and their preparation have come a long way since the nineteenth century and the wet plate. Today, one does not have to be a chemist to understand the chemistry of photography. One need not even know how to measure chemicals in order to prepare the various solutions for film and paper processing. Only if one chooses to mix a special developer is it necessary to bring out the scales and weights. Almost all chemicals necessary to both film and print processing are packaged ready for mixing with water. The only contribution the photographer makes is to supply a specific amount of water and stir until all chemicals are dissolved.

Although all necessary chemicals are now packaged by manufacturers, experimentation is not dead. In the 1950s packaged chemicals were available, yet discontented photographers sought new and better ways to develop their film or process their prints. They made a major contribution by demonstrating the need for improved materials. Manufacturers took heed and produced chemicals that satisfied the discontent. Today film developers are readily available that were non-existant a few years ago.

While many good film developers, print developers, hypos, neutralizers, toners, and other chemicals are packaged and awaiting your use, their availability does not mean that the potential for chemical control is exhausted. Many unexplored possibilities in the creative application of chemicals still exist in photography.

**film developers**  There are scores of different formulas for film developers. Almost all contain four essential chemicals: developing agent, accelerator, preservative, and restrainer.

What are the purposes of these four ingredients in developers? Let's take them one at a time and define their function. *Developing agent:* Chemicals such as elon, hydroquinone, and pyro are developing agents. They activate the silver in the film to form the image. *Accelerator:* The role of the accelerator is to make the developing agent active enough to do its job. Chemicals that are accelerators are borax, sodium carbonate, Kodalk, and sodium hydroxide. *Preservative:* The preservative minimizes oxidation, which weakens the developing agent. The most common preservative is sodium sulfite. *Restrainer:* Not all developers have restrainers, but some have small amounts of potassium bromide to restrain the developing agent from working on the unexposed silver bromide; thereby unwanted fogging of the film or paper is prevented. By knowing these four parts of developers and the chemicals that function in these roles, you can determine the composition of any developer by examining the ingredients listed on the package.

Whether processing film or prints, the quality of the developed image depends on four things: the exposure, the emulsion, the developer, and the processing. All these factors affect the density or opacity of the negative, and they affect the darkness or lightness of a print. By selection and control of exposure, film, and processing, the photographer controls the quality of his negatives and prints. In previous chapters we discussed the influences of exposure and film speed.

From the days of Henry Fox Talbot photography has been using very much the same chemicals. Ingredients for negative to positive processing have been altered and improved but essentially there is still a developer, rinse, fixer or hypo, and wash.

Now let us concern ourselves with the influences of the developer and other chemicals. Chapters 10 and 11 will discuss processing.

Film developers are classified as fine, medium, or low in terms of grain quality. Fine-grain developers work slowly and produce a grain pattern in the film that is the best possible. Optimal fineness in grain quality is the combination of fine-grain film and developer. But even medium-grain film will have a better grain pattern when processed in a fine-grain developer. Medium-grain developers produce acceptable negatives for general use. Fine-grain films processed in medium-grain developers are quality negatives under most shooting conditions. Speed is the most important factor in low-grain developers. All films

grain quality

may be processed in low-grain developers, giving a grain pattern proportionate to the fineness of the film's grain patterns. A fine-grain film will still have a good grain pattern, even though the developer has reduced the ultimate quality. Very grainy films become ultragrainy when processed in a low-grain film developer.

Film processing is a matter of preference and desired effect. The selection of a film developer is based on these two factors. In the process of making the final selection, you should try many of the excellent developers available. Choose a film that is adaptable to the greatest number of uses to which you will put it. Shoot the film within the recommended exposure range. Keeping the film and shooting steps constant, try different film developers. Process several rolls or sheets of film in one developer before advancing to the next developer. Never test a developer only once; after several different developers have been tried, compare the results. Evaluate the characteristics of density, contrast, and grain. These will aid you in determining the best developer for the film of your choice.

Another factor, which is more subtle but which certainly affects your photography, is the possibility that a developer will reduce the effective film speed, or ASA. Reduction of ASA is not uncommon when a high-speed film is processed in a slow-working developer. Be especially aware of this when you evaluate the results of film and developer combinations. Table 9-1 lists the developers most readily available with their grain category and average developing time.

*Photo on opposite page:*
Developers are usually divided into two categories—fine and less fine. There are variations of each. A fine-grain film is combined with a fine-grain developer for critical quality of image. This picture, enlarged about twenty times, shows a grainy film processed in a medium-fine developer.

**developer for prints**

Selecting a developer for prints is not nearly as difficult as selecting a film developer. Paper developers work only two ways: They are cold tone or warm tone. The cold-tone developers produce rich blacks and whites with a resulting strength in contrast. Warm-tone developers produce brownish-black and white tonal values with a resulting softening of contrast. These two types of developers are usually combined with printing papers that emphasize the tones of the blacks or browns.

Developers for photographic printing papers work fast. The average developing time is about 2 minutes. Whereas most film developers are used at full strength from the stock solution, paper developers are diluted according to the concentration and desired working speed. The normal dilution is 2 parts water and 1 part developer. The dilution can range from full strength to 10 to 1. Needless to say, the full strength will develop the image quickly, while the greater dilution will develop the image more slowly.

A medium-grain film is usually fast enough to enable making pictures in low light. This one was taken with a 35mm camera and processed in Eastman's D76 developer.

*Photo on opposite page:* A big negative when processed in fine-grain chemicals will produce a near grainless photograph. In advertising photography the maximum sharpness of a fine-grain image is usually required.

The most commonly used dilution is a developer that is 2 parts water to 1 part chemical; it requires a processing time of 2 minutes when the temperature of the solution is about 70 degrees. Table 9-2 lists many of the packaged printing-paper developers. The directions printed on the package should be followed for the best results.

**other chemicals**

In addition to the film and paper developers, other chemicals are necessary for completing the processing. These chemicals are important but not as important as the developer. They only complete what the developer has begun. However, without them and their proper use the developing step is wasted. Whereas the developing times in processing are very important, the times for other chemicals are not as critical.

short-stop　For many photographers, an intermediate solution from developing to fixing is a must. For others the solution is optional or omitted. But whether or not you use it, you still should be aware of the short-stop bath, acetic acid and water. This mixture stops the developing action. *It does not preserve the image.* The only effect an acetic acid short-stop has on film and paper is ceasation of development. The stock acetic acid is diluted about 32 to 1. Rinsing the film or paper in this solution dilutes the developer and stops the action.

Many other photographers prefer to use plain water as the intermediate rinse. The water does not stop the developing action; it only slows it down. The water does dilute the developer on the film and prevents transfer of working developer into the fixer. The transfer of developer to fixer shortens the life of the fixer. The intermediate short-stop, whether acetic acid or plain water, slows or stops the development action and prolongs the fixer life.

There is a special hot-weather film-developing short-stop bath that is highly recommended when processing temperatures exceed the normal range of 70 to 75 degrees. The chemical is potassium chrome alum (PCA). This chemical gives the film emulsion an additional hardening. The harder emulsion will minimize the danger of damage to the film from reticulation or the separation of the gelatin image. A potassium chrome alum bath is especially useful with negatives under 4 x 5 inches in size. The formula for a stock solution of PCA follows:

| | |
|---|---|
| Water | 32 ounces |
| Acetic acid | 1½ ounces |
| Potassium chrome alum | 4 ounces |

Dissolve the PCA in the water and add the acetic acid. The stock solution is used full strength. Time for the solution is 2 to 3 minutes. The temperature is about 70 degrees. There is no need for a special hardening bath with prints because the emulsion is not as sensitive to high temperatures as film emulsions are.

hypo (fixer)　Hypo makes the image permanent on the film or paper. It fixes the silver salts that have been exposed and removes the unexposed silver. Following this bath, light cannot affect the sensitive silver nitrate emulsion of the film or paper. The same agent for fixing a permanent photographic image has been used since the beginning. Sodium thiosulfate was used by Sir John Herschal to fix the images he and Henry Fox Talbot created in the early years of photography.

The function of hypo is to make permanent the developed image. If the image is not fixed, it will continue to develop and in a short time turn totally black.

Following a correct fixing time, films and prints are soaked in hypo neutralizer to kill the action. They are then washed in running water to remove the neutralizer. If all steps in the process are followed, both negatives and prints will have a minimum life of seventy years.

There are two kinds of hypo. One is thiosulfate crystals and water. The second is a formula which contains hypo plus a hardening agent of alum and acetic acid. All the commercially packaged hypo fixers are of the second category, unless they are specifically identified as nonhardening. Only for special reasons would the nonhardening hypo be used, such as when prints are to be chemically toned following fixing. Another reason for using a nonhardening hypo is when films are subjected to intentional reticulation.

Until hypo neutralizers, or eliminators, were included in the processing procedure, an excessive amount of time was required to wash all the hypo from the film and prints. Failure to wash all hypo from the emulsions resulted in fading or yellowing images. Hypo neutralizers stop the action of hypo and shorten the washing time. Today a 1-minute bath in hypo neutralizer reduces the washing time to 3 or 4 minutes for film and 10 to 15 minutes for prints. Table 9-3 lists hypo neutralizers currently in use.

**hypo neutralizer**

The final chemical needed in film processing is a wetting agent, which helps water to run off the surface of the film and to dry without water spots or streaks. A wetting agent is added to the water following wash time. The film is soaked for a minute and hung to dry. There is no need to wipe the film following the use of a wetting agent. Scratches on film usually occur when a wet film is wiped with a sponge or chamois. This danger of film damage is eliminated with the use of a wetting agent.

**wetting agent**

Some chemicals for film and paper processing are intended to improve the image or to correct mistakes in processing. *Toners* are used on paper to change the colors from black and white to blue, brown, red, or green and white. Brown is the most commonly used.

**additional chemicals**

Sometimes a black and white photograph will look better in a color other than black. When these pictures are completely washed, they can be chemically toned to create a colored effect. A single solution, or in some cases a double solution, replaces the black with another color. The silver image of the black print is replaced with another metal to produce a new color. For instance, with a water scene you can use

**toners**

When the occasion of a
difficult shooting as in an
operating room requires
alteration, there are chemicals
that will accelerate
development, intensify
underdeveloped film, or
reduce contrasty images.
These are additional tools for
achieving successful
photographs.
**Bob Westerlage**

a gold chloride toner to replace the blacks and grays with blue. The depth of the blue will be directly related to the tones of black. Certain papers respond better to certain toners, and it is suggested that you check the photographic paper on which your print is made for its responses to toning.

Here is the recommended procedure for toning prints:

1   Be sure your print is completely washed. If any trace of hypo remains in the print, the toner will act adversely. For example, with most brown toners a greenish iron color will result if prints are not thoroughly washed.

2   If the print has been dried, it may be soaked for 5 to 10 minutes to soften the paper and allow the toner to work evenly.

3   In normal room light, immerse the print in the toning solution for the recommended time.

4   Wash the print again for 10 to 20 minutes to remove the toner. The print is permanently fixed before it is toned. Do not place it in hypo again.

5   Dry the print again.

Because the toner works on the silver image, the action can only last until all the silver has been replaced. When this action has ceased, the only remaining caution is to be certain the toner has been washed off the print.

Toners can create very interesting effects. For the right subject a single monotone such as blue, red, brown, or green can actually appear to be a full color photograph. Not all pictures are suitable for toning, and it is suggested that you employ toning with discretion and concern for the final photograph. Table 9-4 lists available toners.

Two chemicals that can be used to minimize errors in film processing are reducers and intensifiers.

reducers and intensifiers

*Reducers* are used in film correction to reduce density resulting from overexposure or overdevelopment. The most used formula for reduction is Farmer's Reducer. It is commercially packaged with instructions for use. Care should be exercised when working with film reducers because they can ruin your film. Reducers can be used on prints also to bleach highlights or to reduce density. Instructions for using Farmer's Reducer on prints is furnished with the chemical. Follow the directions carefully.

Basic chemicals of film development can be changed in either chemical content or processing procedure to enable "pushing" film that has been exposed at a higher film speed than recommended.

*Intensifiers* are used to build up underdeveloped film. They will not save badly underexposed negatives. An intensifier can only build on the image that is exposed; it cannot work on an image that is not there. Underdeveloped negatives respond very well to intensification, because the exposed silver is there. The intensifier works on the underdeveloped image in the same way that the developer worked on the image originally. Underdeveloped images are actually given a second development in the intensifier.

Underexposed film responds with limitation to intensifiers. The intensifier will build on the image that is there and will sometimes improve the contrast. But it cannot improve the image.

Commercially prepared intensifiers are listed in Table 9-5. Follow the directions that accompany the chemical.

1 Identify the four necessary ingredients for film developers.

2 How are exposure and film development related?

3 What is a fine-grain developer?

4 How can a developer affect film speed?

5 Name four film developers and identify their characteristics.

6 How is a paper developer different from a film developer?

7 Is an acid short-stop necessary? Why or why not?

8 What chemical is used when developing film in hot weather when temperature control is uncertain?

**questions for review**

Chemical toning of black and white prints is accomplished with several kinds of toners. The black and gray tones of a print are chemically turned into blue, red, brown, or green. The print becomes brown and white, blue and white, etc.

9  Why is hypo neutralizer used?

10  What is a wetting agent used for?

11  What are toners and how do they work?

12  Explain the uses of reducers and intensifiers.

**selected readings**  Carroll, John: *Amphoto Lab Handbook,* Amphoto, New York, 1970.

Eastman Kodak Company: *Kodak Reference Book,* Eastman Kodak Company, Rochester, 1972.

Mason, L. F. A.: *Photographic Processing Chemistry,* Focal Press, London, 1966.

Pittaro, Ernest: *Photo Lab Index,* Morgan and Morgan, New York, 1971.

TABLE 9-1
FILM DEVELOPERS

| Manufacturer | Identification | Grain | Speed |
|---|---|---|---|
| Acufine, Inc. | Acufine | Ultrafine | Fast |
| | Diafine (2-bath) | Ultrafine | Fast |
| Agfa | Rodinal | Medium | Average |
| | Atomal | Medium | Fast |
| | Newtol | Low | Fast |
| Best Photo Industries | Panthermic 777 | Fine | Medium |
| DuPont | 16-D | Medium | Moderate |
| | 55-D | Low | Average |
| Eastman Kodak | Microdol | Fine | Moderate |
| | D-76 | Medium | Moderate |
| | DK50 | Medium | Moderate |
| | Dektol | Low | Fast |
| | D-23 (notpackaged) | Fine | Medium-variable |
| Edwal Scientific Products | Edwal Super-20 | Superfine | Medium |
| FR Corporation | X100 | Very fine | Fast |
| | X-22 | Fine | Medium |
| | X-44 | Fine | High |
| GAF | Isodol | Medium | Average |
| | Permadol | Moderate | Fast |
| | Hyfinol | Fine | Fast |
| | Ardol | Moderate/low | Fast |
| Ilford, Inc. | Microphen | Fine | Fast |
| Plymouth Products | Ethol UFG | Fine | Medium |
| Townley | Monobath TC1 | Medium | Medium |
| | Monobath TC2 | Low | Fast |

TABLE 9-2
PAPER DEVELOPERS

| Manufacturer | Identification | Tone | Usual Dilution |
|---|---|---|---|
| Acufine | Printofine | Cold | 2:1 |
| Agfa | Metinol | Warm | 2:1 |
| DuPont | 55-D | Warm | 2:1 |
| | 53-D | Cold | 2:1 |
| Eastman Kodak | Dektol | Cold | 2:1 |
| | Selectol | Warm | 1:1 |
| Edwal Scientific | Platinum Concentrate | Cold | 2:1, variable |
| | Paper Developer | Cold | Variable |
| GAF | Ardol | Warm | 2:1 |
| | Vividol | Cold | 2:1 |

TABLE 9-3
HYPO NEUTRALIZERS

| Manufacturer | Brand | Dilution |
|---|---|---|
| Albert Chemical | Hypo Eliminator | 10:1 |
| Best Photo Industries | BPI Hypo Neutralizer | 10:1 |
| Eastman Kodak | Hypo Clearing Agent | 5:1 |
| FR Corporation | Hypo Neutralizer | 15:1 |
| GAF | Quix Wash | 10:1 |
| Heico Inc. | Perma-wash Bath | 64:3 |
| Townley Chemical | Hypo Eliminator | 5:1 |

TABLE 9-4
CHEMICAL TONERS

| Manufacturer | Identification | Color | Type of Paper |
|---|---|---|---|
| Eastman Kodak | Poly-toner | Sepia to warm brown | All papers |
| | Selenium | Brown | Chlorobromide |
| | Blue Toner | Blue | All papers |
| Edwal Scientific | Color Toners | Blue, red, green, brown, yellow | All papers |
| FR Corporation | Developchrome | Red, yellow, blue, green, sepia | All papers |
| GAF | Direct Sepia | Brown | Bromide |
| | Flemish | Red-brown | Chlorobromide |
| General Photographic | Toner Pactums | Sepia, blue, green | All papers |

TABLE 9-5
INTENSIFIERS

| Manufacturer | Type |
|---|---|
| Eastman Kodak | Chromium |
| GAF | Copper |
| National Research and Chemical Co. | Mercury |

# chapter 10

## film processing

One of the most exciting moments in photography is when developed film is taken from the processing tank and the photographer has his first look at the pictures. The thrill of seeing these new images will continue to excite you, no matter how experienced you are. Processing turns the image you conceived into a tangible product that communicates what you had in mind. There must be excitement at a moment like this.

**film development**  Processing film is a critical step in the image-making procedure. The objective in film development is to maintain the negative quality that began with correct exposure. Controlled film processing will produce a quality negative of correct density and opacity, and quality negatives are the result of correctly exposed and developed film. Both steps are essential to making a negative with tonal values necessary for quality printing. The equipment, procedure, and care of film processing will be our concern in this chapter.

There are two methods which one can use for film processing: *time and temperature* or *inspection*. Both approaches are excellent procedures and both should be learned. There are times when each, or both, will be needed to achieve quality negatives.

As the name implies, the time-and-temperature method of film development is concerned with developing time and a corresponding solution temperature. The normal range of developer temperature is 68 to 72 degrees. At this temperature film processes at a normal rate; there is no potential danger to the emulsion because of solution heat. If the temperature moves above or below the normal range, a change in developing time results. The rate of change in processing time will vary in proportion to the heat of the chemical. Naturally, the processing time will be longer if the developer is colder than 68 degrees. The colder it gets, the greater will be the percentage of time increase. If the developer is below 60 degrees, it should be warmed. Conversely, with warm developer, less time is needed. Developer at a temperature in excess of 78 degrees should be cooled to the normal range.

Sometimes hot developer serves a specific purpose, such as "souping up" badly underexposed film. Usually, the developer is within a 2 degree range of normal. To select the right time for the temperature, consult instructions on the developer package. Follow the recommended times and temperatures until you have determined for yourself whether or not the combinations produce the density and quality of negative you prefer.

Time-and-temperature developing is the most frequently used film-processing procedure. Whether an individual develops one roll of film or a large commercial plant processes thousands, the time-and-temperature method is the procedure likely to be followed.

inspection  Even photographers who use the time-and-temperature process for most film development often use the technique of inspecting their

To load roll film into the
developing reel, remove the
paper backing. Or, for 35mm
film, take the film from its
metal cassette. This is done in
total darkness. The film is
threaded onto a spool
appropriate to the size of
the film. When the film is in
the tank and the top is secure,
the remainder of the process
may be done in normal room
light.

Developing tanks for roll film are made in plastic and metal. They are also adjustable, as this plastic reel, so that different-width roll films can be processed with the one reel. Or, they are designed for one size film only. Economy and personal preference will determine which you select.

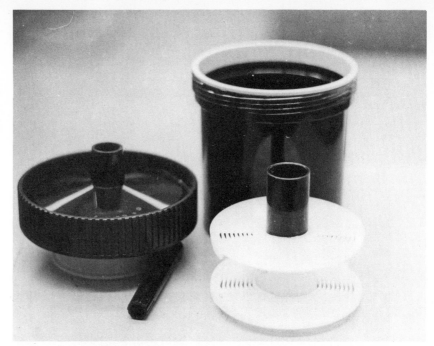

film during processing. Viewing film during development is the oldest approach to film processing, and the films were first developed by this method. The technique has changed because of improvements in emulsion materials, but the approach is essentially the same.

During the time that film is in the developer, a photographer can look at the forming image. This inspection is done in the weakness of a very dark green safelight. When the film has developed at least one-third the recommended time (as determined by the developer temperature), it can be taken out of the developer and held no closer than 2 feet from the safelight. By viewing the *emulsion* side of the film, one can tell if the image is forming. With large film sizes, such as 4 x 5 or 5 x 7 inches and larger, the image itself can be seen. Smaller film sizes, such as 35mm or 2¼ square, are too small for the image to be visible, but the outline of the frame and the darkness of the highlights can be seen. Development of small negatives can be measured by the darkness of the frame outline.

The first inspection can be made after one-third the anticipated development time has passed; then the film can be inspected quickly every 3 minutes. Film should never be held closer than 2 feet from the safelight, and it should not be exposed to the safelight for more than 30 seconds. Even though the light is deep green and safe for pan-

chromatic films, excessive exposure of the film will cause fogging or even solarization of the images. Care should always be the watch-word when developing film by inspection.

Now that we have discussed these two methods of film development, let us examine the equipment necessary to carry them out. Equipment can be as simple as a couple of small trays and two film clips, or

**film-processing equipment**

Sheet film is developed in individual hangers. In this picture the film is being loaded, or unloaded, from the holder used in the camera. Notches indicated emulsion up position.

it can be as elaborate and include an automatic processing machine that costs thousands of dollars. For most photographers, film-processing equipment consists of a small tank or tanks with either reels or hangers appropriate to the film size, and our discussion will center on this kind of equipment. We will also discuss how to develop film in a tray because often no other equipment is available.

roll film    Roll film is processed with small tanks and reels appropriate to the film size. Some tanks are designed to hold a single roll of film, while others accommodate many rolls at once. Tanks and reels are made of plastic or stainless steel, the latter being preferred because it handles more easily and lasts longer. But since stainless steel costs more, photographers often buy plastic tanks first. Either material is suitable and will do the job.

Film reels are designed so that a roll of film can be threaded onto them with only its edges touching the reel. There is ample space between the layers of film, and so developer can move around it all, assuring full coverage. Some reels thread from the inside to the outside (all steel reels thread this way). Other reels thread from the outside in (most plastic reels thread this way). Unfortunately, reels that load from the outside into the center are difficult to thread if they are wet, since loading is accomplished by friction. An absolutely dry reel is thus necessary.

Before you attempt to develop a roll of film with either kind of reel, practice loading film in daylight. Watch what happens as the film is threaded. After you have threaded the film successfully several times with your eyes open, close them to simulate a darkroom and try loading the film. Rely only on your sense of touch; feel the motion of the film as it slides, or as it sticks and refuses to move. Let your hands locate the trouble to correct it. When you are in the darkroom, there can be no light to help you, and your sense of touch will be your only link between the physical act of threading film and the mental control you wish to exercise over the situation.

When the film is on the reel, it is inserted into the tank and covered. Almost all developing tanks for roll film are designed to permit pouring the chemicals through the top. These are called "daylight loading tanks," and we will assume that all tanks available to the reader are of that design.

After the top of the tank is replaced, a light can be turned on, and all remaining time-and-temperature processing can be carried out. Development by inspection is accomplished differently, and we will discuss that later.

The sheet film is placed in a hanger for processing.

sheet or cut film

Sheet film, or cut film, is handled differently in processing. While there are reels designed for developing sheet film, they are not commonly used. Rather, sheet film is developed with a hanger that holds one film. Several hangers can be placed in large tanks at one time. Eight to a dozen film hangers fit easily in a tank that holds 1 gallon of developer, and bigger tanks hold up to 5 gallons. But the 1-gallon size is most often used. Some tanks are designed with tops for daylight loading, while others are open and require that all processing be done in darkness. Whichever designs you select, learn to use it quickly and easily. There is nothing more frustrating than to be in the darkroom and be unable to get the film loaded.

**processing procedure**

Now we will examine the processing procedure step by step. Whether you use roll or sheet film, the procedure will be the same. It will be assumed that the chemicals described in Chapter 9 are familiar to you, and they will not be further defined except where special notes might be necessary.

Sheet film is processed in large open-top tanks, usually in total darkness. There are some light-tight tanks that permit processing in room light after the film is safely in the tank.

To avoid the frustration of not knowing where all equipment is located, you must plan your work before turning out the darkroom lights. Orientation to the darkroom is also important. By positioning all the tools you will need in an orderly fashion, there is less possibility of losing an essential item. If you need to leave the darkroom before the film is safely loaded in the tank, you should know where the door or light is located. With this word of caution, let us proceed with the development of film:

*1 Lay out all the equipment you will use*   Position the items from left to right. Place the film to the far left, with the reel or hanger next to it. The tank should be to the right of the reel or hanger and the top to the right of the tank.

*2 Strip the paper backing from the film*   Take the 35mm film from the cassette. Or remove the sheet film from the film holders. Handle the film carefully and on the edges. Never put your fingers on the film surface.

3 *Load the film onto the reel or hanger*   Again, be careful not to scratch the surface of the film against the hanger or the reel.

4 *Place the film into the tank and replace the top*   At this point the room light can be turned on if the film is to be processed by time and temperature only. (If you are developing by inspection, the light cannot be turned on.)

5 *Pour the developer into the tank*   The daylight loading top will enable you to pour developer into the tank in room light. Before the chemical is poured, check the temperature and determine the time of development. Set the clock.

6 *Agitate the film for 1 minute*   After the chemical is in the tank, shake the tank gently for 1 minute. Air bubbles that collect on the film as the

In a negative all tones are reversed. A good quality negative will have detail in the shadows and a full range of gray to white tones.

developer is poured in will be dislodged by this agitation, and the chemical will touch all surfaces. The tank should be agitated for 10 seconds every 2 minutes during development. Care must be taken not to agitate too much, as this will increase the development of the image, resulting in overdevelopment.

*7 Pour out the developer*   When the development time is over, pour developer back into the stock solution. The daylight top will permit this.

*8 Pour in the short-stop*   Whether you are using acetic acid or plain water, the second bath for the film is poured in after the developer. With plain water, this bath is no longer than the time it takes to fill the tank and empty the water out. With acetic acid or with the potassium chrome alum used in hot weather, the film can remain in the short-stop for 2 or 3 minutes.

*9 Discard the short-stop and add the hypo*   Film can stay in hypo for an average of 10 minutes. Fresh hypo is stronger and works more quickly. The fixing time in fresh hypo is about 6 minutes. One can estimate that total fixing time is twice as long as the time required to clear the white (antihalation) backing on the film. After film is in hypo for 90 seconds it can be exposed to room light. If the white backing is fading, you can determine the fixing time to be 6 minutes (2 minutes to clear, 4 minutes to fix). If the film is only beginning to show clearing, you know the total time will be 10 minutes. If the film is not clear in 3 minutes, the hypo is weak, or the temperature is too cold; it should be replaced or warmed.

*10 All chemicals should be the same temperature*   The developer, short-stop, hypo, hypo neutralizer, and wash water should all be within 1 degree of each other.

*11 Film is rinsed in hypo neutralizer*   Following the total hypo time, the film is soaked for 3 minutes in hypo neutralizer to eliminate the acidity of the hypo.

*12 Wash the film for 3 to 6 minutes*   To make the image fully permanent and to prevent fading or chemical change, the film is washed for 3 to 6 minutes. If, for some reason, hypo neutralizer cannot be used, washing time must be a minimum of 15 minutes, and 25 minutes is safer.

*13 Soak the film in a wetting agent*  When the film is fully washed, soak it in a wetting agent before hanging it to dry. The wetting agent will help drain excess water from the film surface and prevent water spots and streaks. Do not wipe the film, as rubbing it with sponges or chamois can scratch it.

*14 Hang the film to dry*  The film should be hung in a place that is dry and dust free. If there is no need to dry the film quickly, let it dry at room temperature. Drying can be done rapidly by using an electric heater with a fan. But never dry the film near an open flame, as it will curl badly, and possibly the emulsion will soften and reticulate. Except in emergencies, dry the film at room temperature. Hang a weight on the lower end of roll film to keep it from curling.

More preparation is required when film is to be processed by inspection. In addition, the film must be processed in darkness until it is placed in the hypo. Here is the procedure:

**development by inspection**

1   Lay out the equipment.
2   Pour developer into the developing tank.
3   Check the temperature of the developer.
4   Check the safelight to be sure it is 2 feet away from the film.
5   Turn off all lights.
6   Separate the film from its protective backing or holder.
7   Load the film onto reel or hanger.
8   Place the film in a tank filled with developer. The top of the tank is left off.
9   Activate the preset clock.
10   Agitate the film.
11   After one-third the development time, turn on the green light. You can determine one-third the time by having two clocks. One is set for full development, while the other is set at one-third the time. At that time you can take the film out of the tank and hold it *emulsion side up* no closer than 2 feet from the green light. Because you have remained in total darkness from the stripping of the film to this point in the developing, your eyes will be accustomed to the darkness, and the dark green light will be bright enough to see the developing image. If the image is faintly outlined, the film is just beginning to develop. If the film is dark, it is reaching full development.

12 Inspect the film every 3 minutes. The film is very sensitive to light and should not be subjected to viewing more frequently than 30 seconds every 3 minutes. Excessive exposure, even to green light, will fog the film badly.

13 Extend the time for processing. The primary purpose for developing by inspection is to alter developing time. If film is thought to be either underexposed or overexposed, inspection development will help correct the error. If the film is overexposed, inspection at one-third the time will allow you to cut the total development time and save the negatives. Underexposure can be corrected by inspecting the negatives until they are totally developed. In this case, development time is extended to whatever length is needed to increase the density of the images. Inspection development is highly recommended when "pushing" or "souping up" the ASA of film.

14 Rinse the film in short-stop.

15 Place the film in hypo.

16 Neutralize the hypo.

17 Wash the film.

18 Hang the film to dry.

**forced processing**    For most film processing, you will follow the recommended times and temperatures of your developer. But sometimes lighting conditions or the slowness of the film in the camera will demand more than normal development. At such times, forced development, or "pushing" the film, can remedy the shortcomings. Pushing film in development does not replace the need for good exposure, but it can salvage a printable negative when the film would otherwise be lost.

To push the film speed beyond its normal latitude requires increased development. Film can be processed for longer times or at higher temperatures to achieve this. To force development with higher temperatures, increase the temperature by 5 degrees for each full increase in ASA. If the ASA is 160, one full increase would be ASA 320; two full stops, ASA 640; and three stops, ASA 1200. Therefore, if you increase the ASA from 160 to 640, you would increase your developing temperature by 10 degrees. If the normal temperature and time for your developer is 9 minutes at 70 degrees, the pushed processing would be 9 minutes at 80 degrees.

Extreme care must be taken when processing film by increased temperatures, as the film emulsion is very soft and easily damaged.

At the least, it is in danger of reticulation, and sometimes the emulsion can slide right off the film base when processing is pushed to extremes.

All chemicals must be at the same temperature. If the developer is very warm and the potassium chrome alum (which must be used whenever warm-temperature developing is done) and the hypo are at lower temperatures, the film can expand when warm and then "freeze" in its expanded state when it is placed in colder chemicals.

Never assume that you can shoot film haphazardly and then make up for it when developing. Pushing film is a planned operation, and there are some elements of decreasing quality that are inherent in pushed film. Graininess is greatly increased; contrast exceeds expected ranges, making highlights difficult to render with full tonality; and the ratio between highlights and dark tones may not be printable. One accepts these factors as "normal" when pushing a film's performance.

**tray processing**

Should the time come when you are forced to process film and have no equipment to do it, you can process either roll or sheet film with a tray or bowl and two clips to hold the film.

In total darkness, unroll the film from the cassette or paper backing. Clip the pins to each end of the film. Hold the film with the emulsion side down (you can determine the emulsion side by the slight curl on the edge). Begin processing with the film touching the bottom of the tray. Slowly lift one end as you lower the opposite end, always keeping the film in the chemical. As the film is in the developer, it becomes soft and pliable. Move it up and down slowly during developing time. Due to this constant movement, processing time is reduced about 20 percent. When development is finished, proceed with the remainder of the processing procedure, keeping the film moving up and down until it is in fresh hypo for 90 seconds. After the room light is turned on, you can carefully lay the film in hypo, making sure no emulsion surfaces are touching.

**monobath processing**

There has been a continuing search in photography to find a quality single-solution developer/hypo for film processing, and monobath chemicals for film processing have appeared on the market for years.

With the monobath approach, conventionally exposed film is developed and fixed in a few minutes. In such a process, the developing

When film has been purposely underexposed, or the ASA pushed, alterations in developing can bring up the tonal qualities and produce a good printable negative. The alteration can be done by heating the developer, prolonged development, or special developers. With increased film speed, pushed ASA, you must expect some loss in image quality. This recording studio picture was shot with a pushed ASA. **Wendy Woolley.**

Film processing is usually
accomplished in the three-
step method. But monobath
is a single solution that
develops and fixes the film
simultaneously. The total time
for processing is about
6 minutes, regardless of
temperature. Plus X film was
processed in monobath for
this picture.

After film has been processed, it should be carefully handled and placed in protective sleeves. There is no way to repair a scratched or damaged negative. A workable filing method should also be used to locate negatives when they are wanted.

agent acts on all exposed silver and all unexposed silver is removed by the fixing agent. When the two have done their jobs the film is fully processed; this takes about 6 minutes.

**care and storage of film**

After film has dried, it should be cut and placed in protective glassine sleeves. Sheet film should also be inserted in individual protective sleeves. A negative is not replaceable. Damage from dust, scratches, or fungus are lasting effects on the quality of negatives, and caution must be exercised to protect film. Putting negatives in protective sleeves as soon as they are dry is the first move.

For roll film, an entire set of negatives can be placed in one glassine sleeve. But avoid sliding one strip of negatives over the other when removing or replacing strips.

Whether the strips of film are individually placed in sleeves or grouped, they can be marked with a number or letter for filing. No matter what method of filing you select, be sure it is one that keeps the negatives protected yet allows easy access to them.

**questions for review**

1   What are the two techniques of film development?
2   Explain the step-by-step procedure for film processing.
3   How does the inspection method of development differ from the time-and-temperature method?
4   What is meant by "forced" development?
5   How can you develop film when the usual equipment is not available?
6   What is monobath processing?
7   What steps should be taken to safeguard film after it is processed?

**selected readings**

Carroll, John S.: *Amphoto Lab Handbook,* Amphoto, New York, 1970.

Floyd, Wayne: *Floyd's Photo Tips,* Amphoto, New York, 1960.

Haist, Grant: *Monobath Manual,* Morgan and Morgan, New York, 1966.

Jacobson, C. I.: *Developing: The Technique of the Negative,* Focal Press, London, 1971.

Jonas, Paul: *Manual of Darkroom Procedures and Techniques,* Universal/Amphoto, New York, 1962.

Neblette, C. B.: *Photography: Its Materials and Processes,* Van Nostrand, New York, 1962.

Pittaro, Ernest: *Photo Lab Index,* Morgan and Morgan, New York, 1971.

Satow, Y. Ernest: *35mm Negatives and Prints,* Amphoto, New York, 1960.

Wallace, Carlton: *The New Photographer,* Amphoto, New York, 1964.

Woolley, A. E.: *Night Photography,* Chilton/Amphoto, New York, 1964.

———: *Photographic Films and Their Uses,* Chilton, Philadelphia, 1960.

# chapter 11

## print processing

All photographic efforts culminate in the print, the only tangible evidence that anything has happened. The difficulty or pleasure experienced during exposure of the film is of little consequence if the final print is of poor quality. Even the control exercised over negative development is unimportant unless it contributes to the quality of the final print. The print is the photographer's moment of truth.

the darkroom

**printing the negative**  If a negative has been exposed correctly and the film has been pro-
cessed properly, the negative should possess sufficient tonal values to
make printing easy, or at worse a mildly difficult task. Tonal range and
density are major contributors toward a print of quality and brilliance,
for the values seen in the negative are directly related to those in the

A contact sheet is a single
print of all negatives from one
roll of film. The contact serves
as a positive for inspection as
well as filing.

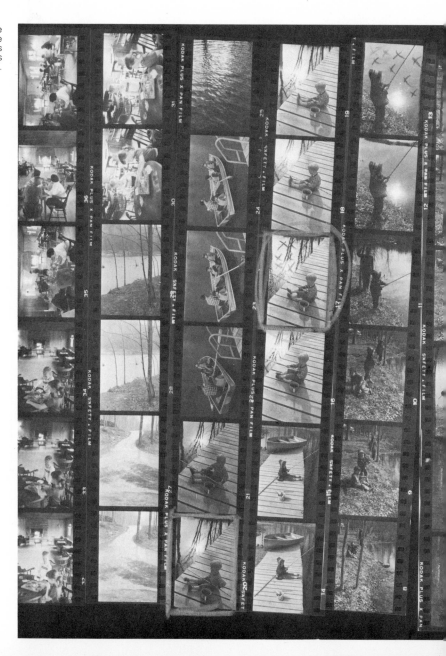

Contact sheets can be printed using either an enlarger or a contact printer. A piece of heavy glass laid over the negatives which are on top of the sensitized paper will hold the film in contact. A hinged frame especially for contact printing with an enlarger is available.

print. Only rarely will deficiencies of a negative be improved in the print. All too frequently, the tonal values of a good quality negative are inadequately transferred to the final print. Making the transfer successfully is the responsibility of the photographer. Whenever the negative contains tonal values sufficient for a quality print, the photographer must transfer those values to the print paper. This chapter contains information to guide you toward achieving successful prints of good quality.

Printing is a very personal statement. Through the controls of exposure and development all shades of gray can be altered to suit the photographer's taste. His desire for deep blacks or bright whites can be satisfied by manipulating the length of exposure time, or of developing time, or both. A photographer's creative statement begins when the contents of the composition are isolated in the camera; it continues into the film processing, and it concludes with the print.

**contact printing**  After negatives have been cut and placed in protective sleeves and marked for filing, a positive print is made for inspection and editing. For all small film sizes, the positive is a *contact sheet.* For larger film sizes, the negatives can be printed individually in contact size or they can be grouped in numbers that will fit a standard printing-paper format.

Small film sizes, such as 35mm and 2¼ x 2¼, are positioned to allow printing the entire roll of negatives on one sheet of 8 x 10 inch paper. Some photographers cut 35mm film into six strips of six frames, while other photographers prefer cutting the strips in seven strips of five frames. The latter choice assumes that the thirty-sixth frame will be of no value, or else one negative must be handled separately. I prefer to use six strips of six frames each, as these easily fit onto 8 x 10 inch paper.

For 2¼ x 2¼ negatives, three strips are cut with four negatives each. The three strips fit onto 8 x 10 inch paper. Negatives that are 2¼ x 3¼ inches are cut into two strips of three frames and one of two frames. These, too, fit 8 x 10 inch paper.

Film that is 4 x 5 inches will fit four to an 8 x 10 inch paper, and 5 x 7 inch film will fit two.

The purpose of the contact sheet is twofold: It is a rough positive to be used for selection and editing, and it can be used to file negatives for later inspection and selection.

There are two ways to make contact prints. One involves the use of a *contact printer,* and the other uses the *enlarger.* Either works well. If a contact printer is available (they range in cost to $500), by all means use it; but there is no reason to buy one merely to make contact prints.

Contact prints save time and money because you can print an entire roll of film in one print. If individual prints had to be made of all exposed negatives, I doubt they would be made. Contact prints help to select individual frames that can be enlarged to *proof prints* of a size

such as 5 x 7 inches. These proof prints can be examined closer before the final print is prepared.

the contact printer

The contact printer is constructed with light in the base, a diffuser about half way between the light and the printing surface; a transparent glass surface on which to lay negatives and printing paper, and a hinged top for pressing the negatives and paper into tight contact. To use the printer, negatives are placed on the glass surface with the *emulsion side up.* Contact printing paper is laid on the negatives with the *emulsion side down.* Thus the emulsions of both negatives and paper are in contact. When the top is tightly fastened, the light in the base of the printer is turned on for as long as is necessary to pass through the opacity of the negatives and reach the paper. (A special contact-printing paper is used in working with a contact printer; it is slower than enlarging paper and requires more light or longer exposure times.)

When the exposure is finished, the print is ready for development, a process that will be described later.

the enlarger

If you do not have a contact printer available, it is not necessary to buy one, as an enlarger can print contact prints. One piece of equipment is necessary when using the enlarger: a printing frame. This is a wooden or metal frame which accommodates 8 x 10 inch paper. The frame has a glass front and is hinged back or front. It is loaded with negatives and paper and placed beneath the enlarger for exposure. To use the frame, place the film on top of the glass with the *emulsion side up.* Place the enlarger paper (you can use the same paper used for final prints) on top of the film strips with the *emulsion side down.* Put the hinged top of the frame on the paper and clamp it in place. Pressure from the hinged back brings film and paper in close contact. The loaded frame is then turned over and placed beneath the enlarger on the base, where the light can hit it. Before the frame is placed under the enlarger, determine that light will fall on the entire surface of the frame. Expose the negatives and paper for a few seconds to make the print.

One can make contact prints without a darkroom by using a printing material called "printing-out paper." This paper can be exposed to the sun to print negatives. The exposed print is reddish in color and is not permanent unless a fixing agent is used. Almost everyone is familiar with these reddish contact prints—they are used generally in preparing

The enlarger: 1. lamp house;
2. negative carrier or holder;
3. bellows for focusing; 4.
focusing knob; 5. lens. The
upright for raising the enlarger
can be either a single or
double post.

studio portraits proofs prints. The process also can be used to make quick contact prints. The printing frame used in contact printing with an enlarger works very well with this method.

Printing-out prints need not be permanent. The fact that they can be made quickly without a darkroom is a primary reason for using

the procedure. When a contact proof is wanted and no darkroom is handy, this procedure works fine. The prints will last reasonably long and will not turn totally dark if they are not exposed to bright light for long. In time, though, they certainly will deepen too much for study.

However, should you want to make the printing-out print permanent, you can do so. *Do not use regular hypo;* this will only bleach the image completely. To fix the print, soak it in a solution of gold chloride for 10 minutes. Following the gold chloride bath, wash the print for 10 to 15 minutes to remove excess chemical. Dry the print as you would other prints.

After the contact print has been printed, processed, and dried, the sheet becomes the vehicle through which specific frames are selected for final printing. With the aid of a magnifier, each frame on the roll is carefully studied, and the best negative is marked for printing. A magnifier enables you to study sharpness, details, and tonal quality. Any magnifier with a power of three times or better serves very well. Some magnifiers have lights built with an opening the size of the negative. Though more expensive than conventional magnifying glasses, these are easier to use, as the built-in light illuminates the image and makes study more critical.

**editing and marking contact prints**

Each frame of the roll is viewed, and the best frame of each situation is marked. Marking contact sheets is done with a soft wax pencil. The best pencil of this type is sold under the brand name Blaisdell China Marker. The pencil comes in several colors, of which red, green, and yellow are the most useful. (Red is probably the most visible in the subdued light of the darkroom.) The wax records smoothly on either glossy or matte surfaces. It also can be wiped away with a soft tissue or cloth. The marks made on contact sheets are not permanent, yet they do not rub off under normal wear and usage.

What are the markings on contact sheets? What role do they play? Whether you are marking contacts for your own information or for instructions to a commercial printing house, the indications are the same. Here are the most commonly used marks:

1   Outlining the entire frame with a solid line (————————) means "print full negative." The solid line indicates specific cropping.
2   Outlining the negative area with a wavy line ( ∧∧∧∧∧ ) indicates general cropping, and the printer is to use his own discretion in composing the print.

Controls during printing
include burning in and holding
back light. This picture
shows the effect of holding
back light on the man's face
during the overall exposure.

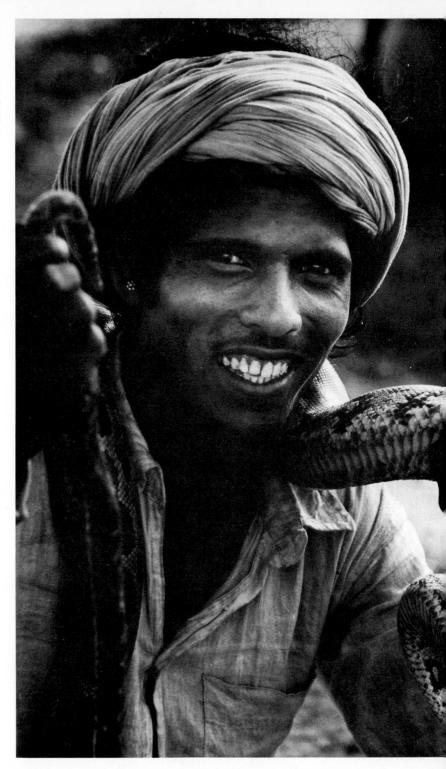

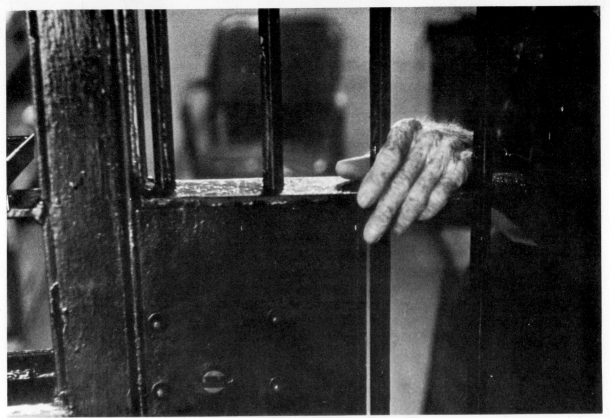

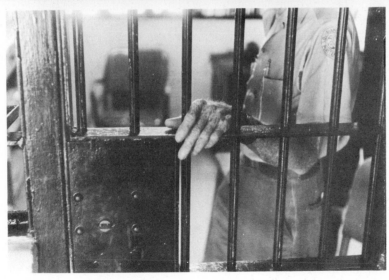

A controlled print with both burning in and holding back of light. The hand was slightly dodged, or held back, in overall time. The rest of the composition has been burned-in extensively to deepen the tonal values. Also shown is a straight print of the negative with no controls.

3    Putting XXX in an area of the composition indicates to the printer that an area is to be printed darker than is visible in the contact.

4    Placing 000 in the compositional area indicates that the area is to be printed in lighter tones than is visible in the contact sheet.

5    The size of the enlargement is written on the frame itself. If there are too many markings on the frame, the size indication can be written adjacent to the frame with a line drawn to the frame.

These five symbols communicate to the printer, or yourself, the decisions that have been made about the appearance of the final print. When final prints are to be made, both the negatives and the contact sheets are furnished to the printer. If you do your own printing, both negatives and contacts are taken to the darkroom. As the final print is being made, the contact markings become guidelines for controlling shape, size, and tonal values.

After contact sheets have been marked for the selected frames, the negatives are selected. Each negative is clipped on the edge with a ticket punch to identify the frame wanted. Clipping the frame to be printed makes identification in the darkroom easy. All one need do is run his finger along the edge until the clipped portion is found. For 35mm negatives the film edge away from the numbers is clipped. For larger negatives, it does not make much difference which edge is clipped. The clipped negatives and the contact sheet remain together. If only the negative selected for printing is sent to the darkroom, the remainder of the roll is left in its protective sleeve. The selected strips are placed in a different sleeve, which is also numbered with the file code numbers.

Before the clipped negatives are ready for the darkroom, they are cleaned. Using a soft, lintless cloth, wipe both sides of the negative with an antistatic film cleaner, available at all camera stores. The cleaner removes any streaks that might have occurred during drying, and any dust or foreign particles that might have stuck to the surface. The antistatic element in the cleaner repels foreign particles that might stick to the film. To clean the film, lay the negative emulsion side down on another piece of lintless cloth. Soak the wiping cloth in film cleaner, then wipe the film firmly but not roughly. Turn the film over and repeat the process.

For convenience in handling, never cut negatives into individual fames. Clipping identifies the frame, and there is no need to cut the individual negative from the strip.

Projection prints, or enlargements, are made from small negatives. **making enlargements**
Prints are the only means of communicating to the viewer the con-
cepts and contents of the photograph. No amount of dialog about
what has happened before, during, and after exposing the film in the
camera will alter the impact of the print. If the print is good, the mes-
sage will be communicated; if the print is poor or lacking in tonality,
it will not be. Thus the photographer must try to make the very best
final print that he can. And he should continue to improve his ability
with each printing session.

The enlarger is very important to the small-negative photographer, the enlarger
and it influences the print quality a negative will produce. There are
three kinds of enlarger: *condenser, semicondenser,* and *diffusion.*
The sharpest enlarger is the condenser. This type projects the light
rays directly. The semicondenser enlarger uses one unit of con-
denser and one unit of transluscent glass. The glass diffuses the light,
and the condenser sharpens it again. The diffusion enlarger has no
condensers and projects a soft light through the negative. With the
condenser enlarger the image is sharp both in line and in grain.

Sharpness lessens with each of the other enlargers, and the grain
pattern produced by diffuser enlargers is very soft. Table 11-1 lists
some enlargers available.

Each enlarger has a means for holding negatives. The negative holder
is located between the light source and the lens. The lens is designed
for use with the enlarger. Camera lenses can and are used on en-
largers. But enlarging lenses are inexpensive and one specifically
fitted to your enlarger should be purchased. Almost all enlarging
lenses have an f:stop of 4.5 as the largest opening, and they close
down to f:32.

The lens f:stops are for controlling light only. They cannot sharpen
an unsharp negative. There is some degree of control over sharpness
if the negative is curling in the negative holder. But the depth-of-field
principle discussed with the camera does not apply to enlargers.

The negative is placed in the negative holder with the *emulsion side
down.* A soft antistatic brush is used to dust the negative before it is
placed in the enlarger.

From this point on, the procedure for projection printing follows the **printing procedure**
same pattern, regardless of negative size.

1 The negative holder is inserted in the enlarger.

2 The light is turned on to project an image on the enlarger base and easel. The lens is open full for maximum light.

3 Focus the negative on the easel.

4 Raise or lower the enlarger until the image is the shape and size indicated on the contact sheet.

5 Refocus each time the enlarger is elevated or lowered.

6 Close the lens to reduce the light intensity. For negatives of average density, the lens is closed to f:8. At this f:stop there is enough exposure time to permit all controls of lighting.

7 Make a test strip to determine the exposure time. Place a piece of printing paper about 1 inch wide and 8 inches long on the easel in a position that will include the most important part of the composition. This is done with the enlarger light *off*.

8 Cover all the test strip except for 1½ inches. Expose this uncovered part for 1 second. Uncover another 1½ inches. Expose it, and repeat the exposure. Continue with this procedure until the entire paper strip has been exposed. If you have made five exposures, the last one will be the shortest and the first one will have been exposed the total time used to make the strip. Each exposure between the first and last will be in multiples of 1 second. If the test has been successful, a correct exposure time for the negative can be determined. If the test is too dark or too light, the seconds of exposure are altered up or down. Or the f:stop can be made smaller. Repeat the test strip as many times as is necessary to establish the correct exposure time for the negative. When the time seems correct, expose a full strip at the determined time to get an overall impression of the gray tones that will be in the print. This test will give a more accurate reading of the tonal scale; if a slight adjustment in time is needed it can be evaluated at this point.

9 After development and a very brief hypo bath, the test strip is viewed in room light. Select the time that produced the greatest tonal values. The test strip saves material and time. But it only works properly when the developing time is constant. When the strip is developed, use a time that does not change with each strip. For most paper developers, a developing time of 2 minutes is workable. If this time is used, be sure it is used all the time. When the correct exposure time is determined by the test strip, the final print is exposed for the same time and developed for 2 minutes also. The objective is to establish as many constant

factors as possible. Fluctuation of time, exposure, f:stop, and other variables will make it difficult, if not impossible, to make a good print.

When the exposure time is determined, make a full-sized print at that number of seconds, and develop the print for 2 minutes. Place the print in hypo for a minute, and inspect it in room light. Evaluate the tonal range to determine whether or not some areas need more or less light.

There are controls for adding or subtracting light and controlling tone during the print exposure time. These controls are called "dodging," or "holding back," and "printing in," or "burning in."

**control of tone**

*Dodging*  While the full exposure time is projected, areas which appear too dark can be made lighter by keeping the light from hitting those areas. The control can be accomplished with your hand or with a piece of cotton on a wire. If the area is large enough, a piece of cardboard can be used. The objective is to hold light from the dark area.

*Burning in*  When an area in the print is not dark enough, it requires more light than the overall printing time. To get this area darker, light is added. Burning in is accomplished with any object that restricts light. Cupping one's hand to let light pass through a tiny hole is one means of burning in. A piece of cardboard with a hole *torn* [cutting the hole makes the edge of the opening too sharp and defined] in the center and another cardboard of the same size without the hole make a good combination for burning-in. The size of the opening is controlled by the cardboard without the hold.

When either dodging or burning in is performed, be certain that the objects used to exercise the control are moved constantly. If they are held too long in one place, the shape of the control tool will be projected onto the print.

Two additional techniques of control might also be used to achieve a quality print: flashing and burning-in with raw light.

*Flashing*  After the negative has been exposed for the established time, large areas such as upper corners or bottom corners can be made darker, subduing the tones and shapes that have already been printed. This process is called "flashing." The negative is taken from

Before a print is made, a test strip for determining the correct exposure time is made. The test strip is developed at a firm time. The best tonal range is selected, and the first full print is made at that exposure. Controls are added if necessary for the finished print.

Papers are prepared in either single contrasts or in one emulsion that is multicontrast and controlled by filters. This series of prints was made with single-contrast papers. This is a soft grade, or number 1.

A print on normal-contrast paper, or number 2.

Hard contrast is achieved with number 3 paper.

High-contrast prints are made on number 4, 5, or 6 papers. Notice how the middle scale of gray is reduced with each increase of contrast.

A controlled print on number 2 contrast paper. A full range of tone is present throughout the print. There is detail in the shells and also in the dark bottle.

Dry-mounting tissue is the neatest method of mounting photographs. (a and c) A regular iron can be used for the entire process, or it can be used only to tack the tissue to the back of the print. (b) The print is trimmed. Tack to the board on which the picture is to be mounted. (d) Place in the mounting press at proper temperature for about 30 seconds. Heat fuses the fiber of the print and the board together with the wax of the tissue. These are commercial tools expressly for mounting available in camera shops.

(a)

(b)

(c)

(d)

the holder following the overall printing time. The holder is returned to the enlarger. The exposed print is still in the easel. Close the lens to at least two stops from the exposure setting. Hold solid cardboard between the lens and exposed print on the easel. Turn on the light. With a quick motion uncover the area when darkening is wanted. It takes only a fraction of a second, because you are using unobstructed light. It is better to repeat the quick uncovering a couple of times than to expose too long in a single motion. After the areas are subjected to the raw light, the print is ready for processing.

*Burning in with raw light*   There are times when it is impossible to burn in an area to the desired depth of darkness. On these occasions the only solution is to burn in with raw light. The best way to do this is with a small flashlight with a cone over the light to restrict illumination. The exposed print is still in the easel. The lens is stopped down to lessen the light intensity. To know where the control areas are, the red safety filter on the enlarger is swung between the lens and easel. Turn on the light. The image is visible on the paper, but the red filter is protecting the paper from additional exposure. The flashlight can now be pointed toward the areas where raw light is required. Again, the flashlight is moved constantly during burning to keep the shape from recording on the print.

**photographic papers**  There are two kinds of photographic paper: *contact* and *projection*. There are many varieties in both categories, and the principal difference between the two is in their chemical content and sensitivity to light. Almost all contact-printing papers contain chloride, and all projection papers are either bromide or a mixture called "chlorobromide." The chlorobromide papers are slower and contain a wider tonal range than bromide papers do. Chloride papers have the greatest tonal range and also are much slower. Some photographers believe the chloride papers are superior to bromide papers, and they have altered their enlargers to accommodate bulbs of higher wattage, in order to print on the slower chloride papers. But such extremes are not necessary for quality projection prints. The papers available have sufficient quality of tonal range to meet the demands of even the most critical photographer.

Table 11-2 lists contact-printing papers, which are available in single contrast, two weights, and many surfaces. Enlarging papers are produced in both single contrast and multicontrast. The single-contrast papers are packaged in degrees of contrast from low to high. A paper with a contrast that is very high is numbered from 3 to 5. Normal contrast is number 2. Low contrast is numbered 1 and 0. Multicontrast projection papers are packaged in one emulsion only. Contrast is controlled through the use of filters. Different companies use different filter systems, but the numbering sequence is the same. The low numbers indicate low contrast, and high numbers indicate high contrast.

Table 11-3 lists available single-contrast projection papers. The characteristics of contrast, weight, surface, and safelight are also indicated. Table 11-4 indicates available multicontrast papers. Paper-surface codes are identified in Table 11-5.

In making the final print, the contrast of the negative is matched as closely as possible with the contrast range of the paper. A negative of normal density will print with good tonal values on a paper of medium or normal contrast. This paper contrast is indicated as number 2 in single-contrast papers and as the number 2 or 3 filters in multicontrast papers. If the negative is thinner, or has greater opacity, the contrast of paper will be higher. If the negative is denser, having less opacity, the contrast will be lower. For special effects or emphasis, a contrast of paper other than the range equal to the negative can be used. Normal-contrast negatives produce greater contrast when printed on a high-contrast paper. The tonal range is reduced, and all the delicate grays are eliminated by the paper of higher contrast. Conversely, contrast is softened or even flattened when a normal-contrast negative is

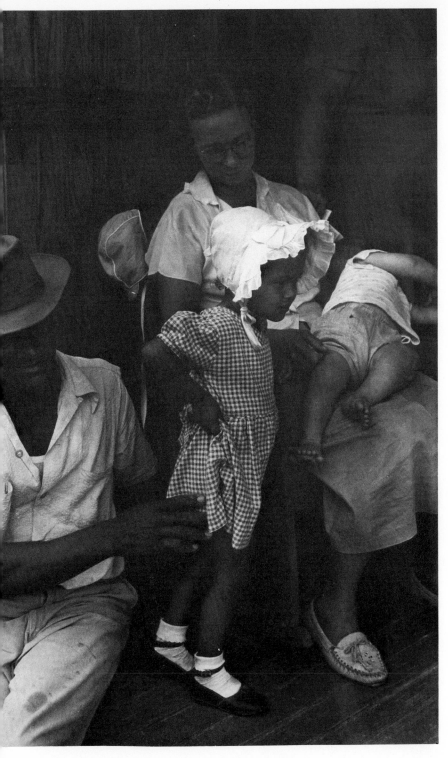

Farmer's Reducer has been used on the child's bonnet to lighten the tones and set the area apart from the rest of the picture.

printed on a low-contrast paper. There are situations when alteration of contrast is effective in the finished print. By working with and experimenting with the full contrast and tonal range possible with negatives and printing papers, you will acquire knowledge of what happens when the right combinations are made.

**developing and processing prints**

In Chapters 9 and 10, the chemicals of developing were listed and discussed. To remind you of those chemicals let us restate those used for developing prints: developer, short-stop or water, hypo, hypo neutralizer, and final wash. The following step by step procedure is used to develop and make permanent photographic prints:

The most comfortable arrangement for trays and equipment in printing is a left-to-right movement. The developer is left with a glass jar holding a print tong between the tray and the next tray with either water or short stop. Hypo or fixer is in the third tray. A jar for the fixer tong is to the right of the tray. Placing the jars for tongs in these positions reduces the temptation to place tongs in the wrong chemical.

*1 Immerse the print in developer* A standard paper developer such as Dektol is diluted with two parts water. The best temperature is 70 to 72 degrees, but room temperature is all right. Developing time is 2 minutes. Standardizing at 2 minutes enables control of exposure. Agitate the print often during the 2 minutes development. If hands are used to move the print, do not touch the paper emulsion; use print tongs to keep hands dry and eliminate the danger of marring the print. I use separate tongs for developer, hypo, and neutralizer. The tongs must never be mixed in the different solutions. If you prefer to use your hands, be certain that they are washed clean of one chemical before placing them in the next chemical. This is especially important when hands have been in hypo and then are placed in developer. Any trace of hypo on the hands will be carried into the developer and weaken it.

*2 After 2 minutes, transfer the print to the short-stop* Acetic acid or plain water can be used. I prefer plain water. The print is rinsed for only a few seconds and taken out. If acetic acid is used, the prints can remain in the short-stop for several minutes. If prints are left in the short-stop acid, be careful that a print just out of the developer does not rest on top of the print in the short-stop. The developer carried over by the new print could cause staining of the prints in the acid bath.

*3 Place the print in hypo* When several prints are made, the prints must be stirred and moved during the 10 minutes they are in hypo. Prints can stay longer than the required 10 minutes in hypo, but not shorter. If a print is not fully fixed, it will turn yellow or fade in a few years.

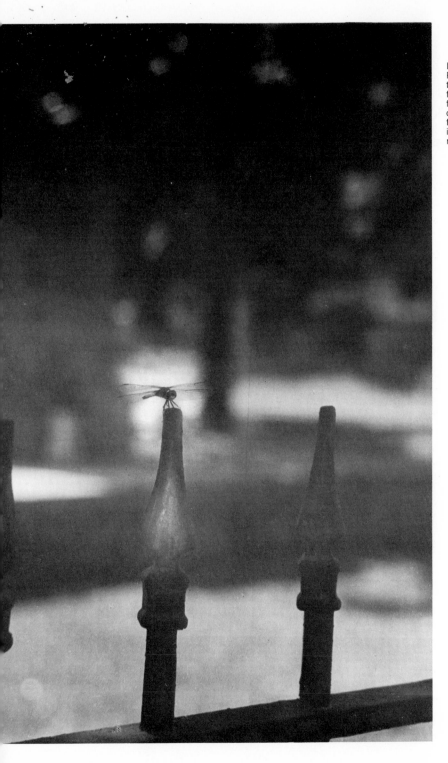

Local reducing with Farmer's Reducer helped to accentuate the firefly perched atop the fence. Reducer is also useful for lowering the overall density of a print. A print with flat tones can be given increased contrast by reducing the general tonality.

*4 Transfer the print to hypo neutralizer* After 10 minutes, move the print into the neutralizer. There is no harm in leaving prints in neutralizer until all prints are made. But stir them occasionally.

*5 Wash the prints for 10 to 20 minutes*

*6 Dry the prints*

drying the print

Single-weight glossy papers are dried on a highly polished surface to attain the glossy effect. Special dryers are made for this type of drying. Less expensive plates of polished chrome are also used. Double-weight glossy papers and single-weight nonglossy papers are also dried in a dryer. The dryer is heated to about 350 degrees, and a canvas conveyor belt feeds the prints into the drum. Minutes later the heat-dried print drops from the drum. Glossy papers are dried with the image facing the polished drum. Nonglossy papers are dried with the image face down on the conveyor belt.

It is not necessary to dry prints in a dryer. I prefer not to subject my prints to heat at all, laying them face down on a *clean cloth,* wiping the backs of the prints and letting them dry at room temperature. It is not recommended that prints be dried in blotter books. When blotter books are new, there is no immediate danger in their use. But as they get older, the possibility increases that prints that have not been fully washed will be dried in the book. One print that was improperly washed can leave enough hypo to cause succeeding prints to be stained. There is nothing more maddening than stained prints that otherwise are of excellent quality.

If laying the prints out to dry is not convenient, the next best way to dry them is to hang them. For many years I hung prints back to back on a line with clothes pins, after the prints were wiped dry of excess water. They dried at room temperature. This is not an advisable method of drying single-weight papers, however, as they curl badly. Even double-weight papers curl somewhat, but they can be straightened by placing them under a heavy weight for a few hours.

displaying the print

The finished and dried print bears testimony to all your experiences in producing the photograph. It should be displayed or presented in the very best manner.

mounting

For the cleanest means of mounting prints on cardboard, masonite, or even wood, dry-mounting tissue and heat are preferred. Dry-

mounting tissue is a wax-like material that adheres to fiber surfaces with heat and pressure. There are different brand names of mounting tissue and all do a good job. Following is a step-by-step procedure for using mounting tissue:

1   Tack the tissue to the center of the back side of the print.
2   Trim the edges of the print.
3   Tack the top of the tissue to the mounting board in the position you want it. Do not touch the surface of the print with the tacking iron.
4   Insert the print and mount board in the mounting press. The heat will melt the tissue and stick the print to the mount board.
5   Remove the mounted print and bend the mount slightly to test if the print is fully stuck. If the print is not stuck securely, return it to the press for several more seconds.

Prints are best mounted with a *mounting press* designed for the job. But a standard household iron can be used. Care must be taken not to scorch prints when using an iron, which—even at its lowest temperature—is hotter than a mounting press. If the iron is not insulated from the print emulsion, the heat will cause both scorching and blistering. Several thicknesses of heavy wrapping paper should be used between the iron and the print.

After mounting, the final act of readying prints for viewing is to spot away any white specks that may have appeared.

**spotting the print**

There are several products for spotting prints. Spotone is a liquid material that is good, but one must learn to use it. Eastman sells a spotting color pad that is water soluable and removable if mistakes are made. And the china stick such as is used by laundrymen to mark packages is also very good. Either of these materials can be applied to prints with success. It takes a little practice. Using a small brush, color is applied to the spot. The objective is to blend the spot with the surrounding shade of gray.

One reason for cleaning the negative with antistatic cleaner before printing is to minimize the number of small white specks. The specks are usually caused by dust and other foreign particles on the negative.

**other controls**

When a print is still being processed, there are several controls which

can be used to improve contrast and tonal values. Principal among the extra controls are local reduction of highlight ones with ferracynide (Farmer's Reducer), overall reduction of density with an increase in contrast, and chemical toning. These three measures are useful and should be given experimental attention.

local reduction    When a highlight area is too close in tonal values to the surrounding gray scale, the best way to make the highlight separate or "stand out" is with local reduction on the highlight. After the print has been placed in the hypo for 90 seconds, the room light can be turned on. Take the print from the hypo and wipe the surface dry with a sponge or paper towel. Dip a cotton-tipped swab into Farmer's Reducer and rub the spot to be reduced. Rinse the print with water and inspect it. Rub the area with more reducing chemical, rinse it again, and place it in hypo. If the tones have changed sufficiently and no more reduction is necessary, continue with the hypo and other chemicals as for standard print processing. If more reduction is required, repeat the procedure as many times as is necessary.

overall reduction of
density

A print that has a narrow tonal range between blacks and whites will usually appear flat or dark. To "pep up" the tonal range, the lights and darks must be separated. Farmer's Reducer will produce the separation. Mix the solution according to the directions on the package. After the print is in hypo for 90 seconds, remove it and rinse it with water. Immerse the print in the reducer for the time suggested, then take the print out and place it in hypo. Repeat the process as many times as is needed to reduce the density of the print. Do not try to make the total reduction in one step. Your eye cannot measure the effect of reduction until hypo has acted on the print. When the print has been reduced to the desired tonal values, return it to the hypo and continue with standard print processing.

toning for effect    A black and white print can be changed to blue and white, brown and white, red and white, or green and white with chemical toners. The toners replace black with another color. Some of the toners are single-solution, while others have two or more solutions. When using single-solution toners, the print is soaked in the chemical for the suggested time. The print is fully washed before toning. Following washing, the print is placed in the toner and allowed to remain for the recommended time. Constant agitation of the print is recommended.

With single-solution toners, the print can be removed at any time. The toner will stop working when the chemical is washed away. Single-solution toners bleach tones only slightly. For this reason many photographers use a toner for all their prints to improve the brillance of highlights.

Toning solutions which have two or more chemicals are somewhat more difficult to use. The print must be washed completely. All hypo must be removed. The washed print is placed in the first solution, which begins a bleaching action. Tones begin to fade, leaving only a faint image. The print is rinsed in running water. The print is placed in the second solution, a redevelopment chemical. The print will reappear in the tone of the chemicals used. Toning chemicals of this type are commercially packaged. Follow the directions on the package and you will have success changing the usual black and white picture to another color and white. After the print is fully toned, wash it for 20 minutes to remove all the toning chemicals.

**printing is subjective**

It was stated at the beginning of this chapter that print making is a subjective act. Perhaps now that processing and control methods have been defined, you can see why printing is highly personal. The photographer has the option of many controls over the negative. If he chooses to exercise any of the options, he is no longer printing a "straight" negative. What was recorded by the camera reflects his vision. The darkroom procedures of film and print processing reflect his later thoughts. It could be said that printing is "second-guessing": Just as the coach is second-guessed by the fans in the stadium, the photographer in the darkroom can second-guess the photographer behind the camera. Both photographers are usually the same man, but they do not have to be. When the two are not the same person, the darkroom man will have the last word with the image.

Assuming that only one photographer is working on the picture, how can he be sure to get the best print from a negative? The best test is to make several prints of the same negative employing all the methods of control and processing at your command. Three prints of a negative is considered the minimum when preparing quality prints. By making at least three prints there is an excellent possibility that one will contain all the values expected. Negatives that are difficult to control will require even more than three attempts.

A good exercise for mastering print making is to select one negative of average density. Make ten identical prints with that negative. At first,

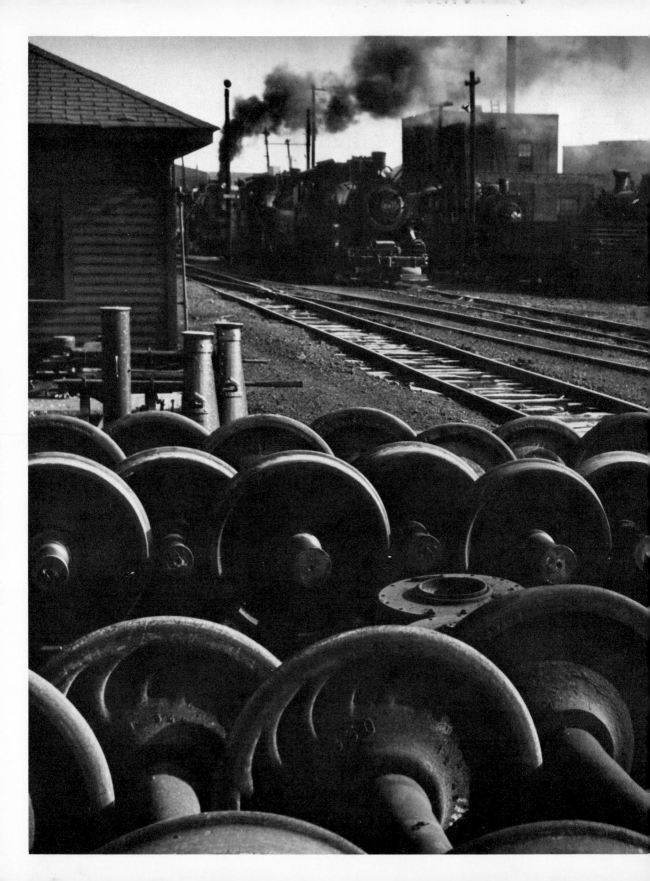

Some papers have a slight
brownish tone as their basic
tone. When these papers are
processed in developers with
warm tones a print with soft
brown values is produced. A
warm-tone paper has been
used in this picture of a
Japanese fishing boat.

*Photo on opposite page:*
Print toning changes a
monochrome print of blacks
and white to a simulated color
print. Selenium or sepia toners
change the tones to browns.
The railroad yard is more
realistic in tones of brown
and white.

you probably will not succeed, but in the process you will learn how to repeat the various controls outlined in this chapter. Dodging, burning in, raw light, and toning (if wanted) will have to be repeated with each print. The duplication of these controls will improve your printing technique. To get ten prints that are close in tonal values will require making many, many prints. The effort will be worth it. You will make better prints in the future.

Another exercise for printing is to see how many variations you can make from the same negative. Here the range of prints will depend on the printer's imagination. Don't be afraid to try anything that might make an interesting effect.

Whether the final print is hung on a wall, printed in a publication, or hidden in a family album, it must be the very best quality that you can produce. The print is your expression of an emotion or experience. Anything less than the full impact of that expression weakens the strength of your statement. No matter how long a time or how many attempts it takes, discipline yourself never to be satisfied with a print which is less than your best.

**Polaroid prints**
So far, the discussion of this book has centered on the conventional three-step process: film exposure, development, and printing. But another approach will be mentioned briefly because it is an important photographic tool. Polaroid photography is a one-step process that produces fine quality pictures almost instantly.

When Polaroid was first introduced, many professional photographers felt the process would pass. The unattractive brownish color of the early prints repelled them. Later, when black and white prints were possible, the Polaroid's popularity increased. While the first Polaroid prints required a minute or more for completion, today's black and white prints require only a few seconds.

At first photographers used the Polaroid to test their lighting and exposure. Gradually, Polaroid prints began to appear as the final product. Exhibitions of Polaroid photography have graced the Edward Steichen Gallery of the Museum of Modern Art, most importantly in a show of Marie Cosinda.

Color was added to the Polaroid system in 1962, and special adapters and backs for cameras enabled one to use Polaroid film with many conventional cameras. Thus, if one wants the Polaroid system as his recording instrument, there is no reason he cannot. There are restrictions, such as not being able to shoot as quickly as with conven-

Printing is a very subjective process. The photographer must use all the controls of tone and contrast to make the final picture communicate his purpose. All efforts are wasted if the final print is not of optimum quality.

tional film, and only one print is made. However, the duplication and enlarging services provided by the Polaroid Company enable one to have any print duplicated or enlarged with the same quality as the original print. Duplication is also possible by making a copy negative.

**questions for review**

1  What is contact printing?

2  What are the tools for editing and marking contact prints?

3  How does one mark contact prints to indicate the pictures wanted and the controls of tone?

4  Identify the three kinds of enlargers.

5  Explain the printing procedure for making enlargements.

6  What are two controls for light during enlarging?

7  Name two additional controls that aid print tone control.

8  Outline the print-processing procedure.

9  Name the chemicals used in print processing.

10  How should a print be mounted?

11  What is spotting and why is it important?

12  What is local reduction and how is it done?

13  What are chemical toners and how do they work?

**selected readings**  Adams, Ansel:  *The Negative,* Morgan and Morgan, New York, 1968.

——:  *Polaroid Manual,* Morgan and Morgan, New York.

——:  *The Print,* Morgan and Morgan, New York, 1968.

Carroll, John:  *Amphoto Lab Handbook,* Amphoto, New York, 1970.

Cory, O. R.:  *The Complete Art of Printing and Enlarging,* Focal Press, London.

Duckworth, Paul:  *Experimental and Trick Photography,* Amphoto, New York, 1967.

Floyd, Wayne:  *ABCs of Developing, Printing and Enlarging,* Amphoto, New York, 1962.

Foldes, Joseph:  *Practical Way to Perfect Enlargements,* Amphoto, New York, 1954.

Gibson, Henry Louis:  *Perfecting Enlarging,* Amphoto, New York, 1966.

Hammond, Arthur:  *How to Tone Prints,* American Photographic, Boston, 1946.

Holter, Patra:  *Photography without a Camera,* Hastings House, New York, 1971.

Jacobs, Lou, Jr.:  *How to Use Variable Contrast Papers,* Amphoto, New York, 1970.

Jacobson, C. I.: *Enlarging: Technique of the Positive,* Focal Press, London.

Jonas, Paul: *Manual of Darkroom Procedures and Techniques,* Amphoto, New York, 1967.

Lootens, J. Ghislain: *Lootens on Photographic Enlarging and Print Quality,* Amphoto, New York, 1958.

Marx, Dick: *Printing with Variable Contrast Papers,* Amphoto, New York, 1961.

Pittaro, Ernest: *Photo Lab Index,* Morgan and Morgan, New York, 1971.

Satow, Y. Ernest: *35mm Prints and Negatives,* Amphoto, New York, 1960.

Wolbarsh, John: *Polaroid Portfolio,* Amphoto, New York, 1959.

Woolley, A. E.: *Photographic Print Quality, Procedures and Papers,* Chilton, Philadelphia, 1959.

TABLE 11-1
ENLARGERS

| Make and Model | Style | Negative Size | Negative Holder | Focus |
|---|---|---|---|---|
| Agfa Varioscop | Condenser | 35mm–4 x 5 | Dustless[1] | Auto |
| Varioscop | Condenser | 16mm – 2¼ x 3¼ | Glass[2] Dustless | Auto |
| Beseler 23C-11 | Condenser | 8mm–2¼ x 3¼ | Dustless | Manual |
| 45M | Condenser | 8mm–4 x 5 | Dustless | Manual |
| CB7 | Condenser | 8mm–4 x 5 | Dustless | Auto |
| 57MUT | Condenser | 5 x 7 | Dustless | Auto |
| Durst J66 | Condenser | 35mm–2¼ x 2¼ | Dustless | Semiauto |
| M300 | Condenser | 35mm | Dustless | Range finder |
| M600 | Condenser | 8mm–35mm | Dustless | Manual |
| A600 | Condenser | 35mm–2¼ x 3¼ | Dustless | Auto |
| DA900 | Condenser | 35mm–2¼ x 3¼ | Dustless | Auto |
| L1000 | Condenser | 35mm–4 x 5 | Dustless | Manual |
| L138S | Condenser | 35mm–5 x 7 | Glass Dustless | Manual |
| Leitz Focomat IIC | Condenser | 35mm–2¼ x 3¼ | Glass | Auto |
| Focomat IC | Condenser | 35mm | Semiglass | Auto |
| Valoy | Condenser | 35mm | Semiglass | Manual |
| Lott 135 | Condenser | 35mm–828 | Dustless | Manual |
| Minox | Condenser | 8mm–16mm | Dustless | Manual |
| Simmons Omega A3 | Condenser | 35mm–126 | Dustless | Manual |
| B7 | Condenser | 35mm–2¼ x 3¼ | Dustless | Auto |
| D2 | Condenser | 35mm–4 x 5 | Dustless | Manual |
| D4 | Condenser | 35mm–4 x 5 | Dustless | Auto |
| Solarmatic 120 | Condenser | 35mm–2¼ x 3¼ | Dustless | Semiauto |
| Solar 120 | Condenser | 35mm–2¼ x 2¼ | Dustless | Manual |

[1]Uses no glass to hold negatives; holder grips film on edges and holds firm.

[2]Film is sandwiched between two pieces of glass to hold negative flat and firm.

TABLE 11-2
CONTACT-PRINTING
PAPERS

| Make | Size | Contrast | Weight[1] | Surface[2] | Safelight[3] |
|---|---|---|---|---|---|
| *Agfa* | | | | | |
| Contactone | 3½ x 5, | | | | |
| | 20 x 24 | 1,2,3 | SW,DW | 111 | OA |
| *Eastman Kodak* | | | | | |
| Azo | 3 x 5 to | | | | |
| | 8 x 10 | 0,1,2,3,4,5 | SW | F,N,E,D | OA |
| Velox | 3 x 5, | | | | |
| | 8 x 10 | 0,1,2,3 | SW | F | OA |
| Athena | 3 x 5, | | | | |
| | 8 x 10 | 0,1,2,3 | SW | B,G,Y | OA |
| *GAF* | | | | | |
| Cyko | 2¼ x 2¼, | | | | |
| | 20 x 24 | 1,2,3,4 | SW,DW,M | GL | OA |
| Lustrex | 5 x 7, | | | | |
| | 8½ x 11 | 1,2,3 | SW,DW | GL,K | OA |
| Proof Glossy | 4 x 5, | | | | |
| | 8 x 10 | 2 | SW | GL | OA |

[1] SW: single weight; DW: double weight; M: medium weight.
[2] See Table 11-5.
[3] Orange-yellow filter.

TABLE 11-3
PROJECTION-PRINTING
PAPERS,
SINGLE-CONTRAST

| Make | Size | Contrast | Weight[1] | Surface[2] | Safelight[3] |
|---|---|---|---|---|---|
| *DuPont Agfa* | | | | | |
| Brovira | 4 x 5, 20 x 24 | 1,2,3,4,5,6 | SW,DW | 111,119 | OA |
| Record Rapid | 4 x 5, 20 x 24 | 2,3,4 | SW,DW | 111,118,119 | OA |
| Pro-Proof | 4 x 5, 11 x 14 | 2 | SW | 111,118,119 | OA |
| *DuPont* | | | | | |
| Velour Black | 4 x 5, 30 x 40 | 1,2,3,4 | SW,DW | AW,R,RW,ALW, DL,T,YW,BW | 55X |
| Warmtone | 4 x 5, 20 x 40 | 2 | DW | DL,DLW,DDL, DS,Y,ZL | 55X |
| Adlux | 5 x 7, 16 x 20 | 2 | DW | Film | 55X |
| *Eastman Kodak* | | | | | |
| Illustrator's Azo | 5 x 7, 16 x 20 | 0,1,2,3,4 | SW,DW | F,E | OA |
| Kodabromide | 5 x 7, 16 x 20 | 1,2,3,4,5 | SW,DW | F,N,A,E,G | OA |
| Medalist | 5 x 7, 16 x 20 | 1,2,3,4 | SW,DW | F,J,E,G,Y | OA |
| Opal | 5 x 7, 16 x 20 | 2 | DW | B,C,G,P,L,R, V,Y,Z | OA |
| *GAF* | | | | | |
| Vee-Cee | 4 x 5, 20 x 24 | 1,2,3,4 | SW,DW | | OA |
| Cykora | 3¼ x 4¼, 20 x 24 | 1,2,3,4 | SW,DW | | OA |
| Jet | 3¼ x 4¼, 20 x 24 | 1,2,3,4 | SW,DW | | OA |
| Allura | 2¼ x 3¼, 20 x 24 | 2 | DW | | OA |
| Indiatone | 2¼ x 3¼, 20 x 24 | 2 | DW | | OA |
| Projection Proof | 4 x 6, 16 x 20 | 2 | DW | | OA |

[1] SW: single weight; DW: double weight.
[2] See Table 11-5.
[3] Orange-yellow filter; 55X filter for DuPont papers.

TABLE 11-4
PROJECTION-PRINTING
PAPERS,
MULTICONTRAST

| Make | Filter | Size | Weight[1] | Surface[2] | Safelight[3] |
|---|---|---|---|---|---|
| *Agfa* | | | | | |
| Gevagam | Agfa | 4 x 5 to 20 x 24 | SW,DW | KB | 55X |
| *DuPont* | | | | | |
| Varigam | DuPont | 4 x 5, 20 x 24 | SW,DW | A,AL,R,B,BT, DL,DS,T,Y | 55X |
| Varilour | DuPont | 4 x 5, 20 x 24 | SW,DW | AW,R,RW,ALW, DL,T,YW | 55X |
| High Speed Varigam | DuPont | 4 x 5, 20 x 24 | SW,DW | R,A,AL,B BT,DL,T | 55X |
| *Eastman Kodak* | | | | | |
| Polycontrast | Eastman | 5 x 7, 16 x 20 | SW,DW | F,N | OA |
| Polycontrast Rapid | Eastman | 5 x 7, 16 x 20 | SW,DW | F,N,G,Y | OA |
| Polylure | Eastman | 5 x 7, 16 x 20 | DW | G | OA |

[1] SW: Single weight; DW: double weight.
[2] See Table 11-5.
[3] Orange-yellow filter; 55X filter for DuPont papers.

TABLE 11-5
CODES FOR
IDENTIFYING
PAPER SURFACES

*Agfa: 111:* white glossy; *118:* white, fine-grain, semimatte; *119:* white, fine-grain, luster; *K8:* white, glossy; *1:* white, glossy; *2A:* white, semimatte

*Eastman Kodak: A:* smooth, white, luster; *B:* smooth, cream-white; *C:* matte; *D:* fine-grain, white; *E:* fine-grain, white, luster; *F:* white, glossy; *G:* fine-grain, off-white; *J:* smooth, high luster; *K:* fine-grain, high luster; *L:* rough luster; *N:* smooth, semi-luster; *P:* old ivory; *R:* tweed, off-white; *V:* extreme matte suede; *X:* tapestry, cream-white, luster; *Y:* silk, cream-white; *Z:* tapestry, old-ivory, luster

*DuPont: AW:* brilliant white, semimatte; *BW:* brilliant white, semimatte; *BTW:* brilliant white, semiglossy; *DL:* white, luster; *R:* white, glossy; *RW:* brilliant white, glossy; *T:* white, glossy, double weight; *TW:* brilliant white, glossy; *YW:* brilliant white, silk; *AL:* white, semimatte document

*GAF: A:* smooth; *B:* stippled sheen; *GL:* smooth, white, glossy; *J:* fine-grain, slight sheen; *K:* white, light-luster; *M:* silk, high sheen; *N:* semimatte, medium rough; *T:* deeply embossed; *V:* pure white, moderate sheen; *X:* high sheen; *Y:* silk, high sheen

# part 4

## photography and you

# chapter 12
## experiments

There are many ways to make exciting or unusual photographic images. These experimental processes can become a standard operational procedure for photographers who like to manipulate their pictures.

**image management** There are several well-known photographers who have made their reputations with one or more of the experimental procedures mentioned in this chapter. Printing double negatives, or montages, or photograms are three methods used as standard procedure by several professional photographers. All three are useful creative techniques. Others that are not as frequently used — but nevertheless serve well — are *develart* (drawing with developer on photographic paper), *solarization* (a partial turning of the positive print tones to negative tones, or with a negative the tones are turned to partial positive), *montages constructed from prints* that are cut and mounted to form one picture, *negative prints from color slides, positive prints from color slides,* and *copying* from original prints.

All techniques are tools for the photographer's use. They might not be part of his usual approach to photography, but they should be a part of his knowledge about the total potential of the medium.

photograms No negative is needed to make a photogram. Any assortment of shapes and objects such as pliers, screws, leaves, keys, wire, that will fit on the printing paper may serve as images. In a darkroom with proper safelighting, place the items you want to use for a photogram on the emulsion side of a sheet of printing paper (contact or enlarging). Arrange the shapes in whatever composition you desire. Expose the paper to light (the enlarger light is recommended). Without the negative in the holder, unobstructed light hits the light-sensitive surface of the paper. The objects restrict light in the areas they cover. Where the light hits, the paper will print dark; and where the objects hold the light, the areas will be either totally white or shades of gray, depending on the transparency of the object. Any light source will do the job, even a flashlight. A desk lamp can be used. When the paper with the objects has been exposed to light, it is processed as any photographic print would be.

develart No darkroom is required to make develart drawings. The drawings are produced in normal room lighting, or even outside. The tools required are photographic printing paper, brushes, pens or other drawing instruments, hypo, and developer. The paper is exposed to light. (Once the paper is exposed, it can no longer be used for conventional printing.) Expose only the amount of paper you think you will use. It is better to expose too little and be able to get more. Nothing happens to the paper when it is exposed. Only when developer is applied will the paper react.

Develart, drawing with developer, is a technique to make photographic sketches. Light-sensitive paper is exposed in room light and the images are drawn using various dilutions of paper developer. The completed drawing is processed in fixer and washed as a regular print.

Develart drawing. **John Solowski.**

Develart drawing of William
Faulkner.

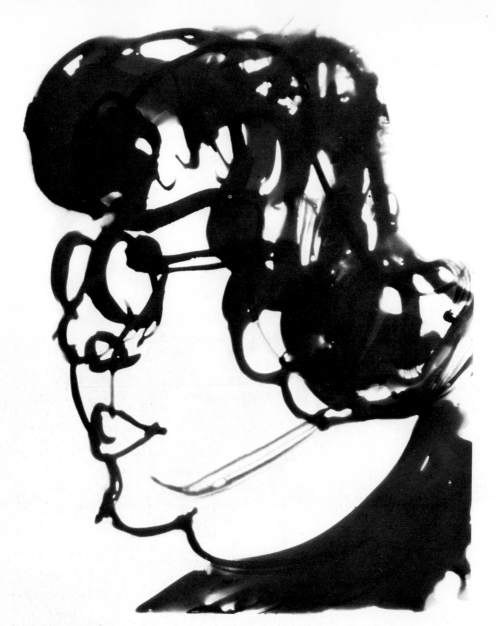

Develart drawing completed
in 1 minute. Using a weak
dilution of developer, the
entire sketch was done before
the image began to appear.
The technique is excellent for
overcoming the urge to erase:
Once the line is drawn, it
cannot be removed.

Develart drawing on film
which is printed in the usual
photographic method. The
drawing was a negative
image, and the print is a
positive image.

The two photograms, here and on the opposite page, by a five-year-old who learned the basic processes of photography in a four-week workshop. By using different exposure times, there is a deeper penetration of light through the leaves. **Jennifer Kennedy.**

Drawing instruments—brushes, pens, cotton swabs, etc—are used in develart. The drawing tool is dipped in developer and applied to the exposed paper. The strength of the developer will control the darkness of the lines drawn. Undiluted developer will make rich black lines, and diluted developer will record gray or light lines. Any standard paper developer works. Figure drawings, still-lifes, landscapes, or abstract designs are all good subjects for drawing with developer.

When developer is applied to the paper surface, the image will not appear until seconds later. The weaker the developer, the longer it will take for images to appear. Develart is an excellent technique for the person who is inhibited by fear of making a mistake when drawing. Once the line is drawn, it cannot be seen immediately or erased. If

quick drawings are made, you will be finished before the lines are fully visible.

When the drawing is completed, it is placed in hypo and processed as any print would be. The action of the developer will stop when the print is in the hypo. There are times when it will not be possible to put the drawing in hypo immediately. When drawing out of doors the drawings can be placed between pages of a newspaper to protect them until they can be placed in hypo. The developer will continue to work, but the newspaper will absorb much of it.

Variations of develart drawings may be achieved by first drawing the image with a soft wax pencil, then applying the developer. Make sure the area around the wax lines are covered with developer. After the

developer has acted, place the drawing in hypo. The wax lines will dissolve in hypo and leave white lines. The visual effect is a white line drawing on a dark background.

montages

When several images are combined they are called "montages." The combination can take place in the darkroom or when the prints are finished and ready for mounting.

Montages made in the darkroom use two or more negatives. The theme of the final print is designed and a sketch is made of the placement of each of the negatives. A sheet of white paper is used on the enlarging easel to sketch the areas where the negatives will be printed. This sketch becomes the blueprint by which the montage will be constructed. When selecting negatives for a montage, it is advisable to use negatives of almost identical density. Having the negatives of the same density will enable printing on the same contrast of paper without tonal variations. Even when using multicontrast papers, the negatives will print better if they are of the same density.

This photogram was composed with objects that were not transparent. The tones are white and black. **Jennifer Kennedy.**

Combining two negatives during printing resulted in a montage that illustrated a story on headaches. Montages frequently will make a statement that a single image cannot.

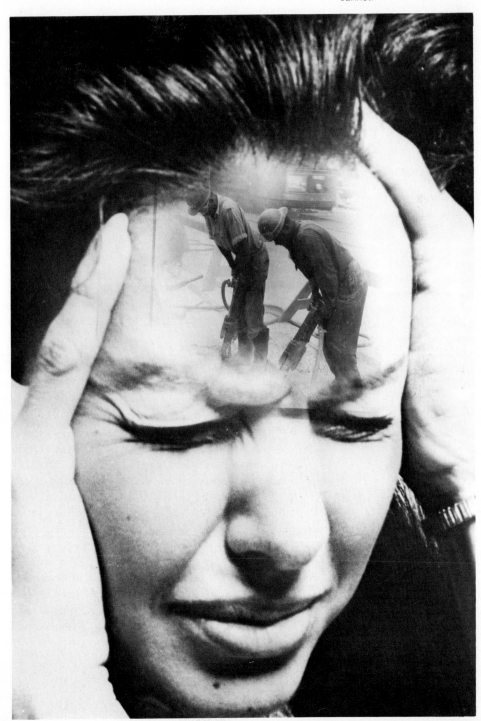

When one area of the composition is printed, the other areas must be protected from light. If one negative is to fit inside an area of a second negative, the area must be held back to keep the tones from printing over each other. When the second negative is printed, the first image will have to be held back to keep the second negative from printing over the first. This control of tones and overlapping images must be maintained with as many negatives as you fit together in the montage.

Development and processing are no different for montages than for conventional printing processes.

The second method for creating montage prints is by fitting completed prints together. Again a master theme or blueprint is conceived. Either the prints are made to scale according to the master plan, or they are selected from prints already processed. The parts of the whole are cut and glued together or mounted with tissue. Care must be taken to cut all edges as clean as possible. It is not uncommon for retouching and spotting of edges to be required in this method of montage making.

When all the pieces of the montage are assembled and mounted, you will have only one print, the original. To get a master negative of the original, a copy negative must be made.

In fact, when either the printed montage or the constructed montage are completed, you have only the original. If either is to be reproduced, a copy negative must be made, as discussed later in this chapter.

double printing

Another form of montage print, not so demanding as the previous technique, is the double-printing technique. Two negatives that fit together in design and density are sandwiched together and placed in the enlarger holder. They are printed as a single negative with both images projecting at the same time. Juxtapositioning of two shapes or objects will often form interesting compositions. The two images will make a stronger statement than the two shown as separate photographs. Sandwiching negatives for double printing does not mean they are to be stuck together. Place one negative over the other and hold both in place with the negative holder. Never cut or damage a negative.

solarization

Positive tones become negative tones in a print that has been solarized, and negative tones become positive. Solarization is a reversal of existing tones from negative to positive or from positive to negative. The effect is achieved by exposing a partially developed print or negative to raw light.

Two negatives were combined in this composition to illustrate how it feels to be on a drug trip.

In this montage a starlit
night is combined with a
nightgowned model to
illustrate sleepwalking
**Andre de Dienes.**

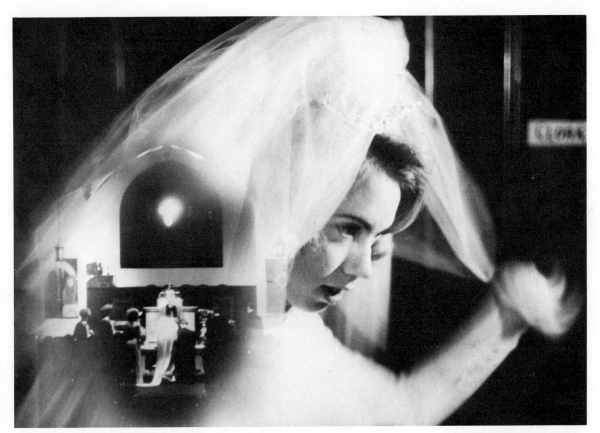

Double printing was used to produce a montage of a young girl and her wedding. Montages can also be created in the camera, but you must be able to double expose the film.

This is a triple exposure in the camera on one negative to include images that could not be pictured together in any other way.

A double exposure of the full figure and a close-up of the girl's head made this montage. Different lighting for tonal variation added to the composition. **Lennie Warren.**

A negative of the stock-market page and a negative of two happy market players were sandwiched together and printed as one for this double image. **Marty Blumenthal.**

Solarizing negatives is done when the film is three-quarters developed. Single sheets of film can be handled one at a time. But single frames on a roll of film cannot be solarized without cutting them from the roll or solarizing the entire roll. The film is taken from the developing tank and given a flash of raw light. The film is not returned to the developer. This would cause the film to turn totally black. The film is soaked in water for the remaining development time. Developer on the film will continue the processing. Place the film in hypo following development and continue standard processing. There is no definite way to know what solarized images will look like.

Solarizing prints is done the same way as negatives, except you can watch the results. The print is exposed for the required time. When the print has developed over half-way, take it from the developer and place it in water. Turn a light on briefly and allow the print to continue developing in water. You will be able to see the negative/positive changes. When the picture pleases you, transfer it to hypo and follow through. In this process, as with montages, you will have only one original. A copy negative must be made if additional prints are wanted.

positive prints from color

Interesting effects are possible when a color transparency is used as a negative and printed. The positive color tones are printed to negative tones. The effect is the same as if the contents of the color photograph had been shot originally in black and white. But a negative print is the product. The exposure time usually is longer than for negatives, but a test strip will help determine it. Two or more color compositions can be combined as with double printing. Variations with this kind of experimental printing are as broad as your imagination.

negatives from color transparencies

There are times when a black and white negative is wanted from a composition originally shot in color. The color transparency can be converted to black and white with highly acceptable tones. The color film is "printed" on panchromatic film. Using film rather than paper, the color shot is projected just as if a paper print were being made. The film is a slow and fine grained. Exposure is determined by the speed of the film and the f:stop on the enlarger lens. After the exposure is made, the film is processed as conventional film. All the printing is done in total darkness.

When the color image is sized and shaped for the film enlargement, a negative holder is used in place of the print easel. Focus is made for the position of the holder. Normal darkroom light can be used until

The two images shown here and on opposite page were solarized, one as a negative, the other as a positive, after a copy negative had been made. The reflection in the glasses was cut out and; pasted in place before the copy negative was made. There is an endless number of combinations that both solarizing and double imagery can compose. **Rick White.**

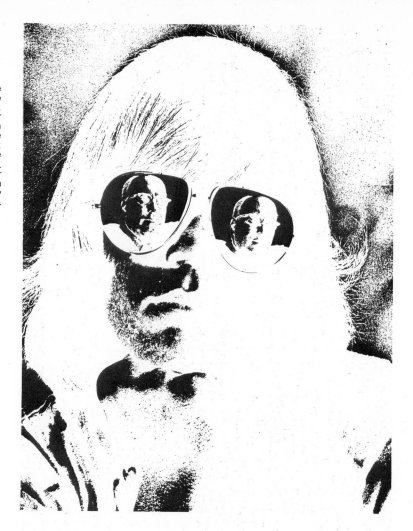

the film is ready for exposure. Position the holder for the printing. Turn off all lights and expose the film. Then load the film in a tank and process it. If several film negatives are to be printed, they can be left in the film holder with the protective slide covering. When all the film is ready for processing, it can be loaded into the tank. Unless a uniform exposure time has been established, it is advisable to develop each film immediately after exposure. Inspection of the results will determine if another exposure is necessary.

I prefer to make color conversions from transparencies on 8 x 10 sheet film. The negative is contact printed, and no additional enlarging is required. When a small transparency is enlarged into a conversion

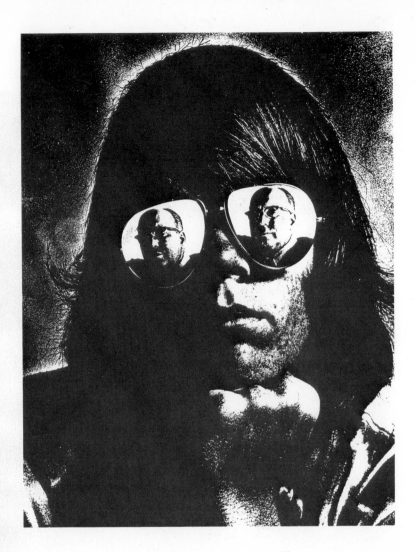

negative, and it is again enlarged to make the positive print, there is a definite increase in grain pattern and a breaking down of linear sharpness. Very good quality black and white prints are made from color conversion negatives that are contact printed.

This is a process for making full-toned negatives from print originals. **copying**
Any film will copy positive prints. But not all films will record the tonal scale and values with accuracy. Only films sensitive to blue light will restrict the tones to their true value. Unfortunately, blue-sensitive copy films are available in sheet form only, and a view camera is needed to do quality copy work. The original is positioned in front of the cam-

Double images were printed and the print partially solarized. The disadvantage of this approach to solarization is that only one print is produced. Any future copies will have to be made by making a copy negative from the print.

era with no glare or reflection. The camera is focused to fill the nega-
tive with the same composition as is in the original print. Exposure
is metered, and the picture is made. Because the film has limited
sensitivity, it can be developed by inspection under a weak yellow
lamp. The remainder of the processing is the same as for other film
development.

It is possible to get some unusual patterns on a picture by spreading **salt the surface**
either salt or sand on the surface of the paper prior to exposure. After
the negative has been composed and focused on the easel, you can
add another element of design by sprinkling or spreading sand or salt
onto the paper. Where the salt or sand is heavy, or concentrated, the
light will not penetrate. Lighter concentrations will permit the pro-
jected image to record on the paper. In addition to the negative image,
the texture of the sand or salt will also be printed. This technique does
not have many applications, but it is one to remember for the special
times when it can be useful.

If you want a sheet or roll of film to be highly grainy, one easy way to **grainy texture**
accomplish the objective is to develop your film in developer normally
used for print making. Almost any film can be made to be grainy when
developed in Dektol. The faster films, such as Tri-X, become very
grainy when force developed in Dektol. The texture of excessive grain
can enhance moods of certain compositions. When you want to ob-
tain this excessive grain, the process should begin at the time of expo-
sure. Slightly overexpose: If the exposure should be 1/125 second at
f:11, expose at 1/125 second at f:8. This one stop will be enough to
increase the density without making the negative too dense for print-
ing. Develop the film in Dektol that is diluted with one part water for
3 minutes at 70 degrees. A favorite subject for this kind of treatment
is nude photography. The added texture created by the grain gives a
stoney granite feeling to the pictures.

Motifs of tone are possible by printing a conventionally exposed and **high contrast**
developed negative on very high-contrast paper. Dropping out middle
gray tones, which happens with high-contrast paper, leaves an almost
black and white outline effect. The higher the contrast, the less gray
tonal values will be recorded. You can also employ this technique by
printing the negative on high-contrast lithograph film to get a high-
contrast positive. This positive is then printed to a high-contrast nega-

Print reversal has been used here to produce a negative effect. The original negative has been printed on process film.

A negative print was made from a color transparency. There are times when interesting effects are possible by printing the positive tones of a color picture to reverse tones.

This positive picture was converted from a color transparency. The color picture was printed on negative film using the enlarger as though the original scene had been shot using black and white film. The negative was processed and printed, producing this positive.

Interesting effects in tonal contrast are possible by printing a normally exposed negative on high-contrast paper. If the negative has been slightly overexposed, the contrast will be even greater.

Texture screens can turn an ordinary picture into a photograph with visual interest. The two pictures on this page and the picture at the top of p. 350 are the same negative with a steel line screen, paper-negative screen, and tapestry screen.

A paper negative from a
35mm transparency. The
paper is thin-weight Eastman
Polycontrast A.

A positive print from the paper negative. The image is softened and diffused because of printing through the paper thickness.

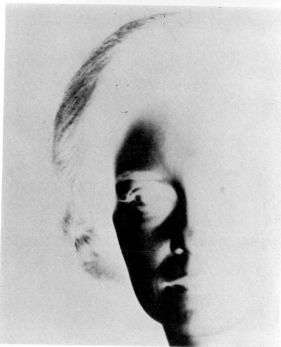

A paper negative on which lines have been drawn on the back to outline the eye, nose, cheek, and chin.

A print from the previous paper negative. **Lennie Warren.**

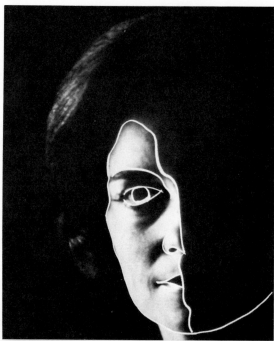

A straight print from the paper negative without drawn lines.

A paper negative made from a color transparency was used to make this print. To achieve the paper negative, make a print on a thin-weight paper, such as Eastman's Polycontrast A, and process as usual. When the print is dry, it is printed on any paper to get a positive.

tive, with a continued loss of tone. You can repeat this as many times as you wish, and the tones will be reduced on each exposure. The negative that contains the degree of tonal drop-out and contrast you want is then printed as a paper positive for a final print. It is not necessary to go through the process of making negative and positive film images to get a high-contrast print. You can accomplish the goal by using high-contrast paper, underexposing the print slightly (about one-third the time you would give a full-tone print), and developing it longer than the usual 2 minutes. Portraits are sometimes very striking when handled this way.

Distortion of a normally
exposed negative can be
accomplished by bending the
paper on the easel during
printing. All vertical and some
horizontal lines will bend in
the shape of the bent paper.

Funny and curious images are possible by drawing lines on the actual print during printing. These figures were created by drawing lines with a red wax pencil on the print and then exposing the negative in the usual manner. During hypo time, the wax dissolved, leaving white lines and the figures suggested by the broken glass windows.

When the techniques, processes, and procedures of conventional photography have become second nature to you, the experiments in this chapter will extend your creative efforts. The techniques are not to be considered cures for badly handled photographs. Rather, they are means to innovate and expand photographic creativity.

**questions for review**

1 Name and define seven methods and techniques of image management.
2 Explain the process for making a photogram.
3 What is develart?
4 What is the difference between a double-negative print and a montage?
5 How is solarization achieved in films? In prints?
6 Explain the process for making a copy negative from a print.

**selected readings**

Carroll, John S.: *Amphoto Lab Index,* Amphoto, New York, 1970.

Cory, O. R.: *The Complete Art of Printing and Enlarging,* Focal, London, 1970.

Duckworth, Paul: *Experiments and Tricks,* Universal/Amphoto, New York, 1961.

Feininger, Andreas: *The Creative Photographer,* Prentice-Hall, Englewood Cliffs, N.J., 1955.

Holter, Patra: *Photography without a Camera,* Hastings House, New York, 1971.

Lootens, J. Ghislain: *Lootens on Photographic Enlarging and Print Quality,* Amphoto, New York, 1958.

Moholy Nagy, L.: *Vision in Motion,* Theobald, New York, 1947.

Newman, Thelma: *Wax as an Art Form,* Thomas Yoseloff, New York, 1966.

Pittaro, Ernest: *Photo Lab Index,* Morgan and Morgan, New York, 1971.

Woolley, A. E.: *Creative 35mm Techniques,* A. S. Barnes/Amphoto, New York, 1963, 1970.

———: "Develart-Drawing with Developer," *School Arts,* vol. 59, no. 1, pp. 17–20, September 1959.

———: *Photographic Films and Their Uses,* Chilton, Philadelphia, 1960.

———: *35mm Nudes,* Amphoto, New York, 1966.

# chapter 13

## which approach for me?

Throughout this book the objective has been to present concepts, techniques, and procedures which are necessary for the production of photographs. Philosophies of compositional design, techniques, camera operation, and the theories of final prints have been established and defined. In short, all information which would be useful to anyone starting out on an adventure into the exciting world of photographic art and communication has been packed into the chapters of this text. With an understanding of the material presented herein, the next step is to decide how you can best apply them. The question to be asked is, "How do I use photography?"

**the choices**  There are many "schools" or approaches to photographic application, and in my opinion, they are all related. Each of them plays an important role in the development of the photographer's command of the medium. Perhaps the ideas or approaches could be likened to the keys of a piano keyboard. The keys play the same notes but in different octaves. In photography, various "schools of thought" play the same melody but with the results being in a different channel of communication.

Listed below are ten photographic approaches. Some overlap others. Combinations of one or more are not unusual. But each is a way to think and to apply specific concepts of photography.

1  Using the smallest lens opening to attain the sharpest depth of field. This has been named the "f:64 approach."

2  Spontaneous response to uncontrolled action. This is referred to as the "instant image," or "the decisive moment."

3  Maximum manipulation of the film and print image. This approach includes the many special techniques outlined in Chapter 12.

4  Big, blue, and glossy is the technique used in salon or exhibition photography. There are special salons of photography where pictures are selected by judges for hanging. In this type of competition the photographs must have immediate impact. Printing the photograph large, toning it blue, and using glossy paper is one way to achieve impact.

5  Compositions of inanimate objects or peeling paint attract another type of photographer. This has been called the "garbage-can" approach. All images are of nonhuman subjects.

6  The camera as historian is the concern of those who use their photography to report the events of world concern. Photojournalism is a powerful force and demands responsible dedication by those who elect to use their cameras in this field.

7  The studio or portrait photographer is the best known of the camera practitioners. This is also the one approach to photography that has been guilty of the greatest abuse of the medium.

8  Detailed documentation of work or building progress and other activities associated with industry produces another approach to photography. The industrial photographer is both creative and disciplined.

9  Extreme close-up photography explores the world of the nearly invisible. Microphotography and macrophotography see the unseen on film.

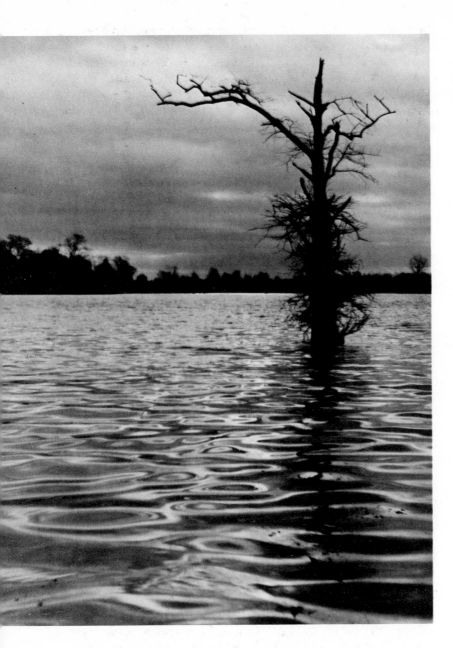

There are many "schools" of photography. From the salon or exhibition approach (as this picture, entitled "Sombrous") to the highly commercial applications, there is an area of photography that can fit everyone's taste and talent.

10 Advertising photography probably uses one or all of the afore-mentioned concepts of photographic application at some time. Yet it is a special approach because it demands exciting imagery while featuring a specific product.

Some of the great photographers have elected to work in only one of these ten approaches to the medium. Edward Weston finally settled in the f:64 school after spending years working in the portrait and manipulation schools. Ansel Adams has devoted most of his photographic life to the f:64 idea, but he has tried other techniques with success. Henri Cartier-Bresson has never left the decisive-moment approach. Aaron Siskind and Harry Callahan prefer inanimate designs and peeling paint. Yet both men have created outstanding photographs of street scenes and people. Alfred Eisenstaedt, David Douglas Duncan, Elliot Elisofon, W. Eugene Smith, Larry Burrows, Cornell Capa, Robert Capa, Bruce Davidson, Charles Harbutt, Flip Schulke, and David Linton are but a few of the great photographers who have devoted their lifetimes to photojournalism. The world is better informed because these photographers have used their cameras to report history.

How one uses his camera is a very personal choice. The things he sees and how he sees them are determined by his education, his knowledge, and his interests. How he prepares himself mentally, physically, and emotionally will help determine the kinds of photographs he takes. Knowing how to expose and process film and paper does not prepare anyone to create pictures. Knowledge of the mechanical and chemical processes of photography is necessary to operate the medium. But an excellent technique of print making does not mean an excellent photograph. The information contained in this introductory text is but the key to open the door of photographic discovery. The key is in your hands.

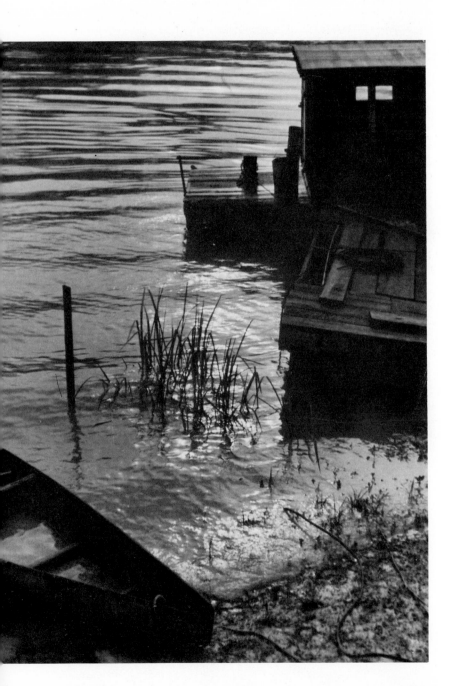

Big, blue, and glossy is one of
the salon concepts that has
produced some exciting
pictures. This river scene is
more dramatic because the
blacks were altered to blue
and the print made big.

There are as many
compositions of inanimate
objects as there are cameras
to picture them. This approach
to photography depends on
strong design for success.
**Burney Myrick.**

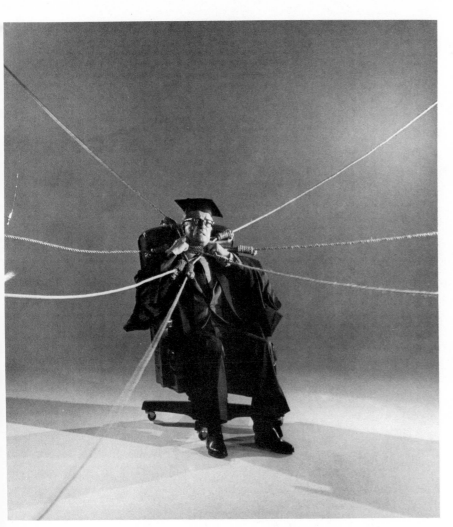

Creative studio photographers are capable of taking ideas and turning them into visual products. In this picture the idea was to show a college president who is drawn in several directions during a crisis. **Lester Krauss.**

Models carry out a theme of a
self-reliant woman. The studio
enables optimum control for
this approach to photography.
**Alfred Gescheidt.**

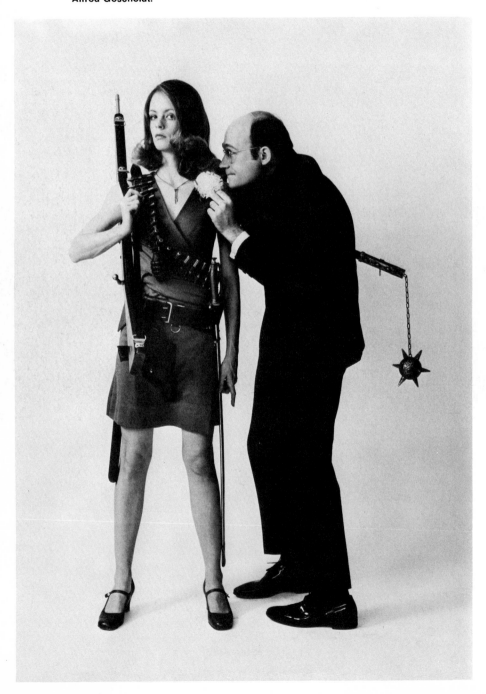

Henri Cartier-Bresson has the entire world as his studio. People in their own environment are the interest of this talented French photographer. Cartier-Bresson is both historian and reporter with his camera. **Henri Cartier-Bresson.**

Photojournalism is a
powerful force in
communication and demands
responsible, dedicated
photographers who often are
required to risk their lives in
search of objective journalism.
This picture is from an essay
on mental health.

For the sharpness necessary to make this picture successful, the smallest lens opening had to be used. All approaches to photography are valid. The photographer should know them, learn them, and use them when they will benefit his work.

# glossary

| | |
|---|---|
| **abstract image** | an image that alters the visual reality of the original object or scene |
| **accelerator** | in development, a chemical or procedural catalyst that speeds up development time |
| **art of subtraction** | isolating the components of a compositional design to form the photographic content |
| **ASA speed** | American Standards Association system of measuring the light sensitivity of a film emulsion. |
| **automatic diaphragm** | a mechanism which sets the f:stop of the lens at the instant the shutter is released |
| **available light** | lighting over which the photographer has no control, existing light |

**backlight** a lighting source that is behind the subject but in front of the camera

**base density** the degree of controlled fog level before film is exposed to light

**bounce light** a lighting source that is reflected onto the subject from a surface

**box camera** the basic pinhole-camera design to which shutter and lens have been added

**burning in** adding light to an area of a photograph when printing; another term for *printing in*

**cadmium cell** a light-sensitive unit in an exposure meter for measuring the intensity of light

**calotype** Henry Fox Talbot's first name for his negative-to-positive process

**camera body** the housing for film and the devices which expose light to it

**camera journalism** reportage that includes illustrations for impact, as in newspapers, magazines, and electronic media

**camera obscura** a dark chamber with a small opening that transmits images by means of light from outside the chamber onto a flat white surface opposite the hole

**collodion process** a wet-plate process for film emulsion in negative-to-positive process

**contact printing** making negative-sized prints with paper and film touching during exposure

**contact sheet** a group of negatives printed by contact on one sheet of photographic paper

**contrast** the range of white and black tonal variation in a print or negative

**cropping** altering the compositional elements of a negative when preparing the print

**crosslight** a lighting source that forms at least a 90 degree angle from camera to subject

**daguerreotype** a direct positive photographic image invented by Louis J. M. Daguerre with important contributions by Niépce

**daylight** the light supplied by sunlight, whether indoors or out

**decisive moment** Henri Cartier-Bresson's definition of the instantaneous recognition and recording of elements that create photographic compositions

**density** the amount of silver deposited on a film, which controls the amount of light that can pass through it

**depth of field** the area of sharpness both in front of and beyond the point of focus at a given f:stop

**develart** a drawing made with developer on light-sensitive paper

**developer** the chemical that activates a latent image on film or paper

**developing agents** chemicals such as elon that act on exposed film

**diaphragm** a device that controls the amount of light passing through the lens

**diffused light** light that is filtered through an object or material to reduce the contrast between light and dark

**discipline of isolation** selecting the elements of a composition by separating them from their surroundings

**dominant third** the most important area of a composition that has been divided into thirds

**double negative** a combination of two or more negatives that produces a positive-image composition

**dry plates** glass-based film emulsions that can be prepared, stored, exposed, and processed in interrupted sequence

**elasticity of image** reduction and enlargement of an original image from full scale to film scale to print scale

**electronic flash** repeating illumination that is electronically produced in synchronization with the shutter

**emulsion** a chemical mixture that coats the film base and is sensitive to light

**enlarger** an instrument for making negatives into prints larger than the original negative

**exposure** the correct combination of lens setting, or f:stop, and shutter speed for a given film

**exposure meter** an instrument that measures the light from a source and determines the exposure for a given film speed

**Farmer's Reducer** a chemical used to reduce the overall or local density of a print
**fill-in light** a secondary source of illumination that supports the main light
**film plane** the position of film in a camera
**film speed** the ASA (American Standards Association) rating of light sensitivity
**filter** a colored gelatin that controls which light rays will be transmitted to film
**filter factor** the number used to adjust light-transmission reduction to achieve correct exposure when using a filter
**flash contacts** the connections that plug flash equipment into a camera to synchronize the flash with shutter release
**focal length** the distance between the center of the lens and the point at which parallel light rays come to a focus point
**format** the shape of a negative
**f:stops** the settings on a lens that control light transmission to film

**gamma** the degree of contrast found in a negative as compared with the contrast found in the original subject
**grain** the individual silver particles grouped together; the chemical properties of a developer which compliment the qualities of a film emulsion

**handheld camera** a camera that is easily operated without a tripod or support
**high contrast** the effect produced when using a light-sensitive material with a broad range of white to dark and a limited gray tone
**high key** the tonal scale from middle gray to white
**holding back** restricting light to an area during printing
**hyperfocal distance** a preset lens, shutter, and focus that can be used instantly without further adjustment
**hypo** a chemical that fixes the developed image
**hypo neutralizer** a chemical that neutralizes the fixing action of the hypo and shortens washing time

**incident light** light that falls on a subject from a source
**infinity** the farthest point of focus
**inspection** viewing film during the development process
**intensifiers** chemicals that add contrast and density to underdeveloped negatives

**lens** optic used for image and light control
**lens length** the covering power of a lens at maximum f:stop focused at infinity
**lens speed** the maximum f:stop for a given focal length
**lighting ratio** the degree of intensity between the main light source and fill-in light
**low key** the tonal scale from middle gray to black

**main light** the principal source of illumination
**monobath** a single-solution chemical that develops and fixes the film in one operation
**montage** a composition created by using two or more images; may be accomplished by exposure in the camera or by printing in the darkroom
**muticontrast papers** printing papers that have been coated with emulsions which respond to special filters to produce varying degrees of contrast

**orthochromatic film** film that is sensitive to all colors of light rays except the red end of the spectrum

| | |
|---|---|
| **panchromatic film** | film that is sensitive to all colors of light rays, but less sensitive to green |
| **panning** | moving the camera during exposure to follow the action of the subject and pressing the shutter release during motion |
| **paper negative** | a negative image formed on thin paper which is then used to print a positive by contact printing |
| **photoflood** | an artificial light source |
| **photogram** | an image produced by placing objects directly on photographic paper in the darkroom, exposing it to light, and processing the print |
| **photographic paper** | light-sensitive material (including chloride, bromide, chlorobromide) bonded to paper on which a positive image is printed |
| **pinhole camera** | the basic camera body to house film which is exposed by light passing through a lens formed by punching a hole with a pin |
| **polychromatic film** | film that is sensitive to all colors |
| **preservative** | a chemical that extends the life of a developer |
| **printing in** | adding light to an area of a photographic composition during printing |
| **printing-out paper** | a slow-speed paper that can be printed with sunlight |
| **pushing film** | extending a film's speed beyond the accepted ASA rating |
| **rangefinder** | prismatic lenses coupled with the camera lens for focusing the image onto the film plane |
| **real image** | an image that reproduces the original subject as nearly as possible |
| **reducer** | a chemical that alters the density or contrast in film and paper images |
| **reflected light** | light that is reflected from the subject to the exposure meter |
| **resolving power** | a film's capability to render fine detail |
| **roll film** | a continuous strip of light-sensitive emulsion mounted to a flexible base and wound around a spool, the number of exposures dependent upon the size of each frame and the length of the flexible strip |
| **selective focus** | isolation of sharply focused subject with foreground and/or background out of focus |
| **selenium cell** | the light-sensitive unit of an exposure meter that measures light intensity |
| **sheet film** | individual pieces of acetate that are coated with light-sensitive emulsions |
| **short stop** | plain water or diluted acetic acid that is used after developer to stop developing action without fixing the image |
| **shutter** | mechanical control for transmission of light to film; film is exposed in fractions of second |
| **single-lens reflex camera** | a camera with a single lens for viewing the subject and taking the picture |
| **solarization** | partial reversal of negative and/or positive tones to produce abstract qualities |
| **talbotype** | the negative/positive image invented by Henry Fox Talbot |
| **telephoto** | an angle of vision that is narrow than normal and thus enlarges the image size |
| **theory of thirds** | the approach to photographic images that divides them into three equal parts both vertically and horizontally |
| **35mm camera** | a small-format camera that uses film measuring approximately 35mm in width; first used for movie cameras |
| **time and temperature** | a method of developing film by using a combination of chemical degrees and minutes in solution |
| **tonal range** | the values of black, gray, and white that produce the contrast in a negative or print |
| **toners** | chemicals that replace black tones of a print with degrees of another color such as blue, red, brown, green |
| **tripod** | a three-legged support for large-format cameras |

| | |
|---|---|
| **tripod camera** | a camera that is too large to use without support |
| **2¼-square camera** | a camera format that uses film 2¼ inches wide by 2¼ inches high |
| **view camera** | a large-format camera on which focusing and composition are accomplished by viewing the image on ground glass |
| **viewing square** | two adjustable L-shaped frames that are used to practice compositional structure |
| **walking camera** | a camera that is easily carried and operated |
| **wet plate** | a glass-based film emulsion that has to be prepared, exposed, and processed in rapid sequence |
| **wetting agent** | a chemical that brings about faster, more even drying of film |
| **wide-angle lens** | a lens with an angle of vision that is broader than normal |

# index